By Dawn's Early Light

by

Wallace Ferrier

Grosvenor House
Publishing Limited

This book is published by
Grosvenor House Publishing Ltd
Link House
140 The Broadway, Tolworth, Surrey, KT6 7HT.
www.grosvenorhousepublishing.co.uk

A CIP record for this book
is available from the British Library

ISBN 978-1-83975-227-8

Special Thanks to...

Sgt Chris Frith RM (Britannia yachtsman)
Major Steve Nicoll RM
Graham Reed RM (corps historian, RMA)
C/Sgt Derek McNulty RMVCC
Paul Johnson RM (drone photography)
Stuart Lavery RM

Nick Whelan (legal) Whelan & Co Solicitors
Freda Wells & Staff (Meadowbank Inn)
Lewis Jenkins (Abbey Music)

INTRODUCTION

Welcome to *By Dawn's Early Light* and thank you for buying this book. The contents are a mix of my photojournalistic stories from the Arbroath area. In complete contrast, the book also contains my favourite historical stories that made headlines around the world.

Some of you may notice familiar titles to these stories. To begin with, when I started the book, I completed the first few stories and gave them what I thought were appropriate titles. Perhaps, as in my teens I was a former mobile disc jockey, I subconsciously gave them the same titles as old songs. Anyway, for whatever reason, once I noticed the connection, I sought to name each individual story with a song or film title. This book, *By Dawn's Early Light*, contains quite a mix of stories, which may divide opinions and spawn more questions than answers. Anyway, please enjoy the book.

Wallace Ferrier, March 2020

AS TIME GOES BY

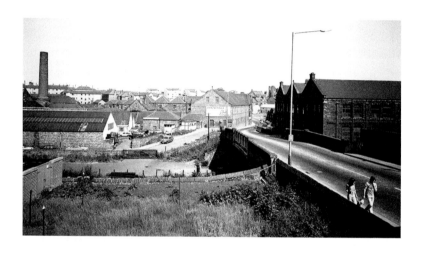

High Road, Brig

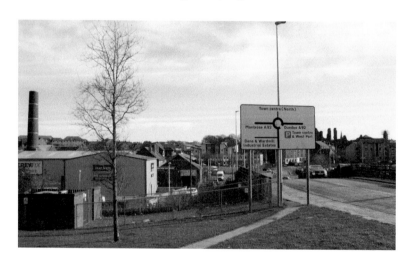

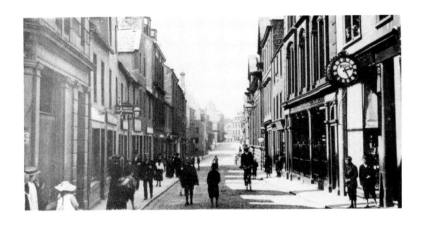

Arbroath High Street

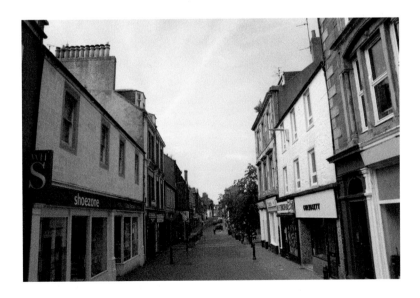

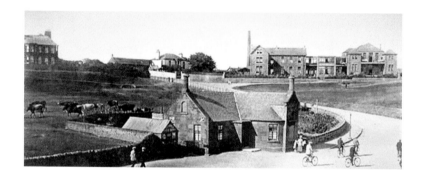

Infirmary Brae

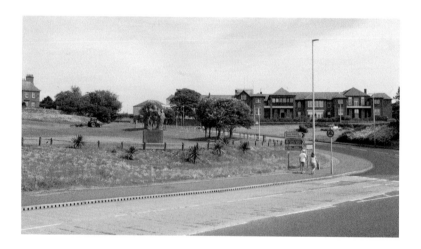

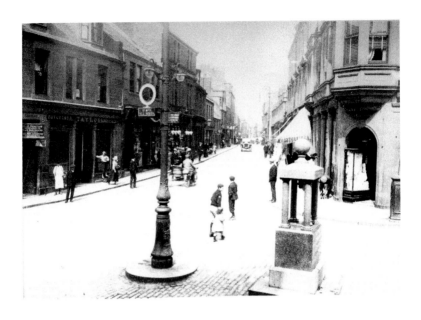

Arbroath High Street

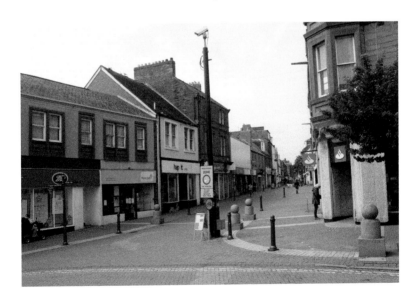

Knox Church

The Low Common

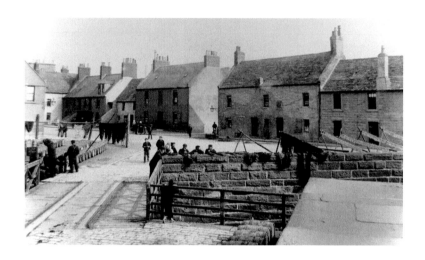

Danger Point

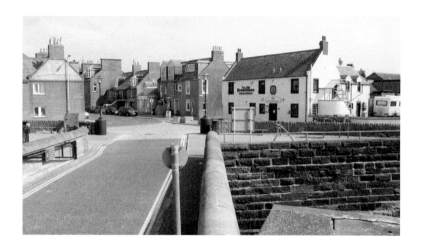

The Pendé

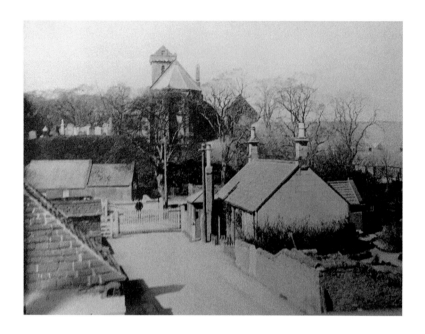

St. Vigean

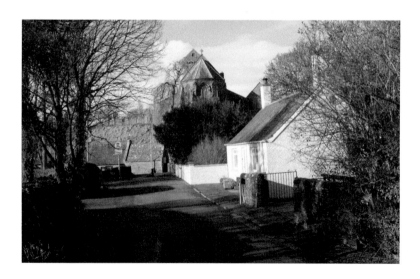

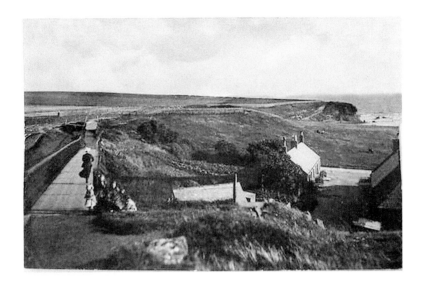

The Ness

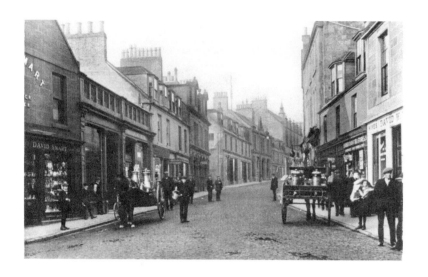

The West Port

BLOOD AND FIRE

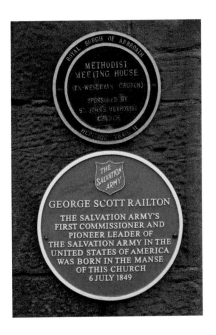

George Scott Railton was born in the manse of St John's Methodist Church in Arbroath on 6 July 1849 to missionaries Lancelot Railton and Margaret Scott. A few years later, young George was educated at Woodhouse Grove School in Leeds, which was a school for children of Wesleyan Methodist Church ministers. When George was 15 years old, both his parents died on the same day (8 November 1864) from cholera. George found himself homeless and unemployed. However, his older brother, Reverend Lancelot Railton, found him work with a London-based shipping company. George, however, didn't like the work involved, so he travelled to Morocco in 1869 to become a Christian missionary. This did

1

not work out either, so, finding himself stranded in Morocco with very little means, George had to work his passage home as a steward on board a ship. Once back in the United Kingdom, George retained employment in the shipping business, only this time working for his uncle. While working in the shipping trade, at every opportunity, George continued to teach the Gospel in his spare time. In 1872, George read a report on "How to reach the masses with the gospel", and was so moved by the report that he immediately offered his services to the cause. That very same year, George travelled to London to commence work for The Christian Mission, which, six years later, would become The Salvation Army. For a few years, he became secretary to William Booth. When Booth's son was old enough to take over the secretarial duties, George went to New York to begin The Salvation Army work in America, and, by 1880, 1,500 had been converted. Then, on 24 March 1881, George Scott Railton gave his first sermon in Halifax, Nova Scotia. The following year, The Salvation Army was established in Canada.

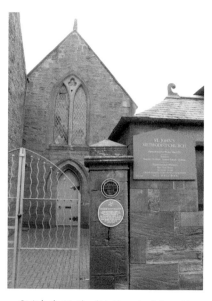

St John's Methodist Church, Arbroath

2

George married Marianne Parkyn, a Salvation Army sergeant from Torquay in Devon, England. They were married by William Booth at Exeter Hall on 17 January 1884. They were blessed with children, but George was rarely at the family home. He travelled extensively with The Salvation Army to various countries, including South Africa, Germany, Spain, France, West Africa, China, Japan and Russia. Although by this time his health was declining, he never seemed to slow in his work schedule. While en route to Le Locle in Switzerland, he had a stopover in Germany, changing trains in Cologne. As the scheduled train exchange was some time away, George decided he would pop in to see the local Salvation Army officers at their quarters. George was made most welcome by their hospitality, and, as usual, they were engrossed in chat as the time passed. Suddenly realising that his train was due soon, George hastily said his goodbyes and departed. Arriving at the train station just in the nick of time, George was running up the station steps with heavy luggage in each hand. Once on board the train, he collapsed in his seat and died of a heart attack. The date was 19 July 1913.

George Railton's son became the Reverend David Railton, who was a clergyman with the Church of England. While Rev. David Railton was serving as a British Army chaplain during World War One, he conceived the idea of the Tomb of The Unknown Soldier. Like his father, David's death was also connected with a train. Rev. David Railton died at Fort William train station in Scotland after slipping and falling from the overnight London Express.

Legacy

The Railton School for Youth Worker Training in Suffern, New York is named after Arbroath-born First Commissioner George Scott Railton. The Salvation Army motto is 'Blood and Fire'.

READ ALL ABOUT IT

I have been taking press photographs on a freelance basis since the mid-1980s. However, I can count on my left hand the times that both a reporter and I have gone out on an assignment together. Nowadays, perhaps due to staff cuts and cost-saving exercises, press photographers are expected to take photographs and write a report, making you not just a photographer, but rather a photojournalist. The caption formula I have always worked on when writing a report is 'The Five Ws'; that is: **who – what – where – why – when**. If you follow that basic formula, you should have a complete story to keep any editor happy. Since the '80s, the media has changed dramatically. For example, the Dundee Courier, when I first started as a freelance photographer in around 1985, I used to send photographs or film up on the train to be picked up at the Dundee station. For a really big story, I remember Grampian TV sending down a motorcycle courier to pick up the film. Nowadays, of course, copy is just sent over the Internet via e-mail or by FTP (file transfer protocol).

The Internet has made photography much simpler, as has digital photography. Someone famous once said, "The greatest story in the world is not worth a dam if you can't get it out." The radio and TV news stations can broadcast a news item over the airwaves and cover a breaking story for a few moments before moving on to something else. At least they can tell a story that happened that same day, even breaking into normal scheduling if the story is a worthwhile newsflash. On the other hand, newspapers go into more depth and can allocate several pages to tell the full story, but, then again, it is

yesterday's news. I would also like to mention that, for a long time, certain national newspapers were politically biased. I always thought it must have been awkward if a reporter showed alliance to the Labour Party while his editor was prone to the conservatives. Anyway, let's get back to the news outlets and the Internet. The Internet is a fabulous way to get up-to-the-minute news out there, including Facebook. I myself have first learnt of breaking stories on Facebook and it's a great source of news. However, beware of certain false stories, including companies that lure you in with a headline, then try to sell you something or other; so be aware.

Most newspapers earn their income not only from paper sales, but also newspaper advertising, and, depending on how big a newspapers circulation is, the cost of an advert can vary in price. Over the last few years, advertisers have been able to pick and choose where they spend their cash to advertise, and that includes TV, radio and Facebook or other Internet outlets. Some newspapers, especially those with smaller circulation, are struggling and will not survive. Newspapers are forced to cut costs to compete in today's multimedia market. A few newspapers have started a community page, relying on members of the public to send in their own photos free of charge to cover their event, thus save paying for a professional photographer. To cut down on paper, more and more newspapers are moving to online as well as hardcopy paper sales. If more people subscribe, they will eventually stop producing hardcopy newspapers for outlets and publish online only. I cannot blame them; anything that saves cash means that their newspaper will survive for a few more editions, at least. The following gallery contains a few of my press photos from over the years.

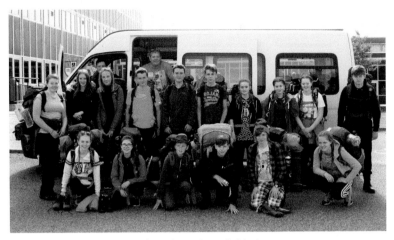

Arbroath Academy field trip

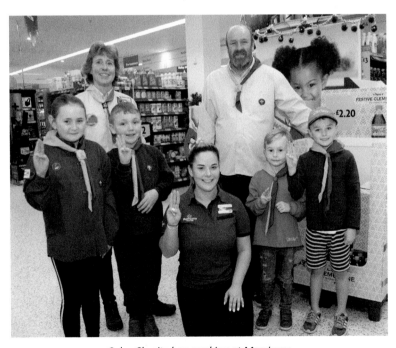

Cubs, Charity bag-packing at Morrisons

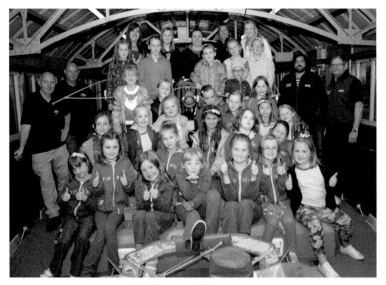

Girl Guides tour lifeboat station

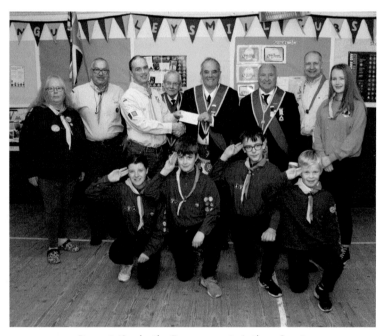

Presentation by the Freemasons to Letham Scouts

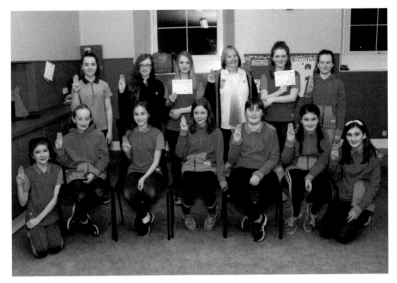

1st Arborath Girl Guides

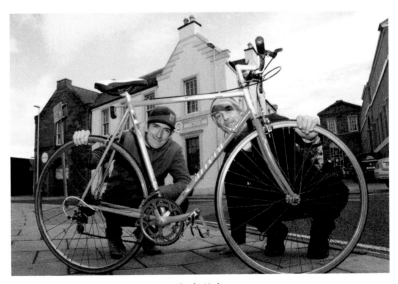

Cycle Hub

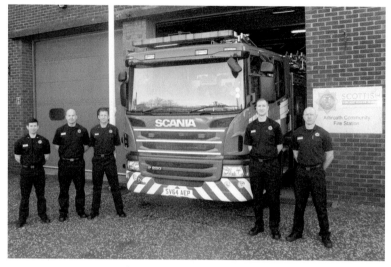

Blue Watch Arbroath Fire Service

Hayshead charity event sponge-throw

Angus Music Festival

Australian kilt-clad tourist with bevvie of beauties

Royal Marines Past, Present and Future on Remembrance Sunday

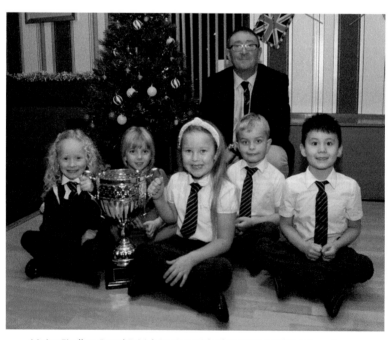

Major Findlay, Royal British Legion with Christmas card Trophy-winners

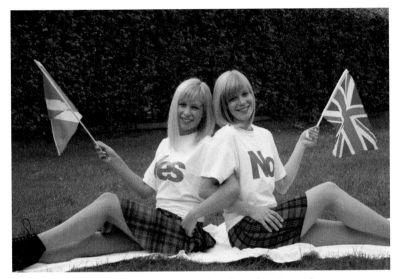

Rachel and Stephanie, Scottish Referendum Press photo

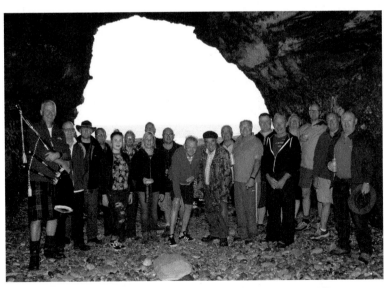

Freemasons gathering within Mason's Cave, Arbroath Cliffs

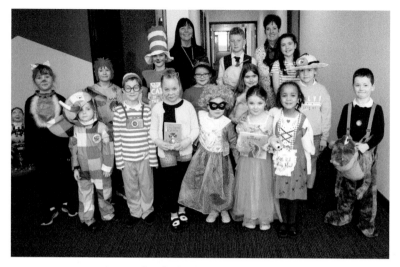

Hayshead School, World Book Day

Police Scotland, New recruit

SMOKE GETS IN YOUR EYES

Dr Neil Arnott FRS LLD was a physician, inventor and author. Neil was born in Arbroath on 15 May 1788 to a family of well-known bakers in the town. Neil did dabble in the family business in his early years, but he left Arbroath to attend firstly Marischal College in Aberdeen, then London University, where he studied engineering and medicine. He eventually qualified as a doctor, and was such a successful and talented physician that, in 1837, Arnott became Physician Extraordinary to Queen Victoria, and the following year a Fellow of The Royal Society.

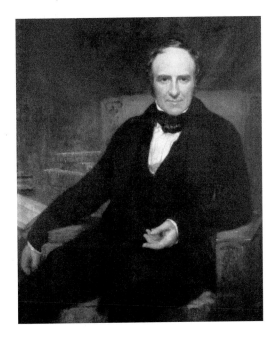

Dr Arnott wrote a few books to much acclaim, which were translated into several languages. Rather surprisingly, as if that wasn't enough to keep his clever and talented mind occupied, he was also a keen inventor, regularly experimenting and jotting down ideas in a notepad he kept with him. Dr Neil Arnott was heavily involved in campaigning for public health reform, and one of his first inventions was in 1833, with his design of a prototype waterbed. His waterbed was basically a wooden box filled with water with a rubber and canvas skin on top, covered with a bed sheet. He wanted to develop this waterbed in an attempt to make a sleeping person more comfortable and eliminate bedsores, especially in the elderly and disabled. Arnott, however, never put a patent on his invention, and several others copied and upgraded the idea. I have to say that Dr Neil Arnott was never given the credit (financial or otherwise) he deserved for inventing the waterbed.

A few years later, when solid fuel was the main source of heat within a home, people were often choked up when fumes filled a room. Perhaps due to the fact he was a doctor, he was well aware of how the public were getting respiratory problems such as asthma, irritable, watery eyes, allergies and coughing fits, etc., so much so that Dr Arnott decided to do something about it. He redesigned the fire grate, which improved heat distribution, and cut down escaping smoke fumes. His design of the improved fire grate was highly successful, and helped improve health and living conditions within a household, so much so that, in 1852, his fire grate design was awarded The Rumford Medal.

Due to the considerable wealth he accrued over the years, Dr Arnott was generous enough to donate in total £10,000 to five universities, each receiving £2,000; four of the universities were in Scotland and one was in London. As a son of an Arbroath baker and a true 'Red Lichtie', Dr Neil Arnott did very well for himself, and, in his lifetime, improved healthy living conditions for many people. Dr Arnott passed away on 2nd March 1874. His widow, Marianne, and his friend, Sir

William Thomson, jointly set up and endowed a university award called 'The Arnott and Thomson Demonstratorship in Experimental Physics', which is given each year to two students who achieve the highest aggregate marks in the junior honours course in physics.

Dr Neil Arnott FRS LLD is interred at Dean Cemetery in Edinburgh.

"ESCAPE TO VICTORY"

Lieutenant Colonel Ralph Garrett Royal Marines DSO, OBE, (1904 –1952)

A Royal Marine war hero and his Red Lichtie lass

It's a long way from the shores of Arbroath to the Mediterranean of World War Two. Yet there is a link between these two locations that tells a tangled tale of love, loss and heroism. Long before the Royal Marines of 45 Commando took over the vacant Royal Naval Air Station at HMS Condor in 1971, there was a local romantic connection between a dashing Royal Marine officer and a Red Lichtie lass. Ralph Garrett and Margaret McBain were married in 1933, and this is their story.

Ralph Garrett joined the Royal Marines Artillery as a second lieutenant in September 1921 aged 17. As a young subaltern, he served on the HMS Iron Duke in the Mediterranean and Atlantic fleets. He was initially commissioned into the Royal Marine Artillery in 1923, but was transferred to the Royal Marines in 1924. Between 1924 and 1926, he was the transport officer at the School of Land Artillery, Fort Cumberland. From 1927 to 1929, he served on the HMS Malaya and was in the Mediterranean from 1929-1931.

Excerpt from the *Arbroath Herald* (August 1933)

"Marriage of Captain Ralph Garret Royal Marines and Miss Margaret McBain on 29th July 1933.

Ralph Garrett married Margaret McBain on the 29th July 1933 at All Saints Church, Kenley, Surrey. The bride's parents, Mr J. A. D McBain CIE and Mrs McBain of Hill House, Surrey have family connections with a legal firm in Arbroath. Margaret McBain is the grand daughter of the late J M McBain, Bank Agent, and author of several books on the history of Arbroath."

(NB: The firm of Gourlay McBain of Arbroath was bought out by Blackadders and now has no family connections.)

Ralph Garrett was serving with the Royal Marines and was deployed at the outbreak of World War Two, firstly in Egypt and then Crete. It was while serving in Crete that the war was not going so well for the British. The German Army was advancing and the British were taking heavy losses and were in full retreat. Garrett was ordered, together with 700 Royal Marines, to take part in a rear guard action. His orders were to hold back the advancing German Army, allowing the main body of British troops to retreat to the south of the island. By this time, Garrett was promoted to the rank of major and he gave the order to his troops to dig in.

Major Garrett was ordered to hold position for four days until 1 June 1941. In fact, Major Garrett and his Royal Marines fought on courageously for six days, allowing 17,000 British troops to evacuate to fight another day.

As part of the rear guard, Major Garrett knew all too well that they were in a precarious situation and were likely to suffer heavy losses. Nonetheless, he and his men fought bravely, continuing to slow the German advance while retreating under fire. It was also obvious to all that they were highly unlikely to get off the island.

However, the Royal Marines were well trained and, on reaching the coast, their survival training kicked in. They managed to acquire various fishing craft and found a LC (landing craft) that had been abandoned due to a fouled propeller. LCs are slow, designed for short coastal journeys, and are flat bottomed to allow them to run up over the surf

and onto the beach. They come in various sizes and the LC that they acquired was designed to hold around 100 troops. However, piling on board were five officers and 134 other ranks, including 56 Royal Marines. With limited water and supplies, they made their hasty escape in the direction of North Africa. The overcrowded flat-bottomed landing craft, and with no keel, was certainly going to roll about in heavy seas, together with the ever-increasing threat of air attack. This was, for sure, going to be a dangerous voyage.

They managed to get to a small island called Gaudopula 20 miles south of Crete. While there, they managed to free up the fouled propeller and also took on water in various containers that they managed to scavenge. Setting out to sea once more, the overcrowded landing craft headed further south, getting a further 80 miles before the engine began to splutter as it ran out of fuel. A few of the party attempted to refuel using cooking oil, but that proved to be unsuccessful, so, with no other option, they managed to rig a small sail fashioned from blankets, which worked to a certain extent, but, with little controllable power, the LC was difficult to steer. Furthermore, they soon ran low on fresh drinking water. Thankfully, again, two Royal Marines came to the rescue. Using their initiative,

they made a distilling plant from containers and a section of rubber hose, and, using the remaining cooking oil, managed to make 4.5 gallons of drinking water in two days.

On 9 June 1941 at 1.30am, the crowded landing craft arrived at the African coast near a place called Sidi Barrani. They had covered nearly 200 miles in a vessel designed for coastal assault. Unfortunately, two of the soldiers on board passed away during the voyage. Nonetheless, it was a remarkable journey. After landing on the deserted beach, two of the passengers, both New Zealand Maoris, managed to locate fresh water, while Sergeant Bowden RM travelled through the night in near total darkness for five miles to reach a British anti-aircraft regiment. The men at the anti-aircraft regiment were somewhat surprised to see Sergeant Bowden, and even more surprised to hear about their daring escape in a landing craft. The regiment sent transport to pick up the rest of the survivors the following morning.

For his outstanding service in his rear party action, and the rescue of his men in the landing craft, Major Ralph Garrett RM was awarded the DSO (Distinguished Service Order).

Major Garrett remained in the Royal Marines until 1951, thereafter leaving the corps, finding work as the Northern Area Field Commissioner with the Boy Scout movement, based at Berryfield House, Lentran, Inverness-Shire. Unfortunately, his life as a civilian was short-lived. On 16 January 1952, Ralph Garrett and his 16-year-old son, Stephen, went on a hunting/fishing trip in the rural area of the Beauly Firth. During the night, the weather turned foul. Family and friends initially were not worried, as Ralph was an experienced war veteran, who had been in various difficult situations and in all weathers. However, when a horrendous snow storm began, and time wore on, friends became anxious. The last confirmed sighting of the father and son was at 4.20pm on the afternoon of 16 January, and, with neither returning home that evening, the family became deeply concerned.

Tragically, the following day, the bodies of both men were discovered some distance from each other. It was later determined that both men had drowned. Both bodies were discovered near the entrance to the Caledonian Canal North of the Kessock Ferry slipway. Ralph's wife and Stephen's mother, Margaret McBain, was spared the tragic news, as she had already passed away some months earlier.

As tragic as any loss of life is, there was a terrible irony attached to the drowning of decorated war hero, Lieutenant Colonel Ralph Garrett, DSO, OBE Royal Marines. In a remarkable story of courage and adventure, he had commanded an improvised maritime escape from Germany occupied Crete across the Mediterranean to safety in Libya for more than 130 allied troops. His extraordinary seamanship and coolness in adversity cruelly abandoned him on something as innocent as an afternoon with his son on the sheltered waters of Beauly Firth.

Having had a full and active career with the Royal Marines for 30 years, including several years of operations during World War Two, Lieutenant Colonel Ralph Garret must have relished the opportunity to be based at home, where he could

look forward to a settled life and satisfying employment. Within only a few months after taking up his new civilian employment, he was to die aged only 48.

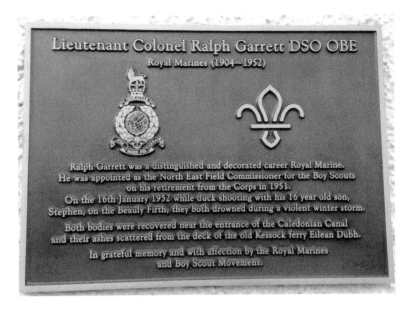

Lieutenant Colonel Ralph Garrett DSO OBE
Royal Marines (1904~1952)

Ralph Garrett was a distinguished and decorated career Royal Marine. He was appointed as the North East Field Commissioner for the Boy Scouts on his retirement from the Corps in 1951.
On the 16th January 1952 while duck shooting with his 16 year old son, Stephen, on the Beauly Firth, they both drowned during a violent winter storm.

Both bodies were recovered near the entrance of the Caledonian Canal and their ashes scattered from the deck of the old Kessock ferry Eilean Dubh.

In grateful memory and with affection by the Royal Marines and Boy Scout Movement.

It's a long way from the shores of Arbroath to the Mediterranean. It's a much shorter journey to the Beauly Firth. In 2020, a plaque commemorating the loss of Ralph Garrett and his son was unveiled on the southern slipway of the old Kessock Ferry, where their ashes were scattered from the ferry Eilean Dubh. This was made possible by the generous support of Royal Marines from all over Scotland to ensure that his memory will not be forgotten.

THOMAS MOONLIGHT

Thomas Moonlight was born in Arbroath (Forfarshire) on 30 September 1833. He was one of 10 children born to Archibald Moonlight and Margaret Elspet Anderson. He was baptised in St Vigean Church. When Thomas was seven years old, it is known that the family lived on Ninety Acre farm on the out-skirts of Arbroath. Much later, when Thomas was in his late teens, he left Arbroath with his two cousins, another Thomas and George. They worked at various jobs, mostly farming, eventually moving overseas to America.

After a few years, the cousins, George and Thomas, relo-cated to New Zealand, where George made a name for himself gaining fame as a wealthy pioneer prospector. Later, George was given the honour of having a town named Moonlight in his honour. Both of the cousins, George and Thomas, are buried near Nelson in New Zealand.

As for Thomas Moonlight in America, when he was 20 years old, Thomas Moonlight enlisted in the US Artillery Regiment. He served in Company D from 1853 to 1856, rising to the rank of sergeant. In 1860, he had settled in Leavenworth County, just one year prior to the beginning of the American Civil War.

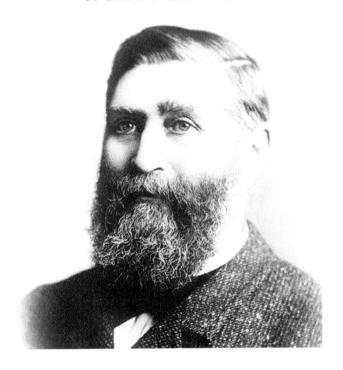

Moonlight served with the 1st Kansas Artillery, serving briefly as captain before being rapidly promoted to lieutenant colonel with 11th Kansas Infantry, which then became the 11th Kansas Cavalry. His battles were mainly skirmishes against border guerrillas, although he did pursue Quantrill's Raiders immediately following Quantrill's massacre at Lawrence.

(Quantrill's Raiders were a unit fighting for the Southern Confederates during the American Civil War; they were guerrilla fighters, often called bushwhackers. Quantrill's Raiders were led by Captain William Clarke Quantrill, and included in their fighting unit were famous gunslingers Jesse and Frank James. The Raiders harassed the Union soldiers where they could, and, in retaliation, supporters of the Union soldiers arrested the wives and girlfriends of men known to be members of the Quantrill Raiders, and jailed them in a town called Lawrence. The jail had been modified and constructed hastily and, due to substandard building material, collapsed on top

of the women, killing some and seriously injuring others. Quantrill's Raiders were furious and, in August 1863, led a raid to rescue and free their women. During this raid in Lawrence, 150 men and boys were killed. Later, Quantrill's Raiders attacked Fort Baxter and massacred 100 Union soldiers. The Union were outraged, as were the Confederates, who disowned Quantrill's Raiders and withdrew material support. Quantrill's Raiders eventually broke up into separate smaller groups. Most were soon cornered and killed, including Quantrill himself. Jesse James and a small group became outlaws and carved their own names in the history of the Wild West).

Throughout his military career, Thomas rose rapidly up the ranks, eventually ending the civil war commanding a unit chasing native Indians off the plains. In April 1865, Thomas Moonlight was based at Fort Laramie in Wyoming, commanding the North sub district over the Great Plains. However, his rapid rise in promotion was eventually tainted by his rather shady exit out of the military. The facts are a bit sketchy, but apparently Moonlight was often drunk, and, therefore, replaced from command. Probably due to having acquired many friends in high places, including President Abraham Lincoln, Moonlight's army exit, for whatever reason, was hushed up and played down.

Political Career

After his military career came to an abrupt end, Thomas Moonlight returned to his wife and seven children to take up farming again. Moonlight was an avid Republican right up to the year 1870, when, for some reason, he suddenly changed allegiance to the Democrat Party. Thomas Moonlight soon became popular within the Democrat Party serving as the Kansas Secretary of State and Adjutant General of Kansas. He was also appointed Governor of Wyoming Territory by none other than the then President of America, Grover Cleveland, prior to being appointed the United States Minister to Bolivia.

Thomas Moonlight died on 7 February 1899. He is buried next to his Irish wife in Mount Muncie Cemetery, Fort Leavenworth, Kansas.

I'm sure you agree, for an Arbroath man Christened at St Vigean Church, Thomas Moonlight sure had an interesting life.

"WHOEVER SAVES ONE LIFE SAVES THE WORLD ENTIRE"

In 1823, the German Jewish poet, Heinrich Heine, wrote, "Where books are burned, in the end, people will also be burned."

I'm sure most of us have seen the movie *Schindler's List*, directed by Steven Spielberg and starring actor Liam Neeson as the lead character, Oskar Schindler. It is a story based on true events and the persecution of the Jewish people by Nazi Germany. The movie was made in 1993 and shot mostly in monochrome (black and white), with the exception of a scene where a young girl is highlighted wearing a red coat. This girl wearing her red coat is seen walking down the ghetto as people are being shot or already lying dead around her. It is a harrowing scene and Schindler is seen riding a horse near the ghetto when he spots the little girl and realises what is happening to the Jewish families. It is from that point on that Schindler attempts to save as many of the Jews as possible, especially when later in the movie he comes across the little girl's body (again highlighted in red) piled up on top of other bodies. The small girl playing the part in the red coat was a Polish five-year-old girl called Oliwia Dabrowska.

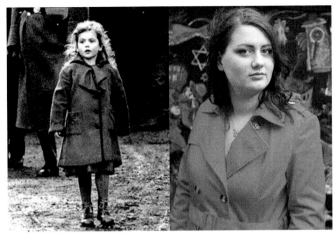

Oliwia Dabrowska Age 5 *Oliwia Dabrowska In 2015*

During World War Two, there was a Jewish girl well known for wearing a red coat in the ghetto. Her name was Roma Ligocka. She actually survived the Holocaust and, after the war, wrote her memoirs in her book, called *The Girl in The Red Coat*. It is not believed to have any connection with the Spielberg movie.

Oskar Schindler

The real Oskar Schindler was of German/Czech nationality, born on 28 April 1908. He spent his early life growing up in Svitavy, Moravia. After his schooling, he tried several jobs in various trades. Oskar even joined the Czechoslovakian Army, rising to the rank of lance corporal. During this time, he was arrested a few times for being drunk and disorderly. In the mid-1930s, Oskar joined the military intelligence of the German Party, and, three years later, joined the Nazi Party. In 1938, just prior to the start of World War Two, he was arrested by the Czechoslovakian Government for spying on their rail network and troop movements. However, he was released quite soon after due to insufficient evidence. Although married, he enjoyed the company of women and had several

lovers. Oskar was very ambitious and desired to become a successful businessman. However, at the time, he had very little money, but was quick to spot business opportunities while the war was on. He met Itzak Stern, who was a Jewish accountant. Stern organised financial backing from Jewish industrialists who gave him funds to purchase his factory.

By 1939, Oskar took over a factory in Kraków, Poland dealing in ceramics. During this time, Oskar remained in the Nazi Party while employing nearly 1,500 workers, mainly Jews. Initially, Oskar was only after financial gain; he employed mainly Jews, as they were cheaper than employing Poles or other nationalities. During this period, Oskar Schindler became very wealthy. I guess, so far, I have not painted a good picture of this man. Obviously, Schindler was a member of the Nazi Party, and a heavy drinking womaniser who was only interested in his own financial gains. However, something changed in the man once he realised how the Nazi Party was treating the Jews. He set about paying off German officers to protect his Jewish workforce, even employing more Jews than what the factory required. Bribing a German officer could have led to serious repercussions, including his death, but he continued to pay off German officers up until the war's end, by which time his wealth had diminished considerably.

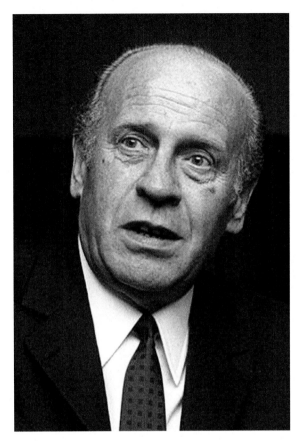

Oskar Schindler

Oskar Schindler was arrested three times, twice for black market activities and once for kissing a Jewish girl on the cheek when it was her birthday. (Kissing Jewish girls was forbidden by The Nuremberg Laws.) He served a total of 11 days in prison. Each time he was arrested, he was released by influential high-ranking Nazi officials who were known to him. On 13 March 1943, the new Płaszów concentration camp opened 1.5 miles from Schindler's DEF factory. The commandant of this camp was the evil sadist Amon Goth, who quickly earned the nickname "The Butcher of Płaszów". This name was very apt, for Goth thought nothing of using a

sniper rifle to pick off the Jews as they moved about camp. Goth wanted to move Schindler's factory within the camp walls, but Schindler used flattery and bribery to persuade Goth to allow him to build (at Schindler's own expense) a sub-camp called Emalia alongside his factory to house his employees. Here, they were well fed and safe from execution. Around this time, Schindler travelled to Budapest several times on the pretext of managerial work for his factory business. Each time, however, he would get in touch with the Zionist leaders to report on the Germans' ill-treatment of Jews. He was given funding by the Jewish Agency of Israel, which he passed on to the Jewish resistance.

In mid-1944, the Russian Army was advancing from the east, and the Nazi Party started to close down concentration camps in the Red Army's path and withdraw the Jews to camps further west, like Auschwitz. By this time, it must have dawned on most Germans that they were losing the war, and the Nazis started to increase the rate of murdering the Jews. The personal secretary to Commandant Goth, a German Jew called Mietek Pempar, tipped off Schindler regarding the factory closures, and suggested to Schindler that he switch from ceramics to arms production, which would allow him to keep his factory and workforce, claiming it was essential for the German war effort. Again using a combination of diplomacy and bribery, Schindler convinced Goth to permit a relocation of his factory at Brünnlitz in Czechoslovakia. Together with Pempar and a Jewish ghetto police officer, Marcel Goldberg, they compiled the now-famous "Schindler's List" of who was to be retained as an essential factory employee; in fact, it was a list of who was to be saved from almost certain death. When the factory opened, the food supplied by the SS was hardly edible, nor enough to feed the entire workforce, so Schindler and his wife used their own finances to feed their workforce.

In January 1945, a train arrived with approximately 250 Jewish workers who were rejected from a nearby mine for

being too ill to work. These people were destined for the gas chambers. Oscar's wife, Emilie, arrived with an engineer from their factory and, using a welder's torch, opened the carriage doors. Although many were dead inside, she took the survivors back to the Schindler factory and made an improvised hospital within, allowing them to recover their health. Finally, on 7 May 1945, Schindler had his workforce gather around and they all listened to British Prime Minister Winston Churchill announce that Germany had surrendered and the war in Europe was over.

As a member of the Nazi Party, Oskar Schindler was in danger of being detained as a war criminal. His friend, Stern, and others from his workforce compiled a letter he could show, should he be captured, attesting to the fact that he was instrumental in saving Jewish lives.

Oskar and Emelia Schindler departed in their two-seater Horsh motorcar, initially with a few fleeing German guards standing on the running boards of the vehicle. Later, they were stopped by Russian troops at the town of Budweis, where their car was confiscated. (Thankfully, the German guards had parted company with them a few miles earlier.) The Schindlers continued on their perilous journey by train and foot, with the few remaining items in their possession, before finally reaching American troops in Lenora. The war had seen Oskar Schindler amass a fortune, but, in the year leading up to the end of the war, he had spent most of it on food, bribes and supplies for his Jewish workforce. He and his wife moved to various locations, living off a $15,000 subsidy received from the joint American Jewish distribution fund. In 1959, he and Amelia bought a chicken farm in Argentina. When his farm went bust, he and his wife parted company, and Oskar returned to Germany alone and destitute. He managed to start another business, which also proved unsuccessful, finally applying for bankruptcy in 1963. He often received donations from various Jews and lived the remainder of his life in a quiet and

unassuming manner. Oskar Schindler died of a heart attack on 9 October 1974. He is buried in the Mount Zion Cemetery in Jerusalem, and remains the only member of the Nazi Party to be honoured this way.

During the holocaust, the Nazis murdered 6 million Jews. Thanks to Oskar Schindler and the factory workers he managed to save, there are now 6 thousand descendants. The ending of the movie is very emotional and has the actual holocaust survivors walking side by side with the very actors who played them; as they line up to honour Oskar Schindler, they each follow the Jewish tradition and place a small stone on his grave.

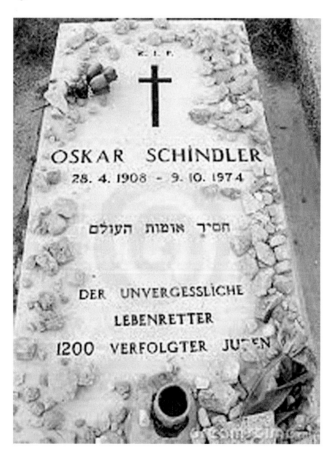

Schindler's List Movie Trivia

The movie *Schindler's List* is based on the book *Schindler's Ark*.

In 1993, during the making of the movie, director Steven Spielberg, his wife, Kate Capshaw, and their two children rented a house in Poland. Kate noticed how depressed her husband was getting when he got home, as Steven was thinking about scenes he had filmed that day or had to film the next day. As a surprise, she had their friend and comedian, Robin Williams, call him on the telephone to cheer him up.

The film company wanted Steven to film the movie in colour, which he refused. The studio then said, well at least film it in colour; we will show it in black and white in the cinema, but, when released for sale on video tape, we can sell the tapes in colour. Again, Spielberg refused.

The movie *Schindler's List* cost $25 million to make, and to date has grossed $322 million, winning seven Oscars.

Due to the movie's popularity, people came in droves to visit Schindler's DEF factory in Kraków. The authorities converted the factory into a museum, with real artefacts from its time as Schindler's factory, and some of the sets they managed to acquire from the movie.

At the war's end, when Oskar and his wife, Emelia, departed his factory, apart from the letter given to him stating that he saved so many Jewish lives, Oscar Schindler was also given a gold ring made from a dental filling removed from the mouth of a factory volunteer. The ring was inscribed with the words "Whoever Saves One Life Saves The World Entire".

THE WHITE STAR LINE

The White Star Line was founded in 1850 to take advantage of all the American trade after gold was discovered there by prospectors. In 1867, the shipping line was bought by Thomas Ismay, and his son, Bruce Ismay, was a shareholder and took over the company in 1899 after his father's death. In 1902, the White Star Line was bought by the wealthy American Peirpoint Morgan, although Bruce Ismay was retained as managing director. It was with the financial backing of Peirpoint Morgan that Bruce Ismay ordered the construction of three ships, with names all taken from Greek mythology, Olympic, Titanic and Britannic. The White Star Line's main competitor was the Canard line, and Bruce Ismay wanted to outdo his competitors by having his three almost identical ships be the biggest and most luxurious afloat.

The Titanic and Olympic

The first two ships, Olympic and Titanic, were built side by side at the Harland and Wolff ship builders in Belfast, to the drawing plans of the naval architect Thomas Andrews. His design would see the ships as very opulent; even the steerage class (third class) would be well above the standards of other ships of the period covering the same route. This was a period in time before air travel, and the best and fastest way to cross the Atlantic to America was by ocean liner. White Star Line's idea for Olympic and Titanic was for one ship to set sail from New York as the other departed Southampton; they would pass each other mid-Atlantic, giving White Star Line the monopoly in fast and luxurious travel over the Atlantic.

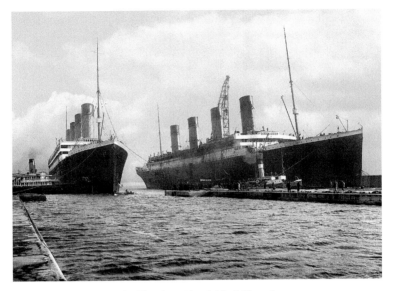

The Titanic on the right of Olympic

The Design

The ships' design had several unique safety features, which should have made them the safest ships afloat. The ships were to have a double-skinned bottom and 16 watertight bulkheads, with large watertight doors that, in the case of an emergency, could be closed from the bridge. Incidentally, the White Star Line never at any time claimed the ships were unsinkable; this was first coined by the press and the theory stuck. The ship had four funnels, or stacks, as they are sometimes called, but the funnel at the rear was fake. It was added to the ship just for appearance, as the ships did not look quite right with just three funnels. The first three funnels obviously took away smoke from the engine boilers, but the last and forth funnel served no purpose other than to perhaps take away some cooking fumes from the kitchen.

Down both sides of the ship, designer Thomas Andrews had placed double davits, which could carry 16 lifeboats either side, plus four collapsible boats, giving the ship 36

lifeboats in total – more than enough to support passengers and crew. However, the owners of White Star Line insisted the boat decks looked cluttered with all those lifeboats, and thought it would offer less space for passengers to walk on the decks, so half the lifeboats were removed, giving the Titanic eight lifeboats on each side, plus four collapsible. For the White Star Line to remove a row of lifeboats from each side of the ship (16 lifeboats in total) may seem foolhardy, to say the least, but they were completely within their rights to do so.

The British Maritime regulations of the Merchant Shipping Act of both 1894 and 1906 both proclaimed and regulated the number of lifeboats on board a ship to be dependent on the tonnage of a ship, and not, as it should have been, based on the amount of passengers/crew on board. The regulations stated that ships of more than 10,000 tons had to have at least 16 lifeboats. However, these grossly outdated rules never took into account how, since 1894, ships had continued to increase in size and tonnage. The Titanic had a gross tonnage of 46,328 tons, yet all she was legally obliged to carry was 16 lifeboats, and, with the additional four collapsible lifeboats on board, Titanic actually surpassed her legal requirements.

While crossing the Atlantic, the officers on board considered the main danger (especially with an April crossing) to be what was known as "growlers". These growlers are large icebergs with a mass that lurks below the surface, with only a small section visible above. In 1912, of course, radar had not yet been invented, so early warning was by deck crew keeping a sharp eye for any obstacles in the ship's path, especially the two lookouts stationed in the crow's nest, located at a high vantage point on a mast forward of the wheel house.

The White Star Line had a policy of rewarding long-serving officers with a set of binoculars. These binoculars were gifted to officers in a presentation box, and, in some cases, were inscribed. One can imagine how proud the officers were to receive such a gift, and how treasured they were. It may come as a surprise to you and be hard to believe, but the lookouts in

the crow's nest were *not* regularly supplied with binoculars, and only occasionally, and only if they were lucky enough, some officer would trust them to borrow their treasured set.

Gugliemu Marconi

Gugliemu Marconi was an Italian inventor and electrical engineer, well known for his pioneering work on long-distance radio transmission. Marconi was credited as the inventor of the radio. In 1909, he shared the Nobel Prize in Physics with Karl Brown for their contribution in the development of wireless telegraphy.

One of Marconi's early goals was to transmit a wireless signal across the Atlantic. Through trial and error, an increase in aerial height, and transmitting strength, a wireless transmission across the Atlantic was finally achieved. In 1903, US President Theodore Roosevelt sent a wireless greeting message to King Edward VII to much publicity at the time.

The Iceberg

We all know our history, or have at least seen the famous movie. As the ship ploughed through the water at more than 22 knots, heading straight for an ice field, the mighty Titanic struck an iceberg at 11.40pm and, immediately, the freezing Atlantic poured in through the burst-open plates along her starboard bow. After consultation with the ship's carpenter and designer, Thomas Andrews (who happened to be on board for the maiden voyage), Captain Smith ordered the radio operators to send out a request for assistance, which they did at once.

Distress Call

The original distress message was typed in Morse code by the letters CQD. It was assumed (incorrectly) that CQD stood for either 'come quick, danger' or 'come quick, drowning'. In fact,

the first two letters, CQ, stood for 'attention all stations', with the D added for 'distress'. However, even at that time, some radio operators just tapped out 'help' when they needed assistance. It was in Berlin during a 1906 radiotelegraphic convention that SOS (three dots – three dashes – three dots) was suggested and adopted as the international Morse code distress signal.

Although the radio operators on the Titanic were employed by Marconi, they received their pay cheques from the White Star Line. The radio operators were Harold Bride and Jack Phillips (Jack being the senior radio operator). Jack Phillips began with the Titanic's call sign, which was MGY, followed by the CQD emergency transmission, which was still widely in use by British ships. It was junior radio operator Harold Bride who suggested that Jack switch to the SOS transmission. Jack continued to send out immediate requests for assistance, alternating between CQD and SOS. Many people believe that the Titanic sent out the first SOS in history, although I find this unlikely, considering German ships had been using SOS for the previous six years.

After the Titanic sank into the abyss, Bride was hauled aboard an upturned lifeboat and survived the sinking. He later gave evidence at the subsequent enquiry into the loss of RMS Titanic. Harold Bride told how, after all the lifeboats were gone, Captain Smith came into the Marconi room and released them from their duties, adding it was now every man for himself. Bride said that he considered his friend, Jack Phillips, to be a hero, as, even though they were released from their duties, Jack Phillips continued to send out distress signals until the radio room lost all power. (Jack never survived and his body was never recovered.)

It should be noted that, in the early days of radio transmitting, especially on passenger ships, the radio room was not located where it should have been, on or near the bridge, where officers control the ship. In the case of the Titanic, the radio room was located on the boat deck. The radio room was not

much more than a glorified wooden shed, with an office worktop at one end where the purser could bring personal messages for the radio operators to transmit. It doesn't seem likely that it was ever considered that the radio room might be required for an emergency call. It was more likely purpose built as a luxury for first-class passengers, who were charged per word to send or receive personal greetings such as 'having a wonderful time on the Titanic' to 'have a car waiting for me when we dock', etc. Several messages of ice warnings were also received from other ships in the vicinity. These were initially passed on to the chief purser to pass on to the officers on the bridge, but the radio operators were soon swamped with private messages to and from passengers. In fact, at one point, an ice warning came in from a ship up ahead, and Phillips was quite abrupt and typed over the top of the incoming ice warning with the message: "Keep out – keep out; I am working Cape Race." (Cape Race was a shore station on the southern tip of Newfoundland's Avalon Peninsula. It was still used for communication up until the mid-20th century, until radio technology made vast improvements and the station became obsolete.)

The Sinking

History records what happened next. The Titanic is the biggest ship afloat, and, to most passengers, it was not immediately apparent that they were in any danger. Some naval architects believe that the Titanic may have survived had she just rammed the iceberg straight on the bow, rather than a glancing blow, but we shall never know.

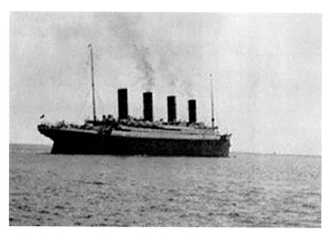

The last known photograph taken of the Titanic on the surface

In the famous James Cameron movie, *Titanic*, the ship dips at the bow and begins to sink. The ship's stern rises perpendicular, straight up out of the ocean, before breaking in two and sinking to the depths. Indeed, the stern would have risen as the bow sunk, but it is highly unlikely that the stern rose straight up. The ship's hull would not have been able to stand that sort of pressure on its superstructure. The ship broke its back and split in two at its weakest point, which was the expansion joint between the third and fourth funnel. RMS Titanic took around two hours to sink, and, with all lifeboats gone, it left around 1,500 people struggling in the water. Most of these unfortunate people did not drown, as, although there were not enough lifeboats, most people were wearing a life jacket were quick to succumb to hypothermia.

The ship sank in more than 10,000ft of water, and experts believe the bow section would have taken around 12 minutes to plough into the ocean floor.

To the Rescue

Many ships and shore stations heard the Titanic's request for assistance, including her sister ship, the Olympic, but the

Olympic was more than 500 miles away – far too distant to be of any help. Although the Titanic officers could see a ship's light on the horizon, possibly stopped due to the ice field, this as yet unidentified ship approximately 10 miles away never responded to radio calls. Perhaps this ship had no radio, they thought, or the radio operator had signed off and retired to his bunk. In desperation, the Titanic sent up rocket flares, but again, there was no response from this mystery ship, which was later identified as the Californian. One ship that did respond to the distress call was the Carpathia. Her captain, 42-year-old Arthur Rostron, was very efficient, and ordered all off-duty crew from their bunks, lifeboats swung out, and had first-aid stations made ready in the dining rooms, where warm blankets and hot soup awaited survivors. He also ordered the heating to the cabins turned off, so that all steam went direct to the boilers, pushing the Carpathia to an unbelievable 17 knots, which, for an old ship, was quite something. However, even at that speed, the Carpathia arrived around 4am, too late to take passengers directly off the Titanic, as she had already slipped below the waves, but they did pick up survivors from the lifeboats. They also spent several hours searching the immediate area for any survivors, but found none.

Captain Rostron then gave the order for his ship, Carpathia, to change course and head for New York, arriving to a heroes' welcome. White Star Line immediately segregated any surviving crew, keeping them well away from the press. Over the following few weeks, the White Star Line also chartered ships to go and pick up bodies – 330 bodies were recovered from various ships. This may surprise you, but White Star actually charged survivors wishing to claim their spouses' bodies. As you can imagine, those survivors from steerage class were with limited means and could not afford to claim their partners' remains. Men at that time were the main breadwinners, so, of the few third-class female survivors, these women found themselves in America, with little money, no job and probably unable to speak English. Charity concerts were organised by

stars of the time and raised £12,000 for destitute third-class families.

Captain Smith of RMS Titanic did not survive and went down with his ship, while Captain Arthur Rostron was dubbed a hero. He and his crew were awarded medals, and Captain Rostron received a cup from none other than the Titanic's most famous passenger (*The Unsinkable*), Molly Brown. Captain Arthur Rostron was also awarded the Congressional Medal of Honour from the American Congress and later, in 1926, King George V knighted him for his services.

The wreck of the Titanic lay undiscovered for decades, until 1985, when an exploration led by underwater explorer Dr Robert Ballard of the Woods Hole Oceanographic Institute discovered its remains.

A Spooky Tale too Close for Comfort

Morgan Robertson was an accomplished author who had several books published. One of his books, *Futility*, published in 1898, has many similarities to what was to happen 14 years later. Similarities almost too scary to mention. In his fictitious novel, Morgan Robertson wrote about how a British-registered mail steamer, the largest afloat, travels on its maiden voyage, in April, crossing over the Atlantic to New York. He tells how the three-propeller liner, while travelling too fast, strikes an iceberg on the starboard bow and sinks, with an appalling loss of life due to not carrying enough lifeboats. Sound familiar?

The coincidence in what was to happen to the Titanic 14 years later is unbelievable, but here's where it really gets spooky. Guess what Morgan Robertson named his ship in the fictitious story? It was called the Titan. Just a mere two letters short of reality.

So what led to so many deaths?

Let us now look at the series of events that led to more than 1,500 deaths.

Design Faults

The Titanic had a double-skinned bottom, which was good, and, down her length, she had 15 compartments separated by watertight bulkheads, which was also good. However, these watertight bulkheads did not go up to watertight decks, therefore allowing water from the breached hull to fill up and overflow back over each bulkhead, flooding the ship...

The Titanic was the largest ship afloat and, although the rudder was nearly 79 feet tall, it still wasn't big enough, and the ship took far too long to respond to the rudder and turn. In addition, the ship's weight and size meant that, at full speed, the Titanic would have taken around a mile to stop.

White Star Line Orders

There were insufficient lifeboats for all passengers and crew on board due to the owners deciding that the boat deck looked cluttered.

As was common practice at the time, the radio stations were not manned around the clock. There were nearby ships, which perhaps could have rescued all on board the Titanic, but their radio operators had switched off their sets and retired to their bunks.

Officers' Decisions

The Titanic was travelling at full speed towards a known ice field despite receiving many radio warnings from other ships.

The lookouts in the crow's nest were not issued with binoculars, which might have helped them to see the iceberg sooner, giving the ship more time to manoeuvre around the berg and avoid collision.

Each of the lifeboats was designed to carry 65 people, but surely, as the sea was flat and calm, each boat could have squeezed in extra passengers. Yet some boats were lowered

half empty. I blame the officers for this; they should have ensured that the lifeboats were at the very least filled to capacity.

Complacency

This was just after the start of a new century, a time when the British class system was at its height. The upper class thought they were invincible and could rule the world; not literally, of course. However, it was a time when the British Commonwealth was thriving and a period in our history when we assumed we could do no wrong. There are indeed many reasons for the appalling loss of life on RMS Titanic, but I feel the word 'complacency' sums them all up.

White Star Line denied that they prioritised lifeboat spaces to first class. However, the facts speak for themselves.

First class child deaths: 1
Second class child deaths: Nil
Third class child deaths: 52
First class women deaths: 4
Second class women deaths: 13
Third class women deaths: 89

Titanic Trivia

Fares from Southampton to New York (1912):

Third class ticket: £7/5 shillings (£700 today)
Cheapest first class ticket: £23 (around £2,100 today)
Most expensive first class suite: £870 (around £79,000 today)

The actual ship, the Titanic, cost $7.5 million dollars to construct in 1912 (around $174 million dollars today).

James Cameron's movie, *Titanic*, cost $200 million dollars to make, without ever having a complete ship.

In the 1996 movie, *Titanic*, actor Leonardo DiCaprio is a great actor, but he cannot draw very well, so, in the scene where Rose (played by Kate Winslet) posed nude to be drawn, the close-up of the artist's hands actually showed the hands of director James Cameron, who drew Kate on the couch.

Titanic Crew Wages in 1912

At the time, the White Star Line policy was that crew were signed on per voyage and the crew would be paid up until the ship docked (or sank), then signed off, and there was no such thing as holiday pay either. A crew member would keep his or her own record (like a CV), which the captain or senior officer would sign at the end of the trip. The crew member would then use his record card to gain employment on the next ship, or, if he was a good worker, he or she would keep the job on the return voyage.

Able seaman:	£5 per month
Male steward:	£3.15 per month
Female stewardess:	£3.10 shillings per month
Radio operator:	£48 per month
Captain Edward Smith:	£105 per month

The Youngest Survivor

Eliza Gladys Dean was two months old when her father purchased third-class tickets and took the family on board the Titanic for a new life in the American state of Kansas. As the Titanic began sinking, her father ordered them to get dressed in warm clothing and go to the boat deck. Her mother carried Eliza and her dad carried her older brother, Bertram, and he saw them off boarding lifeboat 10. They all survived; her

father, like many dads that night, did not. In America, the family were stranded with no funding. The White Star line gave them passage back to England, where Eliza and her family had relations. After schooling, Eliza became a civil servant and cartographer. Her mother, Georgette, died in 1975, and her brother, Bertram, died in 1992. Eliza never married nor had children. In later years, she had some health issues and had to enter a nursing home. Due to the rising cost of staying in the nursing home, she had to sell some of her Titanic possessions. Eliza became the last living survivor of the Titanic. In her final years, her residential costs were paid for by Kate Winslet, Leonardo DiCaprio, James Cameron and Celine Dion. Eliza Gladys Dean passed away on 31 May 2009 aged 97 years. She was cremated and her ashes were scattered at sea off Southampton, where the Titanic had set sail on her doomed maiden voyage.

Wartime Hero

The most senior officer to survive the Titanic sinking was Commander CH Lightoller DSC RNR. Much later, during the early stages of World War Two, and while in his retirement years, Lightoller took his small boat, Sundowner, across the channel as part of the small flotilla of craft to rescue soldiers off the beaches at Dunkirk. A hero indeed.

Radio Operator, Fredrick Fleet

Fredrick Fleet, the radio operator who survived the Titanic sinking, later committed suicide in 1965.

Nurse Violet Jessop

Violet Jessop was employed by the White Star line as a nurse, and remains one of the few people who served on all three of this class of ships. She was firstly on the Olympic when the

ship collided with HMS Hawk, then later survived the sinking of the Titanic by being given a place on lifeboat 16, where she was given a baby to look after. Once rescued by the Carpathia, the mother of the baby, who ended up on another lifeboat, was reunited with her baby. Finally, Violet was part of the medical crew of the hospital ship Britannic when the ship struck a mine and sank.

Violet Jessop returned to work for the White Star Line and other carriers before retiring. Violet Jessop settled in England, where she died in 1971 aged 83 years.

RMS Olympic

RMS Olympic was launched in 1910 and was in service from 1911. Unlike her sister ships, the Olympic had an almost uneventful career, although there was one incident that took place in the Solent on 20 September 1911. RMS Olympic was cruising in the Solent when she was struck by naval heavy cruiser HMS Hawke. HMS Hawke was specifically designed with a ramming bow, and she struck the Olympic on the starboard rear section, breaching the Olympic's hull. Hawke was severely damaged and almost capsized, although no one was injured on either ship. After the collision, Olympic immediately started taking on water, although she managed to return to Southampton under her own power. Surviving a severe collision from a Royal Navy ship fitted with a ramming bow certainly helped fuel the rumour that the Olympic and Titanic were unsinkable. A rumour that, in the case of the Titanic anyway, was to abruptly end in April the following year.

The RMS Olympic

The Olympic was actually at sea and heard the radio distress call from the Titanic after she had struck the iceberg, but she was more than 500 miles away and too distant to be of any help. After the furore of the loss of life on the Titanic, the Olympic was recalled to port and was refitted with additional safety measures. She was given an extra bulkhead, and all her watertight bulkheads were increased in height up to B deck, well above the waterline. The Olympic was also given more water pumps, and, of course, her lifeboats were increased from 20 to 68 – more than enough for all on board.

The Olympic served as a troop ship during World War One and was repainted with staggered colour as camouflage. After the war, she continued with her trans-Atlantic passenger service for another 20 years, earning the nickname Old Reliable. In 1936, she was sold for scrap and broken up. However, several of her more ornate display features were saved, and placed prominently in other ships.

HMHS Britannic

The third and final of the White Star Line's Olympic-class passenger liners was called the Britannic, which was launched on 26 February 1914. Her launch was delayed, as the Olympic was recalled to dock so she could be modified with extra

safety improvements following the Titanic disaster. Those dock workers employed on the Britannic were immediately transferred over to the Olympic, thereafter returning to the Britannic to also add the same additional safety design improvements. There were many lessons learnt after the loss of the Titanic.

After the Britannic was launched, she was still in dock for final preparations prior to beginning passenger service when she was requisitioned by the British Government to be in service as a hospital ship, becoming HMHS (His Majesty's Hospital Ship) Britannic.

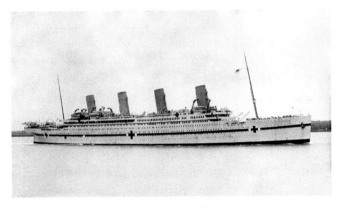

HMHS Britannic

For her first voyage, HMHS Britannic sailed from Liverpool for the Dardanelles under the command of Captain Charles Alfred Bartlett, with 3,309 hospital beds and several operating theatres. B deck rooms were allocated to doctors and hospital staff. On board were 675 crew members, 101 nurses and 388 officers. As part of a fleet joining HMHS Britannic on this trip were HMHS Mauritania, HMHS Aquatania and her sister ship, HMT Olympic, which had also been requisitioned as a troop carrier. These four massive ships must have been quite a sight sailing in formation. After returning to Britain, HMHS Britannic moored off the Isle of Wight for a month as a floating hospital.

HMHS Britannic made five more voyages to and from the Middle Eastern Theatre of Operations, which were largely uneventful trips. On her sixth voyage, HMHS Britannic departed from Southampton on 12 November 1916 after a routine stop at Naples to stock up on coal and water. The Britannic continued on her voyage, sailing into the Kea Channel at around 24 knots. Powering through the sea at maximum speed was often ordered by captains as a good procedure to outrun the threat of U-boats.

On board that night were 673 crew members, 315 Royal Army Medical Corp and 77 nurses. At exactly 8.12am on 21 November, while sailing in the Aegean Sea near the Island of Kea, there was an almighty explosion on the starboard side. Water began flooding in through a hull breach between holds two and three. Captain Bartlett ordered the watertight bulk-heads closed. However, one of the bulkheads was damaged and would not close properly. As the Britannic began to list, Captain Bartlett ordered the lifeboats swung out, but *never* gave the order to abandon ship. Unknown to Captain Bartlett, doctors had ordered the nurses to open the portholes to get fresh air to circulate throughout the hospital wards. As the Britannic listed, water also poured in through these open port-holes. Meanwhile, the captain saw the beach of a nearby land-fall and attempted to save the Britannic by beaching her, so he continued at full power. However, by this time, due to the list, the port propeller had lifted almost clear of the water and was thrashing around, getting the ship nowhere. The captain ordered the ship to be aimed at the beach. Unbeknown to the captain, however, was that some people had taken it upon themselves to lower some of the lifeboats and get away. One of the lifeboats and the people on board were sucked into the thrashing port propeller; dreadful screams ensued as they were chopped to pieces and killed instantly.

The captain assumed that his ship, the Britannic, had been the victim of a German U-boat torpedo strike. Whereas the Titanic took almost two and a half hours to sink, the Britannic

slipped below the waves in 55 minutes. It seems inconceivable that a German U-boat captain would fire a torpedo at a hospital ship, but there were rumours that the Britannic was also carrying badly needed arms and equipment for the war effort; perhaps some German spy in England contacted his government to inform them of this. Under International agreement, a country's hospital ships were painted white and clearly marked with a red cross, and were for the transport of injured men only, and certainly not permitted to carry any equipment such as ammunition to benefit the war effort. The Royal Navy always denied that the Britannic had ordinance material on board. However, it is suspicious that the British Admiralty marked the wreck on official charts around 15 miles from where she actually lay.

It was the famous French underwater explorer Jacques Cousteau who located the wreck of the Britannic in 1975 at a depth of more than 400 feet. After his initial exploration of the ship, he deemed it was sunk by torpedo strike. Subsequent exploration of the shipwreck by oceanographic experts points to evidence that a mine was the most likely cause of the ship to founder. After the war, official German Kriegsmarine charts confirm that there was a minefield in the vicinity. This period was the golden age of passenger ships, but it was soon to be the end of an era. The 1960s saw the advent of airline travel offering a far quicker and more convenient way to travel internationally, so passenger shipping went into decline. Today, however, they seem fashionable again, and have been boosted with far larger, opulent ships that would dwarf the size of the Titanic, offering a luxurious way to have your holiday and relax in style.

Modern passenger liners are much safer, and are certainly equipped with enough lifeboats for all on board. They also have modern technology such as the radio, which is live chat, not Morse code, and the radio is manned 24 hours and located on the bridge, from where officers control the vessel. There are several channels on the radio, but all ships should listen on Channel 16, which is the agreed emergency channel. Large ships have several radars, depth sounders, satellite navigation and helicopter landing pads.

Let us hope a disaster like the Titanic never happens again.

GOING UNDERGROUND

World War Two began with German armed forces invading Poland. Although Poland soon surrendered, some Polish Military men escaped into France to continue the fight against Germany. The allied nations, including Russia, joined together in a pact to defeat Nazi Germany. Volunteer Polish airmen who flew Hurricane aircraft for the allies during the Battle of Britain, even with the language difficulties, proved very successful pilots. After the war, however, things were not so tranquil. Some Polish pilots decided to stay in the UK and make a new life for themselves; others who did return to Poland (now under Communist rule) were not permitted to fly, and Stalin had them arrested on trumped up charges, including espionage. These jailed men were later released after Stalin's death. In the meantime, Germany was divided in two, with the eastern part of Germany going to the Russian Communist state, and a great wall was erected in Berlin, dividing German families and friends.

On 5 March 1946, President Truman introduced Winston Churchill to an audience in Westminster College, Missouri. As Winston stood at the microphone, he delivered his Sinews of Peace speech, which included the following words: "From Stettin in the Baltic, to Trieste in the Adriatic, an iron curtain has descended across the continent." The Cold War had begun, and a deep mistrust had begun between the former allies. In the following decades, the Western nations and USSR would try to outdo each other in the arms race, with the possibility of World War Three becoming a nuclear war a serious reality.

The Cuban Missile Crisis

World War Three almost happened in October 1962. During a secret high-altitude flight over the Communist island of Cuba, an American U2 spy plane photographed nuclear missile silos being installed by Russia on Cuban soil. Meaning that, as Cuba was just more than 100 miles from the American state of Florida, and, together with most American states, was now well within range of their ballistic nuclear missiles, which could be fired with little or no warning. After consultation with his military advisors, President Kennedy addressed the nation via radio and television. He sent an American fleet of naval ships with orders to 'quarantine' Cuba; that is, to stop the Russian cargo ships from entering Cuba, and, if they did not turn around and return to Russia, they would be sunk. Cuba would be firstly bombed, then invaded. After several tense communications between the US and USSR, President Khrushchev of the USSR agreed to turn around the Russian ships if the United States agreed not to invade Cuba. The Cuban crisis was over. During the autumn of 1962, the US Navy was almost three times larger than the size of the Russian Navy. I have often wondered how that crisis might have escalated had the Russian Navy been as superior as America's.

It will be of no surprise to you that, after that showdown on the high seas, Khrushchev ordered that the USSR fleet of surface ships and submarines be increased to at least equal, if not surpass, that of the American fleet. The arms race continued to escalate over the following decades, with a deep mistrust between America, her allies and the Soviet Union. With the ongoing fear of an impending nuclear strike, top secret deep underground bunkers were constructed, ranging from small bunkers housing members of the Observer Corps to large bunkers that would be used to house senior members of the government and military advisors. One such bunker is located near Anstruther on Scotland's east coast.

In the 1980s, President Ronald Reagan went into talks with Mikhail Gorbachev of the Soviet Union regarding the

downsizing of each nation's nuclear arsenal, which eventually led to the Strategic Arms Reduction Treaty (SART), which, in turn, saw the fall of Communism and the end of the Cold War.

Secret Bunkers

With the Cold War ending, in the United Kingdom, the government began to downsize the armed forces, with each consecutive government thinking of cost cutting and diverting funds elsewhere to more needed areas. So these bunkers at secret locations around the country were initially closed down and sealed off, and lay abandoned for several years prior to most being sold off.

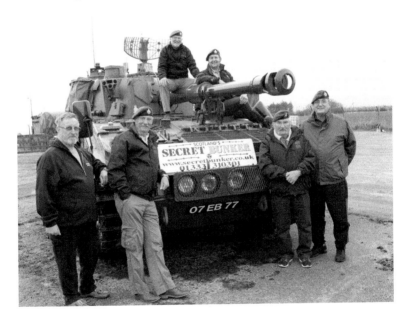

The large secret bunker at Anstruther in Fife is a marvellous example, and a lesson to us all of how just close we came to a nuclear war, and how each side took the very thought of Armageddon so seriously. On the surface (as expected), the building looks like most other farm buildings in the area.

There are a few ventilation ducts scattered nearby that are disguised as farm outbuildings, all are the sort of structures that you wouldn't necessarily give a second glance to; they blend into the scenic area. However, what lies beneath is almost unbelievable.

The bunker was constructed in the early 1950s and the civilian workforce on the structure had to sign the Official Secrets Act. From the bungalow above, you walk down a 450-foot sloped tunnel leading down to three-ton blast-proof doors 100 feet down. The bunker was a ROTOR (elaborate radar warning system) type of structure and is on two levels, which cover around the same size as two football pitches, one on top of the other – in total, 24,000 square feet. Internally, the bunker has a BBC studio containing the latest 1950s broadcast technology (although, as technology advanced, this was upgraded in the years following), a large switchboard room and dormitories for 300 men, including Scotland's senior political ministers, meteorologists and scientists who would have been flown in from Edinburgh to continue to run the country from the bunker. It had enough stores to keep them sustained for several months. There is also a religious chapel, two cinemas and a café. The bunker had the former codename of Troywood.

Thankfully, the bunker was never used for its purpose and was decommissioned in the late '80s. It lay sealed off and abandoned for several years before the government sold it off as surplus to requirements. It was purchased by two brothers, who eventually opened up the bunker as a museum in 1994. Over the subsequent years, the museum has acquired (by purchase or donations) several military vehicles, decommissioned weapons, period uniforms and other militaria. The secret bunker is one of Scotland's four-star visitor attractions, and offers discount tickets for groups and schools, etc. For opening hours, visit their website or Facebook page. For those who have a sat-nav in their vehicle, the postcode is KY16 8QH.

Chairman of 45 commando veterans and former serving Royal Marine Stuart Lavery organised an excursion to visit the secret bunker in the group's minibus. We were given a conducted tour and even saw rooms that are not normally open to the public. We had a great visit, and afterwards drove into Anstruther for fish and chips. Fabulous day out. The following photographs are from the commando veteran's visit.

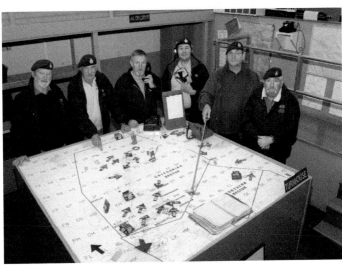

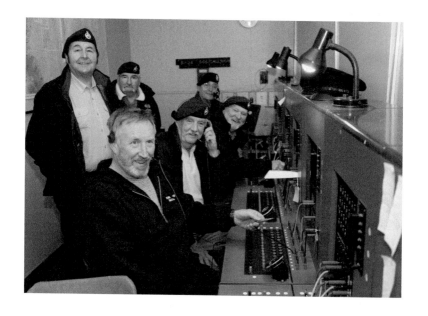

CHARITY BEGINS AT HOME

Reach Across

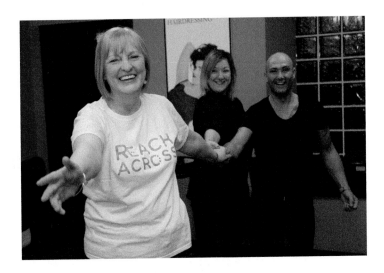

Reach Across is a not-for-profit local registered charity based in Arbroath, and is a registered Scottish Charity (SCO 46240). Following the suicide of Ross Ramsay, the charity was set up by Ross's mum, Sandra, Ross's brother, Ryan, and close family friend, Donna Bow. Following the devastating loss of Ross, they wanted to set up Reach Across to support people who are affected by suicide or are experiencing thoughts of suicide. Reach Across aims to support people bereaved by suicide and this includes activities to reduce the stigma that can be a barrier to receiving support. Reach Across use a personalised approach to support.

The following photographs are from Reach Across events, including from their concert held at the Webster Theatre, Arbroath. Ross was a talented musician, and many of his musician friends were happy to perform for free in memory of him and to raise funds for this worthwhile cause.

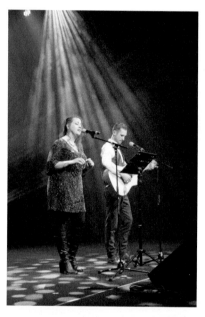

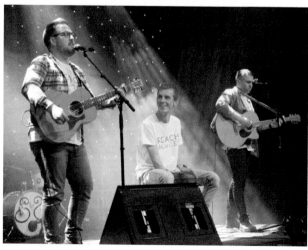

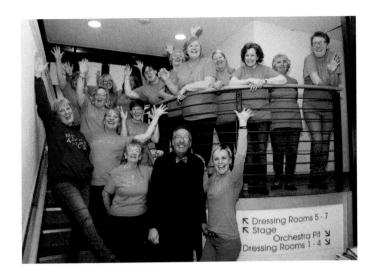

Sandra's son, Ryan, is also a musician and a school physical education teacher. Being so fit, he has undertaken various fundraising activities for the Reach Across charity, including a long-distance cycle ride from Lands' End to John O' Groats, and the impressive Iron Man triathlon challenge. On the weekend of 22/23 July 2017, Ryan and his South African friend, Lexi Ligeti, undertook the mixed gender fastest three-legged run – a distance of 116.4km (72 miles) – all within 24 hours.

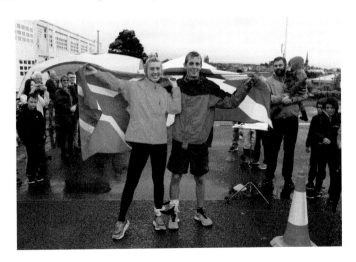

They did this (with the kind permission of Angus Council) in their Bruce House car park. They had a back-up team with recording equipment, and the whole event was filmed by professional video cameraman George Park. Thanks to George's video recording and the official time-keeping team, Ryan and Lexi managed to smash the previous record to rousing cheers as they crossed the finishing line. Ryan and Lexi's three-legged record-breaking run still stands at the time of this book's publication, and is officially recognised by the *Guinness Book of World Records*. Well done, Ryan and Lexi.

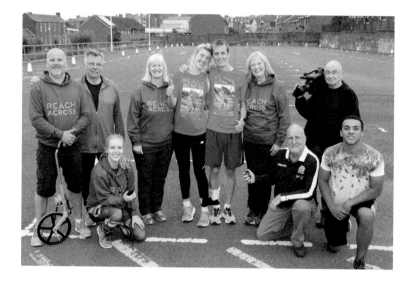

Reach Across is a fabulous charity and they continue to enrich lives and enhance minds by helping those with stress and mental health issues. They can be contacted via Facebook.

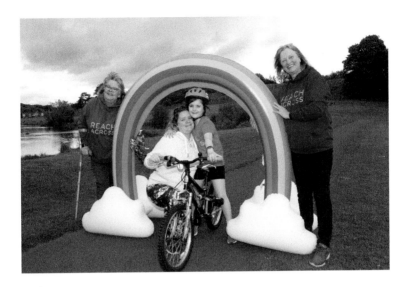

The Covid-19 virus saw the Reach Across charity support Natalie Cargill, who runs the Wild Thyme cafe in Arbroath, and Natalie, together with other cafés around Tayside, got together and distributed food to vulnerable families during this difficult time.

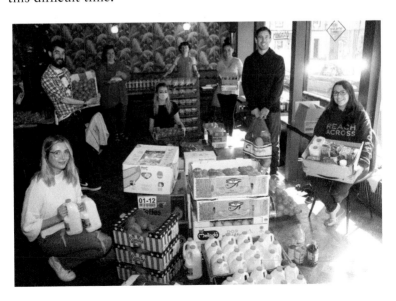

Brenda Ross

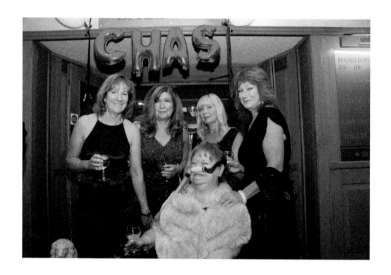

Brenda Ross is a disabled woman from Arbroath. Every two years, she holds a charity ball in aid of the charity CHAS (Children's Hospice Across Scotland). These charity balls usually have a different theme each time and are great fun, raising thousands of pounds for the children's charity. I had the pleasure of attending the last of Brenda's balls, which had a James Bond theme. It was a fantastic night with a licence to thrill. I was both 'shaken and stirred' and a fantastic amount of £8,500 was raised for CHAS. Now that's a lot of 'moneypennies' for the children. Well done, Brenda.

HorseBack UK

Arbroath man, Ian Wren, who was a former serving gunner in the British Army, became aware of HorseBack UK while fundraising for Help for Heroes. He became heavily involved with HorseBack UK while hearing about the plight of wounded servicemen. Ian has been the fundraising manager of HorseBack UK since 2014, and, since that time, has helped to raise thousands of pounds for the charity.

Horseback UK Charity Cycle Run

In November 2008, Jock and Emma Hutchison moved with their young family to Ferrar just outside Aboyne in Aberdeenshire. Their plan was to set up a business using American quarter horses and Western riding to explore the beautiful scenery of Royal Deeside. That Christmas, several friends, many of whom were either serving or ex-military, came to the farm to celebrate New Year. Having played around with the horses during the day and while sitting around the bonfire, a comment was made: "This is what the guys should do when they come back from war." And so the seeds of HorseBack UK were sown. As an ex-marine himself who had served at 45 Commando in Arbroath, Jock approached the current commanding officer. The year 2008 had been a particularly traumatic year for 45 Commando, as, in their recent tour of Afghanistan, they had lost nine of their own in combat, with a further 16 suffering life-changing injuries.

Jock and Emma offered the farm as somewhere that the injured marines could come as a break away from clinical recovery. Over the next 12 months, several groups came to visit the farm. In 2009, HorseBack UK, as it was now known, gained charitable status, with the aim of taking wounded servicemen and women and introducing them to horses. Through working with the horses among a like-minded group,

service personnel who had been mentally and physically scarred could regain their confidence, dignity and, especially in the case of amputees, mobility.

As the idea grew and developed, another crucial layer was added to the initial notion: using those who had been injured as a result of service to their country to assist in the delivery of the courses. This has the beneficial effect of reproducing some of the familiar camaraderie that service personnel have experienced. Most crucially, they do not have to explain themselves. There is the link of shared experience, and the understanding of the military ethos. For the instructors themselves, the ability to give something back, to help their wounded comrades, brings a sense of confidence and achievement. The scope of the operation soon expanded. Although the original idea came in response to the shocking number of casualties in Iraq and Afghanistan, now, the courses include personnel who may have seen service in the Falklands, Northern Ireland and the Balkans. Many of them may have been struggling with physical challenges and the effects of post-traumatic stress for years. Through the courses at HorseBack UK and the voluntary programme, which means that participants may return to work at HorseBack year round, they find a place where they may rebuild, retrench and move forward into a brighter future...

That's Life

That's Life charity show was started with an inspiring idea from three friends, Alan Mowatt, Doug Ford and Stuart Cargill, on the back of a suggestion by Stuart's wife, Susan Cargill. The idea was that these three wonderful and passionate singers would hold a concert singing songs from the swing era of the '40s and '50s – songs from the Rat Pack era, the classic songs of Frank Sinatra, Dean Martin and Sammy Davis Junior.

The venue was chosen to be the Meadowbank Inn, Arbroath. Revenue from ticket sales and the prize raffle would be spread around local charities. What a great idea, guys. The ticket price includes a glass of bubbly on arrival, followed by a two-course meal, and, thereafter, dancing the night away to a fabulous evening of entertainment. The concerts started in 2012 and, excluding 2018, due to other commitments, has been a popular annual event.

To date, the singers have raised the fabulous amount of £32,000 for charity, which has been spread over the following worthwhile charities:

MacMillan Cancer Support – Cancer Research – Heart Foundation Scotland – Motor Neurones Disease – Reach Across – Alzheimer's Scotland – Tayside Mountain Rescue – Tayside Diabetes Family Support Group – RNLI Arbroath – Arbroath Boxing Club – Arbroath United Cricket Club

– Scottish Breast Screening Programme NHS – Cafe Project – Arbroath Town Mission.

Sadly, since starting the charity concerts in 2012, one of the original founders of That's Life, Doug Ford, lost his battle with cancer, but, as has often been said, 'the show must go on', and Alan and Stuart have invited guest singers Tracy Gibson, Valerie Mowatt and John Hayes to join them as guests on stage over the years. The Rat Pack concerts have proved to be very popular, and the singers have also been requested to entertain at other venues to boost charity funds. An additional £8,000 was raised when Val Mowatt organised the Rat Pack for Relay nights, with a further £2,000 raised at a few Masonic Lodge concerts, a further £2,200 raised at the *Elvis Meets the Rat Pack* show held at the Webster Theatre for the Cafe Project, and £900 raised at a fundraiser for Arbroath United Cricket Club and Arbroath Boxing Club, which even saw Stuart's wife, Susan, take to the stage to join him in a fun

duet. At all those events, they enjoyed the sound engineering services of the inimitable 'Jiving Jim' Addison.

To date, that all adds up to £45,100 raised for worthwhile causes within Arbroath and around Tayside.

More recently, during the Covid-19 (coronavirus) lockdown, Alan and his wife, Val, gave up their free time performing sing-along concerts live from their living room over the Internet on Friday evenings to provide entertainment for those people stuck at home. They did those shows in support of the local charity fund set up by Danny Laverty, Paul Johnston and Brenda Ross to raise funds for local NHS. Alan also supported the NHS clap on Thursday evenings, performing live with well-known local guitarist Phil Petrie from Phil's garden.

It was during one of the online charity concerts from their home in Charles Avenue that Alan and his wife, Val, were singing away live on camera when Alan turned unwell. Val asked if he was okay to continue. After loosening his tie and taking a sip of water, Alan, like a true professional, carried on singing. However after the concert was over, Alan was rushed to Ninewells Hospital in Dundee with a suspected heart

attack. We wish you well, Alan, and, as they say in Scotland, "Ca Canny, my friend."

Due to Alan Mowatt recovering from a heart operation, and of course the 2020 Covid 19 crisis; the concert "That's Life" for that particular year was obviously cancelled. The yearly charity concert remained hopeful of a return in 2021.

Relay for Life

The Relay for Life charity event is held at the local Arbroath United Cricket ground each year, raising thousands of pounds for cancer charities. Teams get sponsored to take turns in a relay walk (often in fancy dress) around the cricket park in a 24-hour period.

It's a great fun event to participate or even just to spectate and there are lots of raffles and stalls to keep those attending entertained. Jiving Jim plays disco music throughout the event; even during the night, the relay walkers can wear earphones to hear the music as they walk, and, at various times, the Arbroath Pipe Band performs at the beginning and also play the bagpipes while marching the last few laps.

The Relay for Life committee, currently headed by Ian Angus, keeps this a well-organised annual event, and they also run other fundraising events throughout the year, all adding funds culminating in this big relay at the cricket park.

Finally, I want to add that the people of Arbroath are very generous in supporting local charities, and fundraising efforts of local individuals and groups. There are many more people who truly deserve a mention in their fundraising efforts and I'm sorry that I have no room in this book to mention everybody, but we all appreciate what you do. Below are a few more photos from recent fundraisers.

Walk for Dementia

Tesco staff at charity stall

Charity stall at Morrisons

Slipway musicians presenting charity cheques

Children's fashion show at M&Co.

COME FLY WITH ME

I have a cousin, Morris Greenhill, formerly of Charles Avenue, Arbroath, who has three children called Charlie, Scott and Arianna. Morris, like most parents, is very proud of all his children. However, this story only involves his son, Charlie, born on 9 July 2001.

At an early stage, Charlie enjoyed playing with his toys, especially showing interest in his toy aircraft and helicopters. Most boys would be content with flying via computer games, but not Charlie. He wanted to really fly. So, with encouragement from his dad, Morris, when Charlie reached 15 years old, he enrolled to take a series of helicopter flying lessons, taking his first flight at Shobdon Airfield, Leominster on 17 September 2016.

To keep up with the legal requirements, he kept up his pilot training, completing the minimum 47 flying hours, and, on his 16th birthday, Charlie proudly completed his first solo flight in a R22 Robinson helicopter. Soon after Charlie's 17th birthday, he sat for his PPLH (Private Pilot's Licence Helicopter) and successfully passed, becoming one of the youngest fully qualified helicopter pilots in Britain. Charlie is currently studying engineering, although one day his ambition is to 'scale new heights' and fly helicopters for a living.

Humorously, I have to add that, although Charlie Greenhill is a fully qualified helicopter pilot, at the time of this book going to print, he cannot drive a car, having never taken driving lessons. Morris, Scott, Arianna and Charlie visit Arbroath regularly to meet up with family and friends.

(Adjoining photograph shows Pilot Charlie Greenhill next to a R22 Robinson helicopter.)

DOWN DEEP INSIDE

The Submariners

For Centuries people have imagined what it would be like to travel underwater, to explore our Oceans' hidden depths, and to discover what lies beneath. It does seem hard to believe, but more humans have walked on the moon than travelled to the deepest part of our ocean, the Mariana Trench in the Pacific. The first recognised submarine was conceived in 1620, although, centuries before, it is said that Alexander the Great was lowered below the sea in a glass barrel. Ever since the concept of undersea exploration, countries have thought to exploit the use of submarines for naval warfare. Somebody famous once said: "He who rules the waves rules the world."

Nowadays, modern nuclear submarines are designed teardrop shaped, allowing them to travel much faster submerged, and, with modern technology, in theory, they can stay submerged indefinitely, only returning from patrol to exchange crew and restock food supplies. Unlike a surface vessel, submarines have no keel, so, when cruising on the surface during choppy seas, they tend to roll all over the place, which can be most unpleasant for those on board. During World War Two, however, most submarines were really nothing more than a surface vessel that could occasionally submerge for a brief period of time. During the early days of World War Two, the Germans had rolled over Europe with the British forces in full retreat, cumulating in the British troop evacuation from Dunkirk. Had the Germans been organised and continued immediately with the German advance, crossing

the English Channel, I have no doubt that we, the Brits, would have had some serious problems. However, as Britain was an island, we were initially saved from invasion, as it's certainly not easy to transport a large armoured force across the sea. Although as an island Britain was initially saved from invasion, being so isolated almost became our downfall. Food supplies and other essentials soon became in short supply, and we were solely dependent on those brave sailors of the merchant navy to convoy in supplies, which brings me to the story of the German U-boat.

The Grey Wolves

To start with, Adolf Hitler never seemed to have much interest in U-boats or aircraft carriers. He much preferred battleships and believed that the war in the Atlantic could be won with his surface raiders; the dreaded pocket battleships. (Germany had one aircraft carrier, the Graf Zeppelin, launched in December 1938. She was never fully completed, as construction workers were often diverted to what was deemed far more important work for the Nazi war effort. When it was obvious that Germany was about to lose the war, a skeleton crew scuttled the Graf Zeppelin off the Bay of Pomerania in Poland.)

Ever since Adolph Hitler became Chancellor of Germany in 1933 and Fuhrer by 1934, he had been discreetly increasing the size of his navy and air force, in complete violation of the post-World War One Treaty of Versailles, which limited the amount of military resources Germany was allowed to have. When war had become inevitable, Konteradmiral (Rear Admiral) Karl Donitz requested of Hitler that he be given 300 U-boats. However, this was refused, as mentioned previously. The German war machine had limited resources and funding was diverted to what Hitler believed was more important. It was then at the start of World War Two that Admiral Donitz had only 56 U-boats under his command. Some of the

56 boats were old or coastal submarines, with only 26 U-boats being suitable for long-distance operations in the Atlantic. The most famous U-boats of that time were the Mark V11, which, for a while at least, were very successful, hunting in packs and devastating the British convoys. The Mk V11 U-boats soon became known as the Grey Wolves.

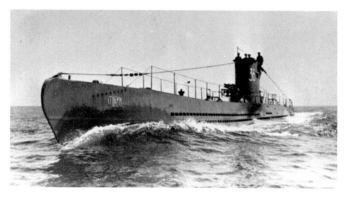

Mk V11 U-boat

As I mentioned earlier, the U-boats were very successful at the start of the war, sending thousands of tons of much-needed British supplies to the bottom of the Atlantic; so successful, in fact, that the U-boat service nicknamed it 'The Happy Period'.

U-47

Ever since World War One, the Royal Navy have used the natural harbour at Scapa Flow in the Orkney Islands. Scapa Flow was thought impregnable, with heavy gun emplacements surrounding the harbour bay. There were underwater mines, anti-submarine nets and, in places of entry, deliberately sunk old block ships, all to stop uninvited guests from entering the natural harbour. However, on a dark, moonless night in October 1939, a dangerous and daring raid by U-47 captained by Gunther Prien took place. He surfaced his U-boat and, while his crew kept very quiet, Prien, with stealth, manoeuvred

his submarine quietly and discreetly through a shallow passage at Kirk Sound, steering around the sunken block ships in the process. In the distance, he spotted a large target. It was the WW1 620-foot battleship, the Royal Oak. From a distance, U-47 fired several torpedoes at the Royal Oak. Prien cursed as only one found its target and struck the starboard side. U-47 started its hasty escape, but, much to Prien's surprise, no alarm went off, no searching floodlights, so Prien ordered his U-boat to turn around for another attack, this time much closer. Meanwhile, there was little damage to the Royal Oak and, to be honest, nobody on board imagined the loud bang was a torpedo strike.

This time with his torpedo tubes rearmed, U-47 fired four torpedoes at the Royal Oak. When they all struck the ship and exploded, the aging battleship lifted almost out of the water and started listing immediately. Most of the men and young boy sailors were trapped below in the darkness as the ship capsized and sank. Those who did make it into the freezing water found themselves in oil-polluted sea, and, in the darkness and confusion, had no idea where the shore was. That night, 833 sailors lost their lives, and today the wreck is a listed war grave. The Royal Oak was a Revenge Class World War One battleship, but, because of its age and limited speed of 12 knots (10mph), it was no longer considered suitable for deployment in World War Two. It was mostly crewed by boy sailors in training. Nonetheless, it was a huge moral loss for the Royal Navy, and the exact opposite for Germany. U-47 had made its escape unscathed, and the crew returned to a heroes' welcome back in Germany. Hitler himself was at the harbour side to welcome Captain Prien and his men. All the crew were awarded medals, with Captain Prien receiving the highest award of any U-boat commander, the Knights Cross of the Iron Cross, awarded personally by the führer. After that daring and successful raid by U-47, Hitler was finally convinced of how useful U-boats were to the German war machine, and agreed to increase U-boat production.

After the fall of France, Germany was now able to build new heavily armoured U-boat pens in Loirient, Brest and St Nazaire, which allowed the U-boats a safer, direct and fuel-efficient route into the Atlantic. The man in charge of the U-boat fleet was Admiral Karl Donitz. Finding himself in command of the entire fleet of U-boats, he was now able to implement a few ideas he had learnt when he was a captain of his own U-boat during World War One. Donitz thought up the idea of the wolf pack, allowing his U-boats to form in a line a few miles apart and, on sighting a convoy, to wait for nightfall and attack in groups. The Wolf Pack initially turned out to be very successful; however, with the advanced development of radar and sonar, and the fact that U-boats were painfully slow while submerged (around 4mph), convoy escort destroyers soon gained the upper hand and more and more U-boats were lost due to constant attack by depth charges. All submarines at the time had to surface to charge batteries, which they usually did during the night in the dark, but, with the introduction of armed sea planes with search equipment and floodlit search beams, U-boats were often caught on the surface and attacked. The increased success rate of the allied navy meant that two out of every three U-boats never returned. In fact, the afore-mentioned U-47 captained by Gunther Prien was attacked and sunk in March 1941 by the Royal Navy Destroyer HMS Wolverine. As the war progressed, technology in echo sound-ing and radar soon turned the tide on the U-boats; their happy period ended and more and more U-boats didn't return from patrol. It is said that two out of three U-boats were sunk. For the German crew at least, the Grey Wolf had become the Iron Coffin.

RMS Laconia Incident

Built as a passenger liner in 1921, the Royal Mail Ship Laconia was acquisitioned as a troop carrier during World War Two.

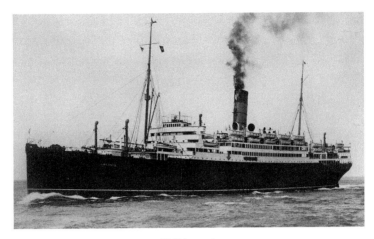

RMS Laconia

During a voyage in 1942, she was carrying mostly Italian POWs from Cape Town to Freetown. During the passage off the West Coast of Africa, the Laconia was spotted by U-156, captained by Korvetten Hartstein, who immediately attacked. At precisely 10.05pm, the Laconia transmitted the following message: "SSS SSS 0434 south/1125 West Laconia torpedoed…" (SSS was a standard code message meaning under attack by submarine.) Most of the Italian POWs were locked up below guarded by Polish soldiers, who it is said bayoneted the Italians when they made a rush for the lifeboats. The Laconia, by this time, was listing badly and only half the lifeboats could be launched, and, with half the lifeboats unusable, there were not enough lifeboats for everybody on board. Hundreds of injured and bleeding men who found themselves in the water were now attacked by sharks, which tore at the flesh of the screaming men.

U-156 now surfaced with the intention of capturing senior officers, but were surprised to see nearly a thousand men struggling in the water. To his credit, U-boat Captain Hartenstein, realising that most were civilian and Italian POWs (allied to Germany), immediately began organising a rescue operation. He hoisted a 'red cross flag' and took on

board survivors (above and below decks). Captain Hartenstein also sent a message to Admiral Donitz briefing him on the situation and requesting further orders. Donitz immediately ordered seven nearby U-boats to alter course to the scene and assist in the rescue. U-156, by this time, had her decks full and had four lifeboats in tow, with nearly 200 survivors, including five women. U-156 sent another message, this time not coded, asking all nearby ships to assist in the rescue and giving his position. The message read:

If any ship will assist the shipwrecked Laconia crew, I will not attack her providing I am not being attacked by a ship or air force. I picked up 193 men 4-53 south, 11-26 west – German submarine..."

Some ships did hear the message, but thought it a dastardly ruse to get shipping in the vicinity so they could be attacked. One British ship, the Empire Haven, was on its way to assist in the rescue, as were neutral French ships. U-156 had been in the vicinity for two days when she was joined by U-506 and U-507 and the Italian submarine Cappellani.

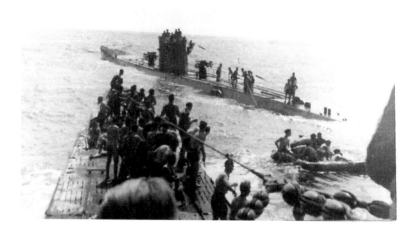

All four submarines headed slowly for Senegal, West Africa, towing lifeboats with additional survivors on decks. The

submarines hoped to meet up the Vichy French ships to transfer survivors. Admiral Donitz thought he had better inform Hitler of the ongoing rescue operation, but Hitler was furious and demanded the rescue be called off.

During the night, however, the four submarines got separated, and, on the morning of 16 September at approximately 11.25am, U-156 was spotted by an American B-25 Liberator bomber on patrol flying out of Ascension Island. Seeing many survivors and the red cross flag, the pilot radioed what he saw and asked for instructions. The pilot was ordered to attack the U-boat. One can only imagine the fear going through the rescued survivors' minds, considering the ordeal they had already endured, when it became obvious that the US bomber was starting an attack run towards them. The aircraft dropped bombs, which exploded near the U-boat, killing several people in the towed lifeboats. By this time, not understandably, U-156 crash-dived below the surface, leaving the survivors to fend for themselves. Of the abandoned survivors (some of which were injured), all low on provisions, more than half were to die as they drifted slowly towards Africa and eventual rescue. After this incident, Admiral Donitz issued the Laconia Order, basically banning all U-boats from picking up survivors.

At the end of the war, this incident was mentioned during the Nuremberg trials, and was a severe embarrassment to the Americans, who attempted to hush it up.

HA-19 Japanese Midget

Five HA-19 (two man) Ko-Hyotecki class midget submarines were used in the Japanese attack on Pearl Harbour on 7 December 1941. They were launched just outside Pearl Harbour from large class one mother submarines. Each midget sub carried only two torpedoes and was also armed with self-destruct charges. The idea was that the crew fired their torpedoes at a warship, then the crew would scuttle their sub

beneath or next to a target ship, set their timed explosives and make their escape. Escape to where remains unclear; sounds more like a suicide mission to me. One HA-19 midget sub was crewed by Kiyoshi Inagaki and Kasuo Sakamaki. When they launched from their large mother ship a few miles from Pearl Harbour, they found that their gyro compass was not working properly, so, basically blind, they headed in the direction of the harbour mouth, but struck a sunken reef several times. They were spotted first by an army plane, which dropped bombs at the sub. The bombs exploded and managed to blast them off the reef, but they collided with the reef again as they tried to enter the harbour. By this point, the main Japanese attack on Pearl Harbour was well underway. The crew managed to get their damaged sub off the reef and dived below the surface. The American Destroyer USS Helm had joined the attack on the mini sub using depth charges.

By now, the submarine was severely damaged and giving off toxic fumes from the batteries, so the crew decided to set the self-destruct charges and abandon the submarine. However, the charges failed to go off and, as the two Japanese submariners dived the few feet to see what was wrong with the charges, one crewman, Kiyoshi Inagaki, drowned during the attempt. The following morning, an American soldier, David Akui, was patrolling the shore at Waimanolo beach and found the mini sub washed up on the beach, and a few feet away was the body of sailor Inagaki and unconscious crewman Kazuo Sakamnki.

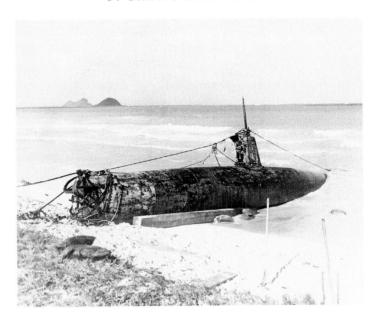

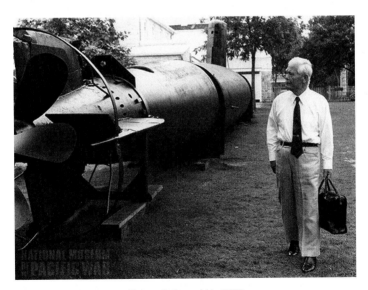

Katzuo Sakamnki in 1991

When Kazuo woke up, he found himself in hospital under armed guard. Kazuo Sakamnki asked for permission to commit

suicide, but this was denied. He became the first Japanese POW (prisoner of war). Perhaps Japanese authorities were furious that Sakamnki was captured rather than commit suicide, but, for whatever reason, Kazuo Sakamnki was struck from the Imperial Japanese Naval records and disowned by the Japanese Military. Kazuo Sakamnki spent the rest of the war as a POW. After the war, he returned to his family in Japan as a pacifist, dedicating his life to peace, and never speaking about the war. In 1991, he agreed to speak at a historical conference in Texas, where reunited with his submarine for the first time in 50 years, he broke down in tears. He passed away in Japan in 1999 after living to the ripe old age of 81 years.

In 1941, the Japanese mini sub was recovered from the beach, inspected, and ended up touring the States helping raise funds through war bonds. The HA-19 mini sub is now on display in the National Museum of the Pacific War in Fredericksburg, Texas.

The Movie *U-571*

The movie *U-571* is a fictitious American-made movie starring actors Matthew McConaughey and Harvey Keitel and rock star Bon Jon Jovi. Without going into too much detail, it tells the story of a broken-down German U-boat getting boarded by American sailors and how they managed to capture an Enigma code machine. The movie was entertaining and I thoroughly enjoyed it; however, let me tell you how sailors of the Royal Navy (not the Americans), managed to capture the elusive and well-sought-after Enigma code machine.

There is an ocean between Britain and America, and all too often an ocean between fact and fiction. The Royal Navy ship HMS Bulldog (H91) was a B-class destroyer, assigned to patrol the Atlantic on convoy escort duty. On 9 May 1941, the Corvette Aubretia detected and attacked German submarine U-110 using depth charges, causing severe damage and forcing the U-boat to surface. At this point, HMS Bulldog fired shells

at U-110, and the U-boat captain ordered the crew to abandon the submarine. As the crew hastily departed the U-boat, Bulldog Sub-Lieutenant David Balme led a boarding party and rowed over in Bulldog's launch into the eerily dim abandoned German U-110. This was an extremely brave thing to do, as sailors knew all too well that U-boats were equipped with an explosive self-destruct device set on a timer. The British crew could well be entering a time bomb due to go off at any second, killing and sending them to the bottom of the ocean. There was not a moment to lose. While a few sailors from HMS Bulldog scoured the submarine, Sub-Lieutenant Balme grabbed an odd-looking machine that wasn't dissimilar to a typewriter; this turned out to be the Enigma code machine. Others within Bulldog's boarding party grabbed all the code books and paperwork they could lay their hands on. Thankfully, in their haste to abandon their U-boat, the U-boat captain never had time to set the self-destruct charges; perhaps he thought he was about to be rammed, and the U-boat was certainly taking hits from Bulldog's shells. It is also likely that the crew thought it prudent to get out of their sub as fast as possible.

HMS Bulldog

The severely damaged U-110 was taken under tow for further inspection. However, the U-boat was taking on water from

various holes in her casing, and, the following day, her tow rope was cut and she was allowed to sink to her resting place at the bottom of the Atlantic. In the previous day's engagement, 15 German submariners were killed; the other 32 German submariners were held in isolation for the duration of the war. The Royal Navy wanted to exploit the fact that they were now able to decipher and read German Military transmissions, and, for this ruse to work, Germany had to believe that U-110 was lost with all hands and their Enigma machine was safely on the bottom of the sea. Had the German Government known their Enigma machine was captured, they would have certainly changed their codes.

As it turned out, the brave actions of Sub-Lieutenant David Balme and his boarding party allowed the code breakers at the top secret base at Bletchley Park to read the German signals for the duration of the war. When the German Navy received signals from their U-boats, the message usually ended with the U-boat transmitting their position. The Royal Navy were able to divert convoys around areas where U-boats were known to lurk, or send warships and aircraft to search, patrol and engage the enemy where possible. Once the German codes were deciphered, it turned the tide of World War Two, with more allied convoys getting through with much-needed supplies to Britain, while at the same time German U-boat losses increased. I have no doubt that the actions of HMS Bulldog, especially the bravery of Sub-Lieutenant David Balme and his boarding party capturing the Enigma machine, shortened the war by several months.

At the war's end, the German POWs were returned to Germany, while HMS Bulldog was found to be surplus to requirements and, in 1946, she was sold for scrap.

The Real U-571

U-571 was a World War Two German type V11C U-boat launched in 1941. The U-boat served its country well, having

BY DAWN'S EARLY LIGHT

some early success in sinking allied shipping. However, while on patrol off the West Coast of Ireland, she was surprised near the surface by an Australian-crewed Sunderland aircraft (flying boat) and attacked using depth charges, and severely damaged. U-571 began to sink. Flight Lt Lucas on the Sunderland reported that most of the U-boat's crew got off the boat before she sank. However, as there were no known survivors, we must assume that the crew who made it to the water later succumbed to hypothermia.

The Sub that Sank a Train (USS Barb)

USS Barb (SS-220) was an American Gato class diesel electric submarine launched on 2 April 1942. On her first war patrol, she sailed out of Rosneath in Scotland on a reconnaissance patrol, prior to and including the allies invading North Africa. Later, USS Barb was ordered to Pearl Harbour, where she conducted many successful war patrols in the Pacific. On one patrol, Barb sank 17 enemy ships, sending thousands of tons of much-needed Japanese supplies to the bottom of the sea. Barb even sank the Japanese aircraft carrier Un-Yo. They are also credited in the rescue of 14 Australian and British POWs after their ship was sunk.

Nam Kwan (now called Yanpu Wan) was a Japanese town thought to be a safe refuge for Japanese convoys, as the approach to the harbour at Nam Kwan was heavily mined and shallow, with hidden reefs and sunken anti-torpedo nets. On a quiet, moonless night, USS Barb snuck into the harbour area and, seeing many enemy ships at anchor, launched on a wide spread of 10 torpedoes, six from her forward tubes, sinking Japanese shipping and damaging others, then staying on the surface, and exited the harbour at flank speed, firing four torpedoes from her rear tubes as she departed. The captain of USS Barb was Commanding Officer Eugene Flucky (nicknamed Lucky Flucky); he was awarded the Medal of Honour for this action, while USS Barb received the Presidential Unit Citation.

While back in the States for a refit, Captain Flucky requested the rockets be fitted on the sub, which was not heard of at the time and raised a few eyebrows. Once back on war patrol in the Sea of Okhotsk, Barb surfaced off the coast and bombarded the coastal towns of Shari, Hokkaido and Shikuka, using both the rocket launchers and her 76mm deck gun. President Roosevelt was so impressed by this submarine's action that he requested to be kept informed of all her reports.

USS Barb

It was USS Barb's final war patrol that would see her reach legendary status. Despite being crewed with only submariners and having no Marines on board, while off the coast of Karafuto, Captain Flucky noticed through the periscope that a military train passed alongside the coast. He asked for volunteers to go ashore in dinghies and lay charges with pressure switches beneath the rail line. On the evening of 23 July 1945, the volunteers did just that, returning just in time to see the train blow up, derail, roll down an embankment and fall into the sea, taking a few carriages with it. This action

ended up being the only engagement by US land troops operating on Japanese home islands. After the war ended, Captain Lucky Flucky was promoted to admiral, while USS Barb was refitted and went back into peacetime service before eventually being decommissioned. USS Barb would be handed over to the Italian Navy, who renamed the sub Enrico Tazzoli (S 511) and used it for several years before it was sold for scrap in 1972 for $100,000. Admiral Flucky was quoted at the time saying that, had he and his original crew known their Barb was for sale, they would have clubbed together and bought her for a museum piece.

The War's End

By early 1945, it was obvious that Germany was losing the war. Hitler made his final public appearance in March of that year, and, a few weeks later on 30 April, as Russian and American troops advanced into Berlin, Hitler and his new wife, Eva Braun, committed suicide. As per Hitler's wishes, their bodies were dowsed in petrol and burnt by his loyal soldiers just outside his bunker. Overall, commander of the U-boats, Admiral Karl Donitz, became Chancellor of Germany. Donitz, on Germany's behalf, was keen to avoid further bloodshed, so, on 7 May 1945, he officially surrendered to the allies, ending the war in Europe. The following day, a radio message was transmitted to all U-boats, ordering them to cease all hostilities, surface and surrender their boats to the allies. Of the U-boats, 33 were escorted by the Royal Navy into Loch Eriboll, which is an open sea loch situated in the north of Scotland.

The Mystery of U-1231

In one of the most bizarre episodes involving a submarine, when U-1231 was escorted into Loch Eriboll and boarded, there were no torpedoes or weapons on board, but rather a

strange, but interesting cargo. Stowed away in every nook and cranny, the U-boat was crammed full of various crates of vintage French wine and brandy. On surrendering their U-boats, the crews were repatriated back to Germany, while the U-boats themselves were towed out to sea and scuttled. However, the biggest mystery of all is that no Royal Naval sailor was ever able to explain (hic) what happened to the wine (hic) or brandy.

The Iron Coffin

To the British, the U-boats were known as the Grey Wolves, but, to the Germans, they were named something quite different. Of the German U-boat submariners, 75% never returned, including the 21-year-old son of Admiral Donitz, Peter Donitz, who was serving on U-954 when it was attacked and sunk by HMS Sennen and HMS Jed.

U-boat submariners took the highest death toll of any service during World War Two, losing 793 U-boats. To the German submariners, they were simply known as Iron Coffins.

Trivia on Loch Eriboll

Loch Eriboll is named after the tiny village on the eastern shore. The loch is naturally deep and open to the sea at the north end of Scotland. It forms a haven and natural harbour from the storms of the open sea. The loch has played host to many fine ships, including HMS Hood and, more recently, HMS Bulwark. Loch Eriboll is around 16km in length and within its waters there is a large island, Eilean Choraidh. This island was used by the Fleet Air Arm for target bombing practise, as a representation of the German battleship Tirpitz, prior to the actual successful Operation Tungsten in April 1944, when Tirpitz was sunk using the 'Tall Boy' bomb designed by Barnes Wallis.

Royal Navy ships often visited Loch Eriboll. However, to the sailors, Loch Eriboll was called Loch 'Orrible, as the weather was usually foul and there was nowhere to go on shore leave. During 1934 when HMS Hood was at anchor in the loch, a few sailors went ashore, climbed the hill on one side and placed large stones among the heather to read 'HMS HOOD', then painted the stones white, so they could be clearly seen by their shipmates on board. Other ships that entered the loch followed the lead and laid similar stones bearing the name of their ship clear to see on the hillside.

Sailors calling their remote anchorage Loch 'Orrible reminds me of an amusing story regarding remote postings serving military personnel who were billeted to outposts on remote Scottish islands, especially during the Cold War. These young recruits, aged in their teens or early 20s, were keen to know if there were any women on these islands. To pacify the soldiers, their sergeant major assured them there was a woman behind every tree. Now some of these remote outposts, especially on the Outer Hebrides, were open to Atlantic gales. When the troops landed on the island, there were no trees, not one...

The Royal Navy submariners are often away from their families for months at a time. Somewhere out there beneath the ocean's depths, they continue to work in the defence of our nation. We salute you all.

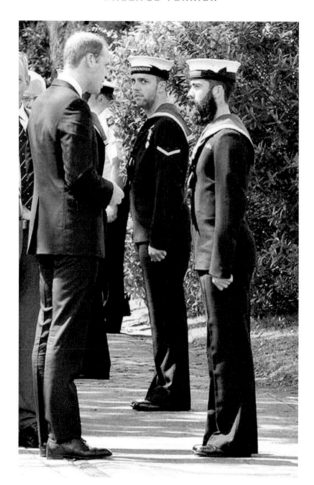

Arbroath submariner Paul McNulty having the honour of meeting HRH Prince William, the Duke of Cambridge. Since this photo was taken, Paul has been promoted to petty officer. His daughter, Poppy (pictured on the front cover), was happy to see her dad return from patrol.

The Dundee International Submarine Memorial Stone in Camperdown Street on the Waterfront, with former submariners, the Dundee Provost and members of 45 Commando veterans attending a memorial service for those submariners 'still on patrol'.

"ELECTRIC DREAMS"

Nikola Tesla was born in Smiljan Croatia on 10 July 1856. After schooling, he studied maths and physics at the University of Graz, then engineering and philosophy at the University of Prague. He emigrated to America, where he gained experience working for the electric power industry, and even worked for a time in Thomas Edison's New York company. Although pretty soon Tesla got frustrated with Edison's obsession to continue with DC current, while Tesla wanted to experiment with AC current, so Tesla left the company to branch out on his own. Nikola Tesla began running experiments with AC current for Westerhouse Electric in 1888, which earned Tesla considerable wealth. Tesla experimented with various inventions, which were successful and developed further. Tesla was keen to show off his inventions to wealthy clients, especially at lectures. However, Tesla was no businessman, and he often forgot to patent his inventions, which were copied by other people, who were given credit and profit that should have gone to Tesla. Tesla is credited with inventions such as the induction motor, the neon lamp, the vacuum variable capacitor, three-phase electrical power and now the TV remote, to name but a few.

Nikola Tesla became great friends with the great American writer Mark Twain, who often visited Tesla in his laboratory. Tesla even photographed Mark Twain during one of these visits using one of his phosphorescent lights. Tesla was interested in high-voltage wireless distribution, and spent most of his savings on experiments in this field, at Colorado Springs, and his incomplete Wardenclyffe Tower, before running out of funding. In his later years, Tesla lived from hotel to hotel, running up unpaid bills; although Westerhouse offered to pay, Tesla didn't like to accept charity. Nikolas Tesla died aged 86 years in a New York hotel on 7 January 1943. Within hours of his death, the United States Government agency, the FBI, entered his room and seized all his document files and equipment contained in the room.

Nikola Tesla is buried at the Ferncliff Cemetery in New York. He has a statue overlooking Niagara Falls, Ontario, where he was involved in a hydroelectric installation, and there is a museum dedicated to him and his inventions at Belgrade in Serbia.

MOONLIGHT SERENADE

My parents, Wallace and Helen Ferrier, were fans of the big band sound of Glenn Miller, and I am sure my dad saw the movie *The Glenn Miller Story* almost 20 times. As youngsters growing up in St Abbs Road, Arbroath, my sister, Moira, and I were brought up with the big band sound on the record player – remember those? To be honest, I also grew to love the music of Glenn Miller, and I have to say that I too, have seen *The Glenn Miller Story* with actor James Stewart performing as the band leader several times.

Glenn Miller disappeared in mysterious circumstances in a small plane over the English Channel on 15 December 1944 while flying to Paris to arrange a Christmas concert.

In the mid-1980s, Glenn's younger brother, Herb Miller, was on tour with his orchestra (including a few original members of brother Glenn's), performing at various venues, including Arbroath's top nightclub at the time, Smokey's Nightclub. They were fantastic, performing all of Glenn's hit tunes. My dad would have got a great kick out of meeting Herb and dancing to all his favourite ballads, but unfortunately my father passed away a few years earlier. I did ask my mother if she wanted to attend, but she replied no, as she would have no one to dance with. To this day, I regret not taking my mother to the gig and giving her a dance or two; not that I could compete with my dad's dancing skills.

In the '40s, Glenn Miller was an officer in the United States Army, although he never took part in any actual fighting, but rather toured with his orchestra playing all his hits, entertaining the troops. He had been performing in England and had to

travel to Paris for a pre-record radio show, which was to be broadcast at Christmas. It is for this reason that he decided to fly ahead in advance of his orchestra, and prepare some new musical arrangements.

Missing Flight

On 15 December 1944, Glenn Miller boarded a single-engine UC-64 Norseman aircraft, and, together with the pilot plus one other, took off from Twinwood Farm Airbase in South-East England, heading for the French capital. However, the aircraft never arrived. Nowadays, aircraft follow strict flight plans and are in constant contact with air traffic controllers. Any flight going missing today would have search parties out within hours, if not minutes. Perhaps as there was still a war going on, or the fact it was not on a scheduled flight plan, but it was several hours before anybody noticed the flight was missing, and several days before it was announced that the well-known band leader was on board. The Norseman was a light, yet sturdy aircraft used extensively worldwide in remote areas, such as the Australian outback, Canada and Alaska due to its short take-off and landing capabilities.

The Norseman was used to flying in these remote areas and often challenging weather conditions; therefore, it seems highly unlikely that the aircraft was brought down by inclement weather over the English Channel.

The weather was reasonable and nobody knows for sure what happened to the aircraft. However, an interesting observation came to light recently when a former RAF navigator threw some light on the missing band leader. It was, at the time, standard practice that, when the allied bombers went out on a bombing raid over Germany, they would have a specific target, for instance Berlin, and, in case of heavy cloud cover over the city or some other circumstance, where the initial target was abandoned, they would divert to a secondary target, perhaps another city.

In the case of this secondary bombing target also being aborted, fuel and time restrictions meant the bombers had to return to base. They were not, however, allowed to land their aircraft with a heavy bomb load, and, therefore, had to ditch their bombs at a designated area over the sea. This designated area was a 10-mile circle called a 'jettison zone' off the coast of South-East England. Fred Shaw was a navigator on board one of the British Lancaster bombers during World War Two, and he says, after his bombing raid was called off during the night, they were ordered home. He was usually stuck at his navigation station, but, as they were approaching the safety of the English coast, and since Fred had never seen the bombs drop, he decided to move to a window and watch the bombs fall into the jettison zone. The date was now 15 December 1944 and, as the bombs fell to the sea, Fred clearly saw a few bombs strike straight through the wing of a small plane, causing it to crash into the sea.

Fred mentioned this to his crewmates and it was reported. However, Fred said perhaps they never believed him, as nothing was done about it. As the time and date coincide, it does seem likely that the small aircraft struck by the bombs, causing the aircraft to plummet into the sea, was indeed the

UC-64 Norseman carrying the famous band leader Glenn Miller.

Years later in 1987, a fishing boat off the English coast was hauling up its nets and pulled up a small aircraft wreck. The crew contacted the coastguard, who ordered the fishermen to lower the aircraft wreck back into the sea. The fishing crew did, however, note the position on the chart, which was approximately 30 miles south of Portland Bill Dorset, at a depth of 130 feet. The International Group for Historic Aircraft Recovery intend to investigate this aircraft wreck further. How unfortunate it would be if it were proven that one of the best pop stars of his generation was bombed out of the sky by friendly fire; a terrible accident indeed. In any case, the big band sound of Glenn Miller lives on with his many recordings, and continues to keep his appreciative music lovers 'in the mood'.

Glenn Miller

CELEBRATED ARBROATH BOTANIST

George Robert Milne Murray FRS FRSE FLS was born in Arbroath, North-East Scotland on 11 November 1858. He was educated at Arbroath High School and the University of Strasburg, where he studied botany. Once qualified, he became a celebrated botanist and naturalist. George took part in several scientific exhibitions, including being part of the scientific crew on the RRS Discovery with Robert Falcon Scott and Earnest Shackleton, travelling to and exploring Antarctica, a continent that was mostly unexplored at the time.

George was elected a fellow of the Royal Society of Edinburgh and, later, in 1897, he was elected to the Royal Society. He had many written works published in *The Journal of Botany* and published two books, *Handbook of Cryptogamic Botany* and *An Introduction to the Study of Seaweeds*. In his later years, George Robert Milne Murray suffered from ill health, and passed away in December 1911 while in Stonehaven.

SCOTLAND AND THE FASHION ICON

Hugh Grosvenor was born to a wealthy dynasty on 19 March 1879. Following his father's death, he became the second Duke of Westminster and one of the wealthiest men in the world. He had a distinguished military career serving with the Royal Horse Guards in both the Boer War and World War One, where he was awarded the GCVO and the DSO. The duke was known by the nickname of Bendor to his closest friends. (Bendor was also the name of his grandfather's horse, which won the Derby in 1880.) The ancestral home was the Cheshire country estate, Eaton Hall, which had 54 bedrooms and was surrounded by 11,000 acres of parkland, including stables. To give you a further idea of his wealth, the rooms in Eaton Hall were adorned with paintings of artists such as Goya, Rubens, Raphael and Rembrandt. Hugh also owned no less than 17 Rolls Royce automobiles and often sailed on the Cutty Sark. He enjoyed sailing so much that he bought his own yacht, called Flying Cloud. In a further show of extravagance, he had a rail track built from Eaton Hall into London, so he could easily commute between Eaton Hall and his London Townhouse, Grosvenor House. (Grosvenor House was later to be leased to America and served as their embassy.)

Although the duke was already married, over the years, the aristocrat took many lovers, and, in 1925, the duke was attending a party in Monte Carlo when he was introduced to Gabrielle (Coco) Chanel, and became immediately besotted with her. He invited her to dine with him on his yacht, the Flying Cloud, which was berthed in the harbour. They soon became lovers and the 'IT couple' to be seen with around town.

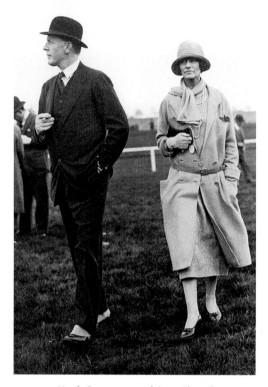

Hugh Grosvenor and Coco Chanel

The besotted duke lavished her with expensive gifts of jewellery and clothing. The duke also gifted her with a house in London's Mayfair and land on the French Riviera, where Coco later had her villa built, calling it La Pausa. As an avid fan of hunting, the pair often retired to the duke's Scottish hunting estate in Sutherland called Rosehall, near Loch More. Coco Chanel added her French artisan touch by having the walls adorned with wallpaper that she herself designed. Coco even had a bidet installed in her bathroom, and it is widely believed that this was the first bidet fitted in any Scottish bathroom. Coco enjoyed fishing and hunting on the estate, even fishing with the future British Prime Minister, Winston Churchill, when he came to visit.

Rose Hall

Coco Chanel loved the Scottish tweed and often wore the garment with her own style. It is said that she was so inspired by tweed that it can be seen in many of her designs. The affair between the second Duke of Westminster and Coco Chanel lasted around 10 years, before they both moved on with new spouses. Hugh Grosvenor, the second Duke of Westminster, died at his Scottish estate, Rosehall, on 19 July 1953 aged 74 years. Coco Chanel died on 10 January 1971 in the Ritz Hotel in Paris aged 87 years.

Today, Rosehall has been abandoned for years and is currently in a sorry state, but It remains the only property in Britain still to retain a few walls that were decorated by the fashion icon Coco Chanel.

There is even one of Coco's old sewing machines lying in the basement. It is indeed a pity that this building is going to ruin. I believe Rosehall and its internal decor should be saved for the public to enjoy. Perhaps the current Duke of Westminster (the seventh duke), a 20-something billionaire, whom incidentally is also called Hugh Grosvenor, could have Rosehall refurbished back to its former glory – now wouldn't that prospect be a 'fashionable' idea?

FORGOTTEN TALE OF AN ARBROATH HERO

A footnote in a book about events of World War Two contained a comment that revealed the almost forgotten exploits of Arbroath man Captain Landles Nicoll. His heroically selfless consideration for his crew and passengers cost him his life. This is his story.

On 13 September 1940, the SS City of Benares, part of Convoy OB-213, sailed from Liverpool on its journey to Quebec. Prior to departing, 90 children aged 5–16 years old had embarked under the terms of a scheme operated by the Commonwealth Overseas Reception Board (CORB). As the ship slipped its mooring, the children serenaded their anxious parents with a tear-jerking rendition of *Wish Me Luck (As You Wave Me Goodbye)*.

Commanding the SS City of Benares was a well-respected and experienced career mariner, 51-year-old Captain Landles Nicoll, born in Arbroath and the son of Captain David Nicoll who had drowned at sea in 1911. Married to Jean Caroline Smith in 1917, they lived in Leewood Cottage, Viewfield Road, Arbroath with their three daughters.

On 17 September, with several of their naval escorts withdrawn and the convoy dispersed by bad weather, the SS City of Benares was struck by a torpedo fired from U-boat 48. Two other torpedoes had already missed the intended target. The torpedo exploded near the stern of the ship beneath the cabins where most of the children were sleeping.

In a force 8 gale, Captain Landles Nicoll was reluctant to order to abandon ship, but, with the City of Benares already

sinking, he had little choice. In the high winds and heavy seas, lifeboats were smashed to smithereens on the side of the ship as they were lowered. Others were swamped with water and sank almost immediately. Great efforts were made to rescue as many of the children as possible, but they had only 30 minutes, as the horrendous weather hampered attempts to keep the City of Benares afloat.

Adult survivors would later report how they had clung onto the children for as long as possible and until they were certain they were dead before releasing them into a watery grave; others slipping from their grasp slid from the boats and drowned.

Captain Nicoll was heard by survivors assuring everyone to: "Take care of yourselves and get into the lifeboats."

In total, 260 of the 407 crew and passengers were lost. Only 13 of the 90 child evacuee passengers survived the sinking. The sinking was controversial; the allied powers criticised the 'barbaric' actions of the Germans, and there was an outpouring of sympathy and support for those who had lost children in the sinking. The Germans defended the attack as being on a legitimate military target, and insisted that the British Government was to blame for allowing children to travel on such ships in war zones. The tragic loss of the City of Benares caused such a public outrage in Britain that it led to Winston Churchill cancelling the Children's Overseas Reception Board (CORB) plan to relocate British children abroad.

Captain Bleichrodt, the U-boat commander, was later charged with war crimes, but was cleared on the grounds that he could not have known that children were on board the City of Benares.

Little is known of how his widow and three daughters fared after the tragic loss of Captain Landles Nicoll, who tragically shared the same fate as his father. It's story that should not be forgotten.

Captain Landles Nicoll (1889–1940)

HE'S A JOLLY GOOD FELLOW

Rick Jolly OBE (29 October 1946 to 13 January 2018)

Rick Jolly was born in Hong Kong on 29 October 1946. His father was a Polish gunner who was a Japanese POW for the duration of World War Two, and his mother was an ambulance driver during the same war. Rick was educated at Stonyhurst College and studied medicine at St Bartholomew's Hospital Medical College (now called Barts and the London School of Medicine and Dentistry).

Rick qualified as a physician in 1969 and, while he was working as a houseman (doctor in a hospital), a senior colleague suggested he join the Royal Navy Reserve as a RN doctor. Rick became attached to 42 Commando Royal Marines and was deployed firstly in Belfast, and also completed two tours with the Fleet Air Arm.

The Falklands War

In 1982, forces from Argentina illegally landed on the British dependency Falkland Islands group in the South Atlantic. Days later, Doctor Jolly was part of a seven-man team who were secretly flown on to Gibraltar to meet up with the passenger ship Canberra. Rick's job was to board and take notes on how and where to attach helicopter pads, and which decks could be converted to hospital wards, etc. The Canberra was obviously going to be one of the many merchant ships the Royal Navy would require as part of the task force heading to the Falklands, in a term known as STUFT (ships taken up from trade). The

British Government assembled a naval task force with orders to sail south and retake the Falkland Islands. Rick Jolly was the senior officer commanding the Commando Logistic Regiment RM. During the voyage to the South Atlantic, Rick Jolly (nicknamed The Doc) gave first-aid training to Marines, Paras and a few journalists who were on board.

While deployed with 3 Commando Brigade, Captain Jolly set up a field hospital within an old meat locker at Ajax Bay on East Falkland.

Conditions inside the makeshift hospital were sparse, cramped and not ideal, to say the least. The hospital had lighting, which was rapidly rigged and poor. The medical staff often had to work during nearby air raids that shook the building violently. Brigadier Julian Thompson wanted a large red cross painted on the roof of the hospital. However, due to a nearby ammo dump, and other buildings used for military purposes, under

the terms of the Geneva Convention, this was not permitted. Consequently, the makeshift hospital was nearly hit by two bombs from Argentine Sky Hawk aircraft. Thankfully, these bombs failed to explode, due to the fact that they never had time to arm after being released from the fast low-flying attack aircraft. For a while, the medical staff had to work on patients with these unexploded bombs a little too close for comfort.

Captain Rick Jolly

Captain Rick Jolly did not give preference to British soldiers; he attended both British and Argentine troops alike, giving priority to the most seriously injured, no matter what the colour of their uniform. All the medical staff did a great job under strenuous conditions, and those attended by Captain Jolly who arrived alive, left alive.

Post-War

Fast forward 16 years after the Falklands War, when, in 1998, Doctor Rick Jolly was planning a holiday to Argentina. Rick

had an idea and contacted the authorities in Argentina to enquire about their men he had treated during the 1982 conflict. Rick gave the Argentine authorities a list of names and rank of those men.

The Argentine Foreign Ministry located most of the men on the list, and, following enquiries with their veterans, discovered the truth of Doctor Jolly's medical skills and compassion towards the Argentines injured at Ajax Bay Hospital.

Around 50 of these surviving former Argentine soldiers were invited to a ceremony to meet the doctor who had treated them, and, in many cases, saved their lives.

Many tears were shed that night as these men were reunited with Doctor Jolly. Then, to his complete and utter surprise, Doctor Jolly was given an award in recognition of his outstanding work in saving the lives of Argentine soldiers and pilots.

Doctor Jolly was appointed as an Official (officer) in The Order of May to thunderous applause by those grateful men in attendance. It is not usually permitted for one to wear a foreign medal with your other medals at any military ceremony in the UK. So, on his return to Britain, Captain Doctor Rick Jolly had to write to Her Majesty the Queen for permission to wear his Argentine Order of May alongside his British medals, including his OBE, which Her Majesty had given him previously. Her Majesty the Queen quickly replied, giving full authorisation to wear his foreign award at all and any occasion.

Further reading on Rick Jolly is available with two books written about his experiences in the Falklands War, called *The Red and Green Life Machine* and *Doctor for Friend and Foe*. Rick Jolly went on to co-found the South Atlantic Medal Association 1982 (SAMA82) with a former British Paratrooper, Denzil Connick.

Captain Doctor Rick Jolly OBE passed away on 31 January 2018, and to date remains the only known person to be awarded a medal from both sides in a war.

KEEP RIGHT ON 'TILL THE END OF THE ROAD

There is a famous Scottish song that was championed by the likes of Sir Harry Lauder, Andy Stewart and many others. The song is called *Keep Right on 'Till the End of the Road*. Every time I hear this song, it reminds me of the persistence and determination of islander Malcolm MacLeod. Malcolm was born in Glasgow in November 1911, although, since his school days, he preferred to be known by his Gaelic name of Culum. Culum was quite a clever lad at school and learnt well. In 1916, World War One started and, while his father was away serving in the forces, Calum, his two brothers, three sisters and mother moved to a croft on the island of North Raasay, West Scotland. Calum started his working life at around 15 years old, and, as the years passed, he acquired several jobs. Having multiple jobs was, and still is, quite a common pastime for a Scottish islander. Calum was assistant lighthouse keeper at Rona, a crofter, part-time postman for North Raasay and part-time journalist for a Gaelic newspaper, and these are only the jobs we know about. Obviously, he was a hard-working man keeping busy earning a few pounds to make ends meet wherever he could. It seems hard to believe he had enough time for a social life; however, Calum did meet, fall in love with and marry Lexie MacDonald, and they settled down in a remote cottage on the island of Raasay.

Calum and Lexie's marriage produced a daughter called Julia MacLeod (now Julia Allan). When Julia got to school age, she had to walk almost two miles down the dirt track

to reach the main road in order to catch the school bus. Quite a trek for a wee lassie, especially in the winter. Calum approached the council about getting a grant to lay a tarmac road. However, despite repeated requests, he was rebuffed on several occasions. Not to be deterred, Calum bought a book on road making and road maintenance for the princely sum of two shillings and sixpence. After reading the book, Culum decided to give it a go himself. So, armed only with basic tools of a wheelbarrow, a shovel and a pick, Calum began building his road in 1964. He didn't have much spare time as it was, so the road building would be painfully slow and hard work.

Many thought he would give up, or at least, after the press and TV news stations covered the story, the council would step in and finish the job – they did not. Unfazed, Calum was determined to finish what he had started. He had one and three quarter miles to construct and could only work on his road during his spare time; as the years progressed, he got nearer and nearer to his goal: the main road.

Calum finally completed his road in 1974 after toiling for 10 long years. It will probably come as no surprise that, a few

years after Calum finished his road, the council finally stepped in and gave it a top coat of tarmac.

Calum MacLeod was awarded the British Empire Medal (BEM), probably due to his persistence and determination in his road-building endeavours. However, due to his conflict with the council, he could not be seen to be rewarded for his road building, so Culum was instead officially given the BEM for his dedicated work on the Rona lighthouse.

Calum passed away in January 1988. His road has now been officially recognised and has a proper road sign, 'Calum's Road', and by the road sign bearing his name is his original, old, rusty wheelbarrow. His persistence and determination are surely a good lesson for us all – whatever challenges life throws at you, never give up. Well done, Calum.

BEHIND THE MASK

In late November 2019, the coronavirus was first reported in the Chinese city of Wuhan. Later, on 15 December, the US trade bill was signed (Phase One). Six weeks thereafter, the trade truce was signed with an 'out clause' – a very clever out clause that the Chinese Government made sure was included within the trade agreement. Basically, the clause says that, if there was an act of God, such as a '**PANDEMIC**', then China did not have to make good on what they committed to purchase from the United States. Within days of the signing, China announced the first few cases of the coronavirus. Chinese officials seemed to have known and let the virus run loose around the world prior to shutting down Wuhan. The result was the following.

Unrestricted travel was the sole cause of this virus becoming a global pandemic. The Chinese Government must have known what was occurring in Wuhan, yet they did nothing for six weeks. Was that because they wanted the *out clause* to kick in? The World Health Organization should be held accountable for refusing to hold China accountable. After all, the buck has to stop somewhere, and China deliberately withheld information and data regarding Covid-19 – the result was countless lives lost. Globally, countries were just not prepared for what hit their population, and dithered about, allowing, for a while, at least, unrestricted travel. Announcing that the virus was nothing to worry about and that it's just like the flu caused many people to die directly and unnecessarily. Many more are yet to die indirectly from the virus, due to suicide from missing their loved ones or financial hardship or

failed business. China is a very rich country, and, as of March 2020, held 17% of global GDP (gross domestic product). Although certain people should be held accountable for this pandemic, I suspect the whole incident will be hushed up and swept under the carpet....

Well, there it was that, in March 2020, I had this book finished and ready to go to the publisher, then, as you are aware, the coronavirus took a grip on all of us, and I, like so many others, found myself housebound and only venturing out behind the mask. My press photography work plummeted and I found myself with lots of free time. I did manage to get myself a part-time job two days a week at the Strathmore Foods factory in Forfar. They produce high-quality foods for leading supermarkets around the country and, obviously, their production increased due to supermarkets having a higher demand. One of the technical managers at Strathmore Foods is James Smiles, and I'm grateful to him, as he tipped me off regarding a story of the American submarine Barb – a true story of which I wasn't aware.

The story of USS Barb has since been squeezed into the 'down deep inside' submarine stories. Thanks, James... and, while thanking James, I would also like to thank the following people. In any crisis, some people step up to the challenge, and I will personally take this opportunity to thank NHS workers, doctors, nurses, emergency services, supermarket staff, bin men, care home workers, lorry drivers, farm workers, telecom engineers (to keep us in contact) and those who continue to work/volunteer in these difficult times to help others. We don't always show it, but we appreciate all you do – THANK YOU!

I also want to add my deepest sympathies to anybody who lost a loved one due to the Covid-19 virus. Finally, in these unprecedented times, I also send my sympathy to those who, over the previous years, built up their business to see it all disappear down the tubes.... As for me, well, apart from working those two days, the rest of my free time was like everybody else: isolated at home. I thought to myself, although

my book, *By Dawn's Early Light*, was completed, before going to the publishers, why not add an additional story? So here it is, then: my bonus story regarding a very young, brave girl who sailed solo around the world (talk about self-isolating). However, before I begin, let's get comfortable and start her story from the very beginning...

BONUS STORY

Maiden Voyage

In the early 1990s, a young married couple, the Dekkers, were sailing around the world in their yacht, Diario. The husband was a Dutchman called Dick, and his German-born wife was Babs. This was the mid-1990s. Just off New Zealand, on 20 September 1995, their first daughter, Laura Dekker, was born. As they continued their voyage around various islands, Laura was always the centre of attention, especially on islands where the locals were usually dark skinned. The fair-skinned baby Laura stood out like a sore thumb. Often when travelling with her mother, Laura was passed around, getting many hugs from locals who her never seen such a beautiful white-skinned baby before. Two years later, in 1997, her sister, Kim, was born. Unfortunately, mum Babs did not enjoy the sailing so much. She suffered from sea sickness and was much more concerned now that they had a young family. The Dekkers marriage did not survive, and they separated. Laura, who had spent the first five years of her life living on that yacht, went with her dad, while little sister, Kim, stayed with her mother, although the parents remained friends and kept in regular contact with each other.

After the family sold their boat, Dick Dekker and young Laura moved to the City of Den Osse in the Netherlands, where Mr Dekker gained employment as a handyman fitting kitchens. However, the charm of the sea was never far away and, in his spare time, he began to build another boat. He also began to teach Laura how to sail, even constructing for her a

rather simple sailing craft out of old pieces of wood, but it worked and wee Laura loved it.

Money was often scarce and Laura had to cycle 12km to school and back home again in the afternoon. As Laura got older, she took on small jobs to help bring money into the household, cleaning shops, running errands and, at the street market, she even performed on her unicycle to earn some coins. As time progressed, Laura's sailing skills got better and better.

Laura became quite the accomplished sailor, winning many racing trophies, usually accompanied on board by her faithful pet dog, Spot. Saving up her money, and with the help of her dad, Laura managed to purchase her own small dinghy, which she sailed most days after school. Laura called her dinghy Guppy; this was the first of her many sailing boats that she would call by that name.

Hanging around the harbour most days, Laura noticed that a family friend never seemed to use his larger dinghy, so young Laura asked him if she could borrow and sail it, and the friend agreed to allow her to use it when she wanted. Laura was so happy and sailed it often during weekends and school holidays. Later, Laura purchased a larger 23ft yacht and sailed around various ports in Holland. One day in 2009, her father, Dick, noticed that Laura and the yacht were missing. Dad knew his daughter was an experienced sailor and wasn't too concerned. However, not long after, he was contacted by the British Police, who informed him that his daughter, Laura,

who was only 13 years old, had sailed across the English Channel on her own and had docked in Lowestoft, and was currently being held by the British child social services. She had been denied permission to sail home alone at such a young age. Laura's dad had to fly over to England, where Laura was officially handed over to his care. However, rather than sail back with her, her dad instructed Laura to sail the yacht back to Den Osse, while he headed home with his return flight ticket.

Not long after sailing back from England, Laura discussed with her father that her ambition was to sail around the world, just like her parents had done around 15 years earlier. Laura had already sat for and passed her Masters sailing ticket. However, because of her young age, Laura had not yet received her actual certificate. Laura would also require sponsors and, of course, a suitable yacht to take on such a dangerous voyage. Laura and her father, Dick, scoured the Internet and yacht brokers looking for the ideal vessel. After viewing several yachts, which proved unsuitable, an old yacht was found that had laid abandoned for several years. It was in a sorry state and it took some vision to see its potential, but Laura fell in love with the yacht. A deal was made on this 40ft, two-mast ketch, which now belonged to Laura. Inside was like a war zone, with items lying around everywhere. Laura went about cleaning the yacht while her father checked over the auxiliary engine. Sails were replaced and much painting was done to bring the neglected 1978 yacht back to a presentable state. Laura decided (and this will come as no surprise) to call her yacht GUPPY. Laura was still only 13 years old, and, if she successfully circumnavigated the globe, she would become the youngest female sailor to do so – a record breaker. However, this was not a priority for Laura; she just wanted the freedom to sail the oceans and explore.

While sailing around the world, Laura would still complete her school work, via home lessons on her computer. Sponsors were found and an announcement on Laura's intentions to

circumnavigate the globe was made, to much publicity and media coverage. Then things started to go wrong for Laura. The Dutch Government tried to stop her from departing due to her young age; they attempted to make Laura 'a ward of court' and remove her from her father's custody. The media were there, of course, at every opportunity, to cover court proceedings; they started negative reporting going against their initial positive press coverage. Sponsors started to worry regarding the bad publicity and withdrew their support. Laura was at an all-time low and, metaphorically speaking, 'the wind had been removed from her sails'. Laura, however, did not give up. Every time she was knocked down, she just dusted herself off and got back up again. After several months of court cases, Laura was finally given permission to proceed. Laura, by now 14 years old, was emotionally overjoyed and, with tears in her eyes, she hugged her dad. Nothing could stop her now. Her voyage was on.

Dad and Laura went over Guppy with a fine tooth comb, making sure she was well supplied with food, water, spare parts for the engine, first-aid supplies and spare clothes, including wet weather gear, etc. Guppy was well equipped with hi-tech navigation and even had solar panels fitted at the rear. If he was going to send your 14-year-old daughter out into the wild parts of the ocean, Dad wanted to make sure she was safe. Laura's dad would also be able to track her progress with the electronic satellite tracking system on board, radio telephone, laptop and Skype. Laura also had an inflatable dinghy and, of course, an emergency beacon and automatic inflatable life raft, just in case. Laura sailed the yacht to Gibraltar. Dad was on board, but most of the time he stood back and just observed his daughter sail the boat. This was a good trial run of Guppy, and for Dad to make sure his daughter was ready for ocean sailing. Once they berthed in Gibraltar, the two of them went over final checks, making sure that Guppy was ready. The fuel and freshwater tanks were full, there were spare parts on board and Guppy was all shipshape and ready.

However, was Laura ready? Many doubters thought she wasn't, and thought the whole venture was doomed to failure. However, Laura knew she was up for the challenge and so did her biggest supporter, her father. So it was, then, that, after giving his daughter some last-minute advice, on that summer's day in August 2010, the proud dad, with a tear in his eye, waved off his daughter on her incredible voyage, perhaps wondering, but not dwelling, on the fact that he may never see her again. Laura used the auxiliary motor as she left the comparative safety of the harbour. She could hardly believe she was alone at last as she hoisted the sails and set off, out into the unknown. This wasn't to be a non-stop trip; she had planned the voyage well, and had so many places to visit, new friends to meet and new dangers to endure. Laura had no support vessel following her; this was a solo trip. The wind filled the sails, pushing Guppy forward out into the Atlantic Ocean, one of three large oceans she would have to cross to complete her voyage. A voyage into the unknown, and who knew what the future held for this brave young 14-year-old girl. Guppy rose over one wave, then plunged forward, crashing through the next, causing salt spray to wash over the boat. Laura was in her element and felt exhilarated; this was what she had dreamt of for many years, and now her dream was a reality.

As you stepped down below inside, Guppy had a V-berth up forward at the bow, which Laura used mostly for storage. Back from that, there was the heads (toilet) to the left and clothes storage to the right. Back further still was the main saloon, with the galley (kitchen), and the gas cooker was fitted on a gimbal; that is to say, the cooker was (in theory) able to stay level in swaying seas. Of course, there are times that even a gimbal can't compensate for rough seas: on more than one occasion, Laura's meal ended up on the floor. There was a dining table and bench seating, which all converted to a large double bed. There were also two berths at the rear of Guppy, which Laura mostly used for storage. However, Laura slept most of the time in the sail berth (also known as the quarter berth), which was housed beneath the cockpit seating. While sleeping in this berth, she could, from time to time, wake up at intervals and view the position of the sails through an internal viewing window, all this while Guppy continued sailing on autopilot. Nonetheless, Laura probably only managed to get a long, uninterrupted sleep while at anchor or tied up in harbour. While sailing at sea under autopilot control, Laura slept for short periods at a time, with an alarm to wake her up, so she could regularly check through the viewing window that Guppy was cruising safely and, of course, on the correct course.

The radar, fitted high up on the rear mast, was also fitted with a wake-up alarm. This could be set for 20, 15, 10 or 5 or 3 miles. This meant that, while Laura was busy bellow in the cabin, or even sleeping, if there was any vessel or land obstacle encroaching within the radar's set distance level, a vicinity alarm would sound, and Laura would get up on deck and see if Guppy was in any danger. Unfortunately, the radar does not discriminate from a possible surface obstacle or a harmless aircraft flying overhead. At the rear of the yacht were two auxiliary engines, one being the smaller Yanmar engine. On a frame over the rear of the cockpit was a framework to house the solar panels, which charged some of the electronic safety equipment on board, and a fridge.

On her first day alone at sea, Laura left Gibraltar in her wake and headed for the Canary Islands, a distance of around 650 miles. While at sea during this first part of her journey, she slept little, but was happy that Guppy was cutting through the water at around 7 knots.

Her first port of call was Lanzarote. Once she secured Guppy to the quayside, Laura went to register her arrival at the harbour master's office – the same form and necessary routine at every port of call... Name of the yacht, the yacht's year of construction (1978, by the way), her gross tonnage, time of arrival and, most annoyingly, how long she intended to stay.... Laura quickly made some friends and toured the island. The following morning, on 20 September, Laura was sound asleep in her bunk, snug as a bug in a rug, when, at around 7am, she was awakened by her phone ringing. Still half asleep, she answered with a rather sleepy, "Hello." She quickly had to pull the phone away from her ear as a very loud 'happy birthday' was screamed down the line. It was her mother and sister on the phone and they wanted to be the first to congratulate Laura. Not long after, her father called with the same congratulations. It was indeed her birthday; the young lady had turned 15 years of age.

After a few days' stopover in the Canary Islands, Laura departed, then headed further south to visit more locations on her big adventure. Laura sailed to Gran Canaria and on further still to a few stops at Cape Verde Islands, then from the island of São Nicolau, an island with wonderful mountains. Laura stayed for a few days exploring the island with fellow Dutch sailors she met from another yacht. On 1 December, she spoke with her dad on Skype prior to her big journey across the Atlantic Ocean. The following morning, after a good night's sleep, Laura raised anchor, checked her compass bearing and turned Guppy west, heading out over the Atlantic. The wind was in her sails and now, with 2,200 miles of sailing ahead, at last she felt really alone and her journey began in earnest. After sailing a few hundred miles, the wind dropped and Guppy was becalmed, just sitting there and swaying from side to side with the swell, which made it very uncomfortable and a curse for any sailor. Laura could read a book, update her blog, or even get on with some school work, but, with the boat pitching and rolling, those tasks became very difficult. Guppy was becalmed for a few days. In fact, Laura was sleeping in her berth when, in the middle of the night, the wind picked up. Laura shot onto deck and raised a sail. Guppy immediately started sailing forward, thrusting through the waves. Laura still had many miles to go, but she was happy to be on her way again.

After 17 days at sea, she at last saw land; her navigation was spot on. Memories came flooding back, as Laura had been to Saint Martin the year before, when she flew over with a view to purchase a yacht that was for sale. She wondered if that yacht would still be there. Laura had Saint Martin in sight, but it was getting dark. Thankfully, many town lights were on in this popular spot. Nonetheless, she wanted Guppy in the harbour before it got too dark. Laura heard the radio crackling with messages for her. "Guppy – Guppy." There was a welcoming party waiting for her, and Laura was provided with a hot meal, which was most welcome, as she was rather

peckish. Laura also called her dad on the satellite phone just to reassure him that she had arrived safely after crossing the Atlantic. Laura's dad already knew she had arrived, as he was constantly watching Guppy and Laura's progress on his computer tracking system. Ah, the wonders of technology. Laura at last collapsed in her berth and had an uninterrupted good night's sleep. She deserved it. At Saint Martin, she was joined by her mother and sister, Kim, who flew over to stay on board Guppy for a short holiday. It was great to see her mother and Kim; they all had a wonderful time at Saint Martin. All too soon, though, they had to depart. Laura's mother had to go back to work and, as for her sister, Kim, the school holidays would be over soon. They all hugged each other goodbye and Laura was once again on her own.

Laura then met up with old friends whom she had met the previous year, only, on this occasion, she had time to explore the island properly. There were the endless media interviews, of course, but she managed to shake them off and enjoy a few days on Saint Martin. For this voyage, Laura spent her first Christmas and New Year on Saint Martin. Some presents had already been packed on board by her family, not to be opened before Christmas, no doubt. After departing Saint Martin, Laura sailed Guppy on an island-hopping adventure all in the direction of the Panama Canal. At the Island of San Blas, Laura met up with a couple who were touring in their catamaran, Sea Kat; their names were Mike and Deana. They were also heading through the Panama Canal to the Galapagos Islands. Laura wondered how long she would have to wait, as she was aware of the queuing system to go through the canal and recalled how her father and mother had to wait nearly three weeks before they got their turn to pass through. Laura hoped she would not have to wait that long.

After a considerable wait, Laura's turn to enter the canal had arrived. At this point, Laura could have turned Guppy and headed home, but, once through the canal, Laura and Guppy were in the mighty Pacific Ocean. Laura felt like this

would be a turning point in her adventure. From now on, there would be no turning back; the only direction was onward. Passing through the locks, Guppy was towed by a hand-held line by canal staff; after all, the staff do not want the locks to be damaged, any damage occurring to the locks would be an expensive loss in revenue, considering how busy the traffic is on the canal system.

Once through the canal, Laura steered Guppy in the direction of the Galapagos Islands. It was Day 248 on her adventure and it was late and dark. Laura could see the lights of the two yachts slightly behind Guppy, her friends Mike and Deana on Sea Kat, and another yacht called Double Diamond. All the boats knew they were approaching the equator, and Laura kept a sharp eye on the electronic navigation readings. The three yachts were all conversing with each other on the radio and playing music. It was to be a party at sea. Laura even wore a Neptune crown in honour of the occasion, and, as her sat-nav position read 00.00–00.00, Laura started playing the song *Celebration* by *Kool & the Gang*. She sang over the airwaves to the other boats too; it was a fabulous feeling.

Laura arrived at the Galapagos Islands, as did her new friends from Sea Kat, Mike and Deana. The three of them went with a group of tourists to scuba dive with a professional diving school. Laura adored swimming with all these wonderful creatures beneath the waves. She felt at one with the sea, and this underwater adventure was far better than sitting in a dreary school back in Holland. Later that day, Laura cooked a meal for Mike and Deana on their catamaran. As they ate their delicious meal, they had to dwell on the fact that this was their last evening together. Laura enjoyed meeting new friends, especially in the sailing community, but she also knew the bittersweet fact that, at some point, they would part company and sail to a different point on the compass. The following day, Laura, Mike and Deana each did a final shop for groceries. Outside the shop, they hugged and said their farewells before putting to sea. Mike and Deana, in their Sea

Kat, headed to Hawaii, while Laura, with her stores topped up, sailed in the direction of the Marquesas Islands in French Polynesia.

Laura guided Guppy on an 18-day crossing to the Marquesas group, and entered a bay that was already occupied by several yachts. As she dropped anchor, she settled down to blow up her inflatable dinghy to ferry her ashore to fill in the usual forms at the Customs/harbour master's office. Laura toured a few islands in the French Polynesia group, but only stayed at each for a few days. It was with much sadness that Laura also decided to bypass New Zealand; she wanted so much to visit that beautiful country and see where she was born, but she still had many miles in front of her, and the call of the sea beckoned. Soon enough, Guppy had to sail through the Torres Strait separating the northern tip of Australia and the southern end of Papua, New Guinea. The Torres Straight is a known to be treacherous to sailors, with reefs, shifting sand bars, low-lying atolls and notorious storms.

The seas were rough and Laura quite sensibly hoisted the storm sails and wore her sailing harness, attaching herself to Guppy. It was quite dark as Guppy was tossed around during this passage, and Laura kept a sharp eye on the radar screen, which highlighted danger in the vicinity. While passing through the Torres Strait, Laura didn't get much sleep, nor did she get the chance to eat a proper meal, just grabbing snacks where and when she could. This young, 15-year-old sailor was at full concentration on the task at hand: to guide Guppy through this danger. When Laura finally arrived in Darwin tying up Guppy to the marina, she was exhausted; others could not believe that this young girl had sailed alone through such a treacherous part of the ocean. There was a cost, however, with some damage done. Guppy had torn sails and rudder problems and the steering wheel had fallen off. Lucky for Laura, her dad flew over for a holiday and helped get Guppy shipshape and Bristol fashion. It wasn't much of a holiday for Dad, as they spent most of the time working,

getting Guppy repaired. They also tied up Guppy against two vertical pillars sunk deep in the beach and, when the tide receded, Laura and her father where able to inspect underneath the boat and give Guppy a lick of paint below the waterline.

While at Darwin, Australia, Laura and her father, Dick, celebrated Laura's 16th birthday. Guppy looked so grand, adorned with colourful balloons. Happy birthday, Laura. All too soon, after his brief visit, Dick Dekker had to fly home, and Laura was alone once more with her beloved Guppy.

While having a meal in Guppy's saloon, Laura studied her charts for the next part of her voyage. She had the Indian Ocean to sail across, and Laura liked to plan ahead. After much deliberation, Laura decided to sail across the Indian Ocean, keeping well south. This would add a few days to the passage, but she thought it prudent to keep a distance from the pirates who frequently operated in these northern waters. The sun was beating down like a furnace and, in this sweltering heat, with beads of sweat running down Laura's forehead, she raised the anchor with the manual winch (how she envied those larger yachts with full electronic winch systems); that said, she wouldn't have exchanged Guppy for anything. After being alone at sea for weeks at a time, Laura said she never spoke to herself, but admitted to having conversed with Guppy on many occasions. She had fallen in love with her yacht the moment she clapped eyes on her, alone and abandoned in that boatyard; there was now a bond between them, and they would look after each other.

Laura set sail and steered Guppy into the Indian Ocean. New adventures were waiting (adventures without pirates, she hoped). Laura had sailed in storms and heavy swells, and she thrived in that situation; as long as Guppy was thrusting forward through the waves, Laura was in her element. However, after a few days that saw Guppy almost flying over each wave, Guppy had to endure Laura's worst nightmare. The wind dropped to nothing, and Guppy was becalmed, just floating on the ocean. The sky was blue, the sea was like a

sheet of glass, so peaceful, yet Guppy was going nowhere, just bobbing about on a never-ending sea of tranquillity. Boredom set in as Laura tried to pass the time with playing her flute, updating her blog, doing some school work... anything to pass the time. Guppy was becalmed for almost a week. Late one night, Laura was asleep in her bunk when the wind picked up. Laura awoke to the sound of the stays rattling above, and, jumping out of her bunk, she quickly ran up on deck and hoisted the sails. "At long last!" she shouted as Guppy thrust forward. Despite being becalmed for a week, Guppy soon made up time, sailing over the Indian Ocean and reaching South Africa after 48 days at sea.

Laura stayed in Durban for three days, then sailed on to Port Elizabeth. The next part of Laura's sailing would see her sail around the mighty Cape Horn, which, as we all know, can have mountainous seas. So, after checking the weather forecast, which confirmed that there was a weather window, it was now or never. Laura had only been in Port Elizabeth for two days, but decided to make a dash around the Cape and into the South Atlantic for the final part of the voyage. The weather was favourable to start with, and Guppy was sailing

fast. However, the sea soon changed into a tempest, which was normal for that part of the world, where two oceans meet. The waves got larger as Guppy soon battled through the storm, but Guppy was moving forward, and at least this was better than being becalmed, Laura thought. As Guppy's bow thrust through each wave, a wash of sea water spray engulfed the boat, soaking Laura in the process and filling the cockpit. Guppy was swaying from side to side, causing the water that accumulated in the cockpit to go to the port side, then, the very next second, the starboard side, then back again. Laura, and almost everything else on the boat, inside and out, was soaking wet with salt water. However, Laura was confident that Guppy was sailing well and she would be in Cape Town soon. The only thing that Laura was concerned about was the salt water in her hair. Well, that's a girl for you.

Laura sailed Guppy into Cape Town on 27 November and spent a few days exploring this wonderful city. The top tourist attraction was Table Mountain, and Laura enjoyed the views at the top, sitting on an outcrop of rock, and just marvelled at the view. On 12 December, Laura guided Guppy out of Cape Town into the South Atlantic Ocean, heading north in the final part of her journey. The air was rather cold down in the South Atlantic, and Laura was keen to get near the equator and the warmer climate. While at sea, on 25 December 2011, Laura celebrated Christmas alone at sea.

Guppy was sailing well while Laura put on her Christmas hat and danced on the foredeck for her video camera, which she had set up to film automatically. It was a quiet, lonely voyage from Cape Town and, after 41 days at sea, Laura had Saint Martin in sight. It had been a wonderful voyage and her dad called on the radio saying that he, her mother and sister were all waiting to welcome her at Saint Martin, then he added so was 'the world's press' and many other people. Laura almost altered her course to avoid the fuss, the press, with questions, so many questions. Some people had sailed out to meet her, sounding their foghorns and waving many flags; what a party atmosphere. That afternoon, Laura achieved two things: while sailing into the harbour, she also sailed into the record books. Somebody handed Laura a bouquet of flowers; there was a bank of photographers all bustling for prime position for that perfect shot. After many hugs from her family, she posed for photographers. That evening, Laura enjoyed a meal with Mum, Dad and her sister, Kim. It felt wonderful to enjoy this brief evening of private family time.

The year was 2012, and 16-year-old Laura Dekker had become the youngest person to sail solo on a voyage of 27,000 nautical miles, circumnavigating the globe in 519 days – a record that still stands today.

Laura has written a fabulous book detailing her voyage, called *One Girl One Dream*, published by Harper Collins. It is available to purchase through Amazon.

Trivia

Laura and Guppy eventually sailed on to New Zealand, where she currently resides. Laura allowed Guppy to be used by a

teaching sailing club. Unfortunately, while under the command of novice sailors, her beloved Guppy was grounded on a reef at Caye Caulker (Cook Islands) in the Pacific. The yacht that had carried Laura around the world on her record-breaking voyage was a total loss.

SPEED OF SOUND

Ever since the British engineer Frank Whittle RAF designed the first jet engine, engineers have worked to go faster and faster still, taking to the skies in ever-increasing speeds. During the 1950s, crossing the Atlantic was a bouncy, buffeting experience, travelling in a piston propeller-driven aircraft; a very uncomfortable 18-hour journey. During the '50s and '60s, aircraft were being rapidly developed that were faster and breaking speed records, but these were usually small single-seat planes. Just after World War Two, some former bombers were converted to passenger aircraft, but these were slow and certainly not comfortable. What was sorely required was a larger aircraft that carried multiple seats. A plane that could fly at high altitude above the weather, with many passengers travelling in comfort in a pressurised capsule. In the mid-1950s, engineers began developing a supersonic passenger aircraft that could fly faster than the sound barrier: Mach One. The main problem in supersonic flight is air drag. The engineers soon caught on to the design of swept-back wings. However, if the wings were too thin, they certainly reduced drag, but they were not strong enough. Whereas a thicker wing had more drag,but was much stronger and had more room to include fuel tanks. The Vulcan bomber had swept-back wings and the Fairy Delta Two not only had swept-back wings, but also a pointed nose cone that could be lowered to assist in landing (starting to sound familiar).

The initial estimated cost of developing the Concorde in the mid-'50s was estimated at £70 million. By 1962, that figure had jumped to £150 million, which was an obscene amount of

money. However, with political and technical delays and alterations etc., the final cost turned out to be £1.3 billion (a rough, translated cost of £8 billion in 2020). The development of a fast supersonic aircraft was going to be very expensive, perhaps too expensive for any one country to develop. So it was then that, after much consultation, a joint British and French development committee signed an agreement in 1962 to design and build the supersonic aircraft, which would be called Concorde. Despite language difficulties, some French engineers were often over here in England, while our engineers travelled to France to oversee work in the counterpart factories.

After many delays, design tweaks and tests, the first flight of the Anglo/French Concorde (001) took place on 2 March 1969, taking off from Telus airport in France. The British Concorde (002) took off on its first flight on 9 April 1969 from Filton Airfield in England. However, it was much later that the Concorde took its first paying passengers. On the morning of 21 January 1976, two Concorde aircraft took off at precisely the same time: British Airways flew their Concorde aircraft from London to Bahrain and Air France flew theirs from Paris to Rio de Janeiro. With the high cost of development, Britain was hoping to recoup some of their investment funding in the project from sales of Concorde to airline carriers around the world.

Around 16 airlines showed interest in purchasing Concorde, including Pan Am, who initially ordered seven of the aircraft, then it was noted that several countries banned Concorde due to excessive noise pollution from her huge Rolls Royce engines. Also, Concorde would require special permission to gain flying rights over certain countries. Airlines started to cancel their initial orders. To make matters worse for the government, Aerospace Minister Michael Heseltine, who had been on an international sales tour with Concorde, said British Airways got their (FIVE) Concords for free, as he said, at the time, 'they held us over a barrel'. I mean, who is going to purchase Concorde if Britain's biggest airline isn't flying them?

On 5 January 1976, a public hearing was held in the United States, headed by the then US Secretary of Transport, Mr William T. Coleman. A crowd of environmental demonstrators gathered outside to hear the verdict. To their dismay, Concorde was granted permission to land in New York. However, Concorde was only permitted to fly at supersonic speed over the Atlantic. The first time Concorde flew to New York was November 1977, and quite a crowd was there to see this iconic aircraft arrive – some against and some for. The rich and famous certainly lined up to fly Concorde. Henry Kissinger, the US Secretary of State (1973–1977), said, "Once I flew on Concorde, I never flew anything else." As for a class system, it has been said that, when you fly, the options are economy, business, first class and Concorde class. Once you took your seat on board Concorde, there was constant champagne, and the meals were of a very high standard. Hollywood actress Joan Collins was shooting the American TV series *Dynasty* and was flying back and forth to London using Concorde. Joan said of the on-board cuisine: "The meals were similar to a Michelin restaurant's high standard, caviar, lobster, smoked salmon." It really was a fabulous experience.

However fabulous the experience of flying with Concorde was, the reality is that, after five years of service, the only route making a profit was London to New York (or, in the case of the French Concorde, Paris to New York). By 1981, Concorde was running at a loss. British Airways conducted a survey and discovered that most of their elite passengers had no idea how much they were paying for a ticket and, in some cases, a few passengers thought the ticket price was more than what it actually was. So British Airways bumped up the ticket price, and their wealthy passengers either didn't notice or didn't care. In another attempt to fill the seats, the airline offered Concorde out for lease at around £17,500 for a quick supersonic jaunt out over the Atlantic and back. A full Concorde meant that seats that used to be occupied by the wealthy were now available for the normal everyday person at around £175 per seat. This proved so popular that additional routes were added. Sometimes a wealthy businessman would treat his staff to an excursion somewhere and, even though these trips were for the common man, it was still the full Concorde experience with all the high-class meals and cocktails on offer. In another marketing idea, BA offered Concorde as a Christmas special, flying passengers to Lapland and back, and also day trips to Cairo to see the pyramids. Eventually, it was possible to charter Concorde to more than 250 destinations worldwide.

The Heritage Concorde

In yet another clever marketing strategy, in 1983, somebody thought of the ultimate British class excursion. To fly the flag for Britain and travel to America and back using the two most iconic '60s British transports. Travelling in one direction by Concorde and, after a few days at a luxurious hotel, travel back again by sailing on the QE2 ocean liner. This worked like a charm, and benefited both British Airways and Cunard Line shipping company. This joint co-operation worked well for many years, then the unbelievable happened in France.

The Paris Crash

On the afternoon of 25 July 2000, a Concorde Air France Flight 4590 was lined up on the runway waiting for take-off clearance at Charles De Gaulle airport. On board were mostly German tourists heading for JFK, New York. Once air traffic controllers gave permission, the Concorde started to increase speed down the runway. A small strip of debris that had fallen off a previous flight was lying on the runway. The French Concorde ran over this at high speed, causing the tyre to burst and peel back, striking the underside of the left wing and rupturing the port fuel tank. The fuel poured out and was ignited by the heat from the port engine. Flames were clearly seen flaming back from the Concorde and were actually filmed by passing motorists. On board, the pilots desperately tried to control the aircraft, but, 90 seconds after take-off, Concorde Flight 4590 plunged into a nearby hotel, killing all 100 passengers, nine crew members and four guests inside the hotel.

Within three weeks of the Paris crash, all of the Concorde fleet were grounded until the subsequent investigations found out the cause of this tragedy. After the piece of metal on the runway was found to have led to the accident, engineers went about making sure this accident would never happen again. Concorde had all its tyres replaced with a burst-resistant type. Also at enormous cost, the inside of the fuel tanks were lined with strengthened Kevlar. Concorde was soon ready to take to the skies again. British Airways went about with a well-publicised relaunch of their updated prized aircraft, inviting 100 of its own staff and press on a flight over the Atlantic. However, as luck would have it, while they were flying at high altitude over the Atlantic, something catastrophic was happening in New York. The date was 11 September 2001 and the Twin Towers in New York were under terrorist attack. American aviation authorities soon ordered all aircraft to land at their nearest airport and, soon after, the aviation authorities shut down air travel over the States. This Concorde flight

wasn't going all the way to New York, but it was to affect future flights. Many people wondered if air travel would ever be the same again; people were scared to fly. Concorde had many regular travellers in banking and finance, of which nearly 50 of these valued customers were killed in the Twin Towers attack. Two months later, permission was granted for Concorde to resume flights to New York. However, so soon after this terrorist attack, Concorde found itself flying to New York half empty. Concorde continued to fly with reduced passengers for a while, but, with the ever-increasing cost of fuel, together with the high maintenance cost, both British Airways and Air France decided to pull the plug, announcing that they would retire Concorde in six months. Ironically, in that six months leading up to the aircraft being withdrawn from service, passengers flooded the ticket hotline in an attempt to be one of the last to fly this iconic aircraft, so much so that British Airways had to add additional flights.

End of an Era

Air France withdrew Concorde on 27 June 2003, while British Airways' final flight was 24 October 2003 to much media coverage. A large crowd, including airport staff, all stopped what they were doing to watch as the last three British Airways Concords all landed, one immediately after the other, at Heathrow International Airport in London. To many, it was a sad sight to see the three Concords, which would never again carry passengers, parked up near the runway, and for this '60s icon it was indeed the end of an era...

Trivia on Concorde

There were only ever 20 Concords built, although only 14 ever went into passenger service. A few are now dotted around the globe parked up as museum pieces.

As Concorde can fly faster than the Earth rotates, in theory, the aircraft flies back in time. For example, this gives you the

unusual effect that, after the aircraft departs in darkness shortly after sunset, Concorde actually catches up with the sun, resulting in a westerly sunrise not long after the sun had actually set for the day (talk about flying messing with your body clock). Concorde was the only civilian aircraft capable of such a phenomenon.

At an altitude of 50,000 feet, the outside temperature was well below zero. However, flying at Mach 2, Concorde's skin was hot enough to fry an egg, with a nose temperature of around 153 degrees. Also, at supersonic speed, Concorde increased in length by as much as 12 to 30 centimetres.

The Russian Concorde

Russia had its own version of Concorde called the Tupolev Tu-144. The aircraft looked suspiciously like the British/French Concorde, which makes me think there may have been some industrial espionage involved. This was a period in time of political rivalry between the East and the Western nations, with each side trying to be the first to get things done. The Russian Concorde was soon nicknamed the Concordski.

Its shape was very similar to Concorde, although it was more than three metres longer and had 20 more seats for passengers. It had the drop-down nose for landing and take-off, and had additional small wings added near the cockpit. These were retractable wings called a 'moustache canard' that supposedly helped gain lift at slow take-off speeds. Although the exterior of Concordski look similar in appearance, the interior technical components were far inferior compared to its British/French counterpart. The Russian plane did get into the air in 1968, quite a few months before Concorde, and the pride of the Soviet Union was shown off at the 1973 Paris air show. However, during a flying demonstration, the aircraft broke up in mid-air, killing the crew on board. Concordski did eventually go into passenger service, for a while at least, but how many in Russia could afford the ticket price? In later years, it was used to carry a mix of passengers and cargo, but, similar to our Concorde, it was getting too expensive to operate, and Concordski was withdrawn from service, retiring on 1 June 1978.

America and Supersonic Flight

President John F. Kennedy first mentioned that the future was in supersonic flight back in the early '60s. Decades later, a certain President Nixon also endorsed supersonic flight. Boeing did invest heavily in at least looking into the possibility of building an aircraft capable of supersonic flight. They spent around $40 million dollars on the project, but got no further than a wooden version. Costs started to spiral out of control, and the US Senate voted to cease anymore funding into the programme, so Boeing cancelled the project. Obviously, they would have looked into design of the British/French Concorde and taken note of the fact that it could only seat around 120 passengers. No doubt after much deliberation, Boeing decided to instead concentrate on planes that could carry much more passengers. Boeing's 747 (the jumbo jet) used less fuel, had a

further flying range and, most importantly, could carry far more passengers: 416 passengers in a three-class set-up, 524 in a two-class set-up and 660 in an all-economy cabin.

The Bristol Hanger

In the English City of Bristol, there is an old hanger where work on the Concorde began all those years ago. At one end on a wall is a mural depicting decades of many great triumphs in British engineering, achievements on land, sea and air. There is Brunel's Clifton Suspension Bridge, SS Great Eastern ship, the Spitfire fighter aircraft, the Harrier Jump Jet, and there, above them all at the top of the mural, is the Concorde...

SHIPWRECKED

Barbara Crawford was born in Dundee in 1831. When she was six years old, her father, Charles Crawford (whose trade was a tinsmith), took her to a new life in Australia, boarding the ship John Barry. They reached Sydney, Australia on 13 July 1837 and set up home in New South Wales. Barbara had a good upbringing, but, like many youths of today, by the time she reached her teenage years, she began to rebel. Not long after her 16th birthday, she met a man she was immediately attracted to; he was a ship's captain called William Thompson. They soon became lovers and moved in together. Although it was never confirmed that they ever officially married, Barbara took on her lover's surname and became Barbara Thompson. What nowadays would be called a common law wife.

Captain Thompson heard about a whaling ship that had grounded on a reef and, together with Barbara, set sail from Moreton Bay on the cutter America to attempt to salvage the valuable whale oil stored in abundance on board the grounded vessel. Had they been successful in their salvage endeavour, it would have made them very wealthy. However, as luck would have it, en route, a storm whipped up and they, too, struck a hidden reef and their ship, America, foundered. It was now a fight for survival. They began to swim to the nearest island, but she lost sight of her husband in the waves. Assuming her husband had drowned or been taken by sharks, Barbara had no time, nor the strength, to search for her beloved husband. There wasn't even time to weep for her loss. She battled on through the waves, getting weaker as she swam on, and finally reaching the beach, exhausted from her swim and wearing

nothing but the rags on her back. Barbara had reached the Prince of Wales Island in the Torres Strait, and, as she lay contemplating her precarious situation, she was soon surrounded by native islanders of the Kaurareg people. Barbara was well aware, having been warned by her husband, that islanders in this region were notorious head hunters and even cannibalism was rife. She must have been terrified, a young white woman, lying semi-naked on the beach, surrounded by natives who seemed quite aggressive, shouting in a language she didn't understand, wondering if she was about to be ravished, or even find herself on that night's menu.

For Barbara, though, her run of bad luck was about to change. A village elder called Buwai Gizumabaigalai had lost his daughter a few weeks earlier when she drowned in the sea. Barbara bore a striking resemblance to her, and, believing Barbara was a born-again spirit of his beloved daughter emerging from the sea, the elder ordered that she remain unharmed and, in fact, Barbara was taken in by a family. Barbara lived among these villagers of the Kaurarog people for five years, taking on the day-to-day chores of the village women and picking up some of the language. Nobody wore much clothes and, being naked and fair skinned, Barbara suffered terribly from sunburn, but at least she was alive. The village women called her Gloma, and she became aware of the bitter inter-fighting between rival clans, often witnessing the fighting men return, chanting wildly with the decapitated heads of rivals in their hands.

Rescued at Last

One day while out doing chores with the other women on Evans Bay, they came across a British Naval shore party with their ship HMS Rattlesnake anchored offshore. The British sailors, on seeing a white woman among the natives, spoke to her in English, of course, which, to Barbara, was a great joy. On hearing of her predicament, they took her aboard their

ship, where she was given some clothes and food. The date was 16 October 1849 and, after living with the savages for five years, Barbara was at last rescued and returned to her surprised family, who had considered her long dead. Barbara certainly had a few interesting stories to tell and, after living with the savages for five years, the remainder of her life must have seemed quite mundane. It is said she remarried and had a long life, passing away in 1916 aged 85 years.

A book was published detailing this Dundee lass and her time with the islanders. It is called *Wildflower: The Barbara Crawford Thompson Story.* The author was Raymond J. Warren and it should be available in local libraries.

"SOMEWHERE OVER THE RAINBOW"

Frances Gumm

Born to Ethel Marion (Nee Milne) and Frank Gumm, Frances Ethel Gumm was born on 10 June 1922 in Grand Rapids Minnesota, USA.

Her parents were musical and ran a cinema, Vaudeville Theatre. Frances began to show some musical talent at just two years, singing while her mother played the piano. When she was old enough, Frances joined her two older sisters, Mary and Dorothy, performing on stage as *The Gumm Sisters*.

The sisters didn't like the fact that the audience often laughed when their name, Gumm, was announced; some even called them 'The Glum Sisters'. They continued performing as a trio, with limited success. One day, a lady friend remarked that Frances had a lovely smile, adding it was like a garland of flowers, which the sisters liked, and, by 1934, *The Gumm Sisters* had changed their name to *The Garland Sisters*. The sisters ceased performing as a trio when older sister Mary got married and moved with her husband to Reno, Nevada. Frances changed her name to Judy soon after.

In 1935, Judy Garland was escorted by her father, who took her for an audition at the Metro-Goldwyn-Mayer studios in Culver City. Judy's audition included singing the song *Zing Went the Strings of My Heart*, which young Judy belted out to much appraisal. Judy was immediately signed up, although, at 13 years, Judy was an awkward age, too old for the usual child contract and far too young for any adult roles. Although she was now signed to a studio contract, the studio had no planned projects for Judy, and were initially unsure what to do with her. Judy was often insecure regarding her looks, and remained so the rest of her life. Judy was petite, small in stature and, what she herself believed, had average plain looks, especially when compared to other contemporary actors of similar age. The fact that Judy went to the MGM School with the likes of the very attractive Ava Gardener, Elizabeth Taylor and Lana Turner did not help with her insecurity.

Judy and Mickey

MGM hit on a winning formula when they paired Judy Garland and Mickey Rooney together for the first time in a musical. Together, these two future stars earned the studio so much money from that first movie that MGM capitalised on the pairing by financing several more musicals, piling more and more work on them in what was to be known as the *Backyard Musicals*.

It was such a heavy schedule for the young actors, often with early starts and a late finish. There were the endless rehearsals and several takes, just to get the perfect scene. Judy and Mickey were worked so hard that they often finished one movie, then went straight to another set to begin rehearsing the next. Young stars were often under pressure to keep up with what the studio demanded, as actors knew all too well how some fellow actors never got their contract renewed and were suddenly dropped. Judy was to later claim that it was around this time that the studio supplied them with amphetamines to help stay awake, and later barbiturates to help them get some sleep. However, Mickey Rooney denied this, stating that the studio never offered the pair drugs to help them perform, although stars of the time were told to keep an eye on their weight, especially the young female starlets.

THE WIZARD OF OZ

The 1939 movie *The Wizard of Oz* was based on the book *The Wonderful Wizard of Oz* written by L. Frank Baum.

Initially, MGM studio wanted to cast the female lead character, Dorothy, to the biggest child star at the time, Shirley Temple. Shirley, however, was signed to rival studio 20th Century Fox. Negotiations began between the two rival studios to cast Shirley Temple on a temporary loan basis. Indeed, Shirley was well aware she was in demand and the hot choice for the part. When asked by inquisitive reporters whether she had secured the part, Shirley would only tease the press by smiling and quoting a line from the book, saying, "There's no place like home." Indeed, the rumour circulating Hollywood at the time was that MGM offered 20th Century Fox a temporary swap of Clark Gable and Jean Harlow in return for Shirley Temple on a one-movie deal. This, however, I find hard to believe. Clark Gable, perhaps, but this was 1938 just prior to the start of filming Oz, and Jean Harlow had died the previous year, so something doesn't quite ring true here. For whatever reason, negotiations between the studios faltered. Another acting choice for the part of Dorothy was Deanna Durbin. Durbin had a superb operatic singing voice, but she, too, was signed with a rival studio under contract with Universal Studios, and besides, Deanna Durbin had other work commitments.

So it was then that filming of *The Wizard of Oz* began on 13 October 1938 with Judy Garland cast as the lead character, Dorothy Gale. The fact that Judy was the third choice to play the character, a fact she was sure to know, must have done nothing to help her already low self-esteem and insecurity. Judy was 16 years old at the time of filming, and playing a character of much younger years required her to wear a tight corset to help contain her developing figure. Judy also wore a blonde wig.

All the scenes showing Dorothy at the Kansas farm were filmed in monochrome, only switching to full colour when entering the Land of Oz. Judy did a superb job and one song from the movie, *Somewhere Over the Rainbow*, was to remain her signature tune for the rest of her life. Judy Garland was awarded a well-deserved juvenile Oscar for her performance in *The Wizard of Oz*.

A Star is Born

In the 1954 remake of *A Star is Born*, Judy starred alongside James Mason. However, James Mason was not who the studios wanted; first choice was Cary Grant, but he read the script and decided that playing an actor whose career spirals

out of control with alcohol wasn't the part for him, so James Mason won the role. The movie was beset with problems. Not only was Judy Garland the lead actress, but she and her then husband, Sid Luft, were producers. They often clashed with Jack Warner (Warner Brothers) over various things, including being over time and budget. Filming began in 1953 and, after several days of filming scenes, the Warner Brothers decided they wanted this movie to be their first movie to be filmed in the new 'CinemaScope', so they had to scrap what was already in the can and reshoot from start. The finished movie was three hours long, which made Jack Warner furious; he demanded that the movie be edited down, so several scenes were cut, as were a few of the original songs. The three-hour version has been lost, although the reels may be out there somewhere. The film went on to win several awards, including a Golden Globe for both Judy Garland (lead actress) and James Mason (lead actor).

The Final Curtain Call

Judy Garland had a successful recording career. She was a movie star and, during the '60s, had her own TV show aired in America, yet, despite her success, Judy required constant reassurance that she was wanted, attractive and talented. Judy was indeed a highly talented icon who could fill any concert hall worldwide, and she was given her own star on the Hollywood Boulevard.

Judy Garland had several suitors and was married five times. Her final marriage, in 1969, was to Mickey Deans. By the late '60s, however, the years of alcohol, heavy smoking and substance abuse had ravished her looks, and Judy looked much older than her 47 years.

Judy and her husband, Mickey, were staying at their rented home in Chelsea, London, and, on 22 June 1969, Mickey awoke and noticed that Judy was not in bed. He found her unresponsive and slumped on the toilet. A doctor was called and, after a brief examination, he pronounced her dead. At 47 years old, Judy Garland was taken from us far too soon, but she did pack a lot into her life. As the saying goes: "It's not the years in your life, but rather the life in your years." It is true that, by the late '60s, Judy was not so much in demand as in her glory years of the '40s and '50s. However, Judy retained a huge fan base and her passing made the headlines everywhere. It wouldn't be the first time Hollywood had lost an icon, nor would it be the last.

Quirky Fact

Judy Garland's great-grandfather (on her mother's side) did not live at the end of the 'yellow brick road', nor did he live

'somewhere over the rainbow'. His name was Charles Milne and he was born in the year of 1827 in the town of Arbroath, Forfarshire (Angus) Scotland.

Judy Garland - Family Tree (Mother's side)

Frances Ethel Gumm (AKA Judy Garland)
Born 10/06/1922
_
_

Father	Mother
Francis Gumm	Ethel Marion Gumm (Nee Milne)
Born Tennessee 1886	Born 1893
Died November 1935	Died January 1953
Los Angeles	Los Angeles

_

Father	Mother
John Milne	Eva Fitzpatrick
Born 15/10/1865	Born 04/06/1865
Ontario Canada	Massena New York
Died 07/09/1937	Died 17/10/1949
Illinois USA	North Hollywood

_

Father	Mother
Charles Milne	Mary Milne (nee Kelst)
Born 1827 **Arbroath**	Born 1837 Kilmarnock
Died 1900 Ontario Canada	Died 1892

Trivia

Actor Jack Haley played the Tin Man in the movie *The Wizard of Oz*. His son, Jack Haley Junior, was married to

Liza Minnelli, who, as we know, was the daughter of Judy Garland.

Actor Renee Zellweger did a superb job playing the life story of Judy Garland in the 2019 Hollywood movie *Judy*. It's a great movie, giving an insight into Judy's later life.

The iconic dress worn by Judy in the movie *The Wizard of Oz* sold in 2015 for £1 million pounds.

SPORT

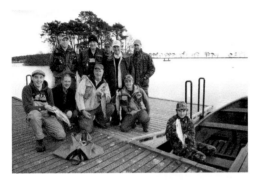

Arbroath Angling club

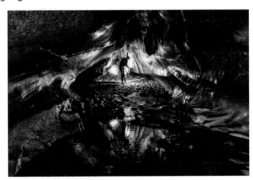

*Arbroath Cliff-trail Kayak trips through the caves,
with Cambo Smith*

Arbroath Lads Club

Bowling Club Trophies

Cricket Kids

Forfar Fitba

Gymnastics

Arbroath United Cricket Club Dinner

Young footballers with a sponsorship deal

Judy Murray

Judy Murray being thanked with flowers

Kids meet Dundee football player

Legends with Carnoustie kids

Ladies Day, Cricket Club

Arbroath Lads Club

Local Golfers

AFC Chairman Mike Caird with Ally McCoist

Old Crocks

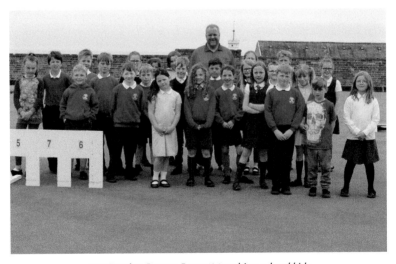

Top Bowler, Darren Barnett teaching school kids

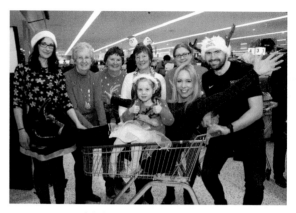

Skilz bag-packing at Morrisons

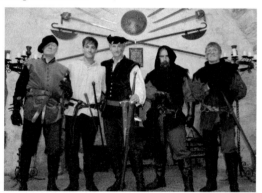

*SPADA sword fighters taking a break during filming of
the movie Justice 1416, at Balgonie Castle*

Skilz Sports at Hayshead School

WHITE WEDDING

Just off the West Coast of Scotland is Loch Ewe, and in the middle lies the Isle of Ewe, so called as it was mostly occupied by sheep. Of course, many couples now visit the island and propose to their partner, as 'Isle of Ewe' can be pronounced 'I love you'. Some couples have even been married on the island (now who said romance was dead).

While on the subject of marriage, I have to say I have been to many weddings over the years, as either a guest or hired as the photographer. I have noticed that many of the youths of today do not seem to know the steps of the traditional Scottish dances. I remember being at Arbroath Academy and Scottish Country dancing was part of the PE school curriculum. Mr Gechie and Mr Beedie and some female teacher (sorry, I cannot remember her name) showed us all the steps. I also remember at the time we would rather play football, but then again, I would rather dance than go out on one of Mr Gechie's cross country runs. So there we were, all lined up, us guys at one side opposite all the girls, equally all lined up. We had to walk over and chose a girl for a dance partner. Most of the guys ran over to pick the best-looking girls; I just walked over to see the girl I was walking towards facial expression change to a cringe as I approached her. I'm sure she was thinking 'oh God no, Wallace is about to pick me'. Anyway, although we all cringed at the time, is was good lesson for dancing at weddings later in life, and happy memories for sure.

I would also like to add more wedding etiquette for a traditional Scottish wedding.

Photographing Weddings

If you fancy becoming a wedding photographer, but are inexperienced, I would like to give a few tips on photographing such an important event.

Have a meeting with the couple and discuss to see what photographs they had in mind (they may even have a photo request list). Perhaps you have done weddings before and you have some photography samples to show the couple.

Preparation

Make sure you have two cameras; in fact, two of almost everything. It is always nice to have a back-up if some equipment is giving you problems. The evening before the wedding, make sure that all batteries are fully charged or new. In my camera bag, you will find camera equipment, of course, but I also carry first-aid plasters, small scissors and a sewing kit with several sewing needles, white thread, dark thread, kirby grips and safety pins, etc. Over the years, I have come to the bride's rescue on several occasions. If possible, visit the venue in advance, either a week or so prior to the wedding, or earlier that morning. Have a scout around the gardens to see where you can take photographs. Try to imagine the position of the sun at the time you are likely to be taking your bridal photographs. Do not dress shabbily; make an effort to look smart. A spare shirt/jacket/jersey might be a good idea. I once had a seagull poop on my shoulder. Is your car fuelled up? BE ON TIME! If the wedding is 2pm, perhaps you should be there around 1.25pm to start photographing the guests as they arrive.

Position

If a couple is going as guests to a wedding, the lady would link into her man's *left* arm, as tradition dictates his right arm (his sword arm) is free and ready to protect his lady. If the man is wearing a flower or piece of heather, it should be attached to

his *left* lapel. The lady should wear her flower above her right breast. That way, when linked in for a photograph, their flowers are close together. If three guests arrive together, put the man in the middle of the two girls, or the girl in the middle of the two guys. If a family arrive, get the kids in the front, but make sure you do not obscure the outfits of Mum and Dad. When I photograph weddings, in most of my wedding poses, the groom will be on the right with his wife linked into his left arm (again, sword arm free); however, there is one exception. In the case of the father of the bride, or whoever is standing in for the father, giving away the bride, the bride uses her left arm to link into her father's *right arm* as he walks her down the church aisle, then at the alter she can kiss her father as he passes her hand to her groom.

As a wedding photographer, you don't want to annoy the minister by jumping about snapping away during the vows. Talk to the minister and find out if you are permitted to photograph during the ceremony, and are you allowed to use a flash gun? Find a spot and don't move from it. Jumping about will only get you banned from the church, or worse still, get all photographers banned. Try to position yourself off to one side, preferably shooting into the face of the bride. Remember, as they exchange vows, they will be looking at each other. Also be ready for when the minister says to the groom, "You may now kiss the bride." That's always a nice photo to capture. One cannot plan the weather, so, if your planned outdoor shoot is a no go due to howling wind and rain, perhaps the minister will allow you back in the church for large bridal group photographs. Always best to have a Plan B in case of bad weather. Once you get to the reception, it's always a good idea to keep on good terms with the hotelier or function manager (you might even get a free meal). Do not annoy the venue manager by taking too long taking your bridal photographs. I usually talk to the venue manager first to see when the meal will be ready and what time do they want everybody seated. I have on occasion been asked to make it quick, or indeed stall and take more photographs as the kitchen isn't quite ready. Remember, you can always come

back and take more photos once they have finished their meal, before the evening's entertainment starts.

Tips for Speeches

It is usually up to the couple when they want to do the wedding speeches. The normal would be an after-dinner speech. However, more and more grooms are having the wedding speech before the meal, as they are nervous about making a speech and want to get that over so they can enjoy their meal. It is the couple's choice; however, they should remember it may have been sometime since their guests arrived for your wedding and they may be hungry. At the end of the speeches, the couple might want to cut the wedding cake, or leave it to cut later in front of your evening guests.

Who Says What

You might be lucky enough to have an M/C (Master of Ceremonies) or the hotel/venue manager could do the job of introducing each person who intends to make a speech.

The usual order is the following:

Speech 1: Father of the bride or stand-in
Speech 2: Groom
Speech 3: Best man
Key points of speeches.

Father of Bride/Stand-in

Example of a dad's speech
He might want to start by saying;

"There are certain people whom the bride and groom would have liked to be here on this special occasion; however, due to Ill health, travelling difficulties or sadly no longer with us, were unable to attend, so, if I may begin, the first toast of the evening is to absent friends."

(Remembering those elderly who may be infirm.) "Those of you are able to, please stand up."

(The Toast is Absent Friends)

Now Dad/stand-in welcomes the groom into the family and says something nice/funny and how proud he is of his daughter.

He might also want to thank certain people who helped make the day special. The minister/did a friend make the cake/ thank the hotelier for the wonderful meal you have enjoyed (or are about to enjoy).

"We have a wonderful band/disco this evening and I would be happy to see people dancing and enjoying themselves; let's have a great night." Finally, there is a toast to the bride and groom.

(Toast to the Bride and Groom)

Dad sits down...

<u>GROOM</u> (should toast the bridesmaids)

1: On behalf of my beautiful wife and me (pause as guests cheer)...
2: Thank guests for attending.
3: Thank guests for the wonderful gifts.
4: Thank all parents.
5: Thank best man, bridesmaids and any flower girls/ pageboys.

(Toast to the Bridesmaids)

6: Thanks again everybody (say 'I will now hand over to the best man' or M/C will do that).

Then sit down to rapturous applause.

BEST MAN

(Best man should reply on behalf of the bridesmaids.)

"On behalf of the bridesmaids and myself, I want to thank ____ and ____ (groom and bride) for allowing us to be part of their amazing day."

Then the best man should tell some funny stories regarding the groom; however, know your audience. Do not be too crude if there are senior or younger members in the audience.

If there are any telegrams/cards that have been sent in, it is a fine chance for the best man to read these out. If, however, there are too many, the best man should only read out cards from people who were *not* able to attend the wedding. He could explain this, adding that the rest of the cards will be placed around the cake for people to read later. (NOTE: some of these cards may have gifts of money inside, so the groom can check this out in advance.)

(Toast to the Bride and Groom)

Sit down to rapturous applause.

(End)

POETRY IN MOTION

THE CLIFFS OF ARBROATH

The cliffs of Arbroath stand rugged and red,
They start at the ness, to the towering red head,
With sea at the bottom, and path at the top,
And in between, that lovely red rock.

Rock carried on carts over a long weary road,
To Build The Abbey, that humble abode.
To walk the cliff top, you see many a design,
The roaring crashing sea, which it left behind.

The inlets an' caves, all part of that wall
A mass standing proud, and ever so tall
The shingle the beaches, all the way along
Treacherous currents ever so strong.

Tuffets of grass, on the cliff edge
Sea birds nesting, on the tiniest of ledge
If you walk along the top, go ever so slow,
Watch your footing, an' mind how you go.

<div align="right">Wullie Smith, 2018</div>

The Day the World Changed

By Riley George Beattie, Age 11 - Timmergreens Primary School

Something happened to the world today,
A nasty bug called Covid came to stay.
They told us to wash our hands and it might go away,
But it was not enough to keep the bug at bay.

Lockdown was scary, it made me cry,
I did not want anyone I knew to die.
Schools were closed, and shops shut too,
At first I gave a big woohoo!
But then we were told to stay at home,
And soon I began to moan and groan.

Homeschooling started and my Mum tried her best,
But she is not as good as my teacher I must confess.
Being with my family keeps me safe and well,
But sometimes I feel like I'm living in a cell.
An hour of exercise we are allowed every day,
Sometimes it takes my sad feelings away.

We clap on a Thursday for the NHS,
To show them we know they are trying their best.
Scientists are trying to find a cure,
I am hoping for it soon but I am not so sure.

I wish it was over and it was all like before,
I will make sure I see my family much much more.
I will never forget the day the world changed,
The memories I have will always remain.

4-15 14-15-24 2-5-12-9-5-22-5
5-22-5-18-25-20-8-9-14-7 25-15-21-18
7-15-22-5-18-14-13-5-14-20
20-5-12-12-19 25-15-21
4-5-13-1-14-4 20-8-5 20-18-21-20-8

A NIGHTMARE ON ELM STREET

Rival news stations have understandably always wanted to be the first to break a story (as do newspapers). Many years ago, when some urgent story was received by tickertape or phoned in by the reporter, and if the news was deemed important enough, the TV news stations used to break into scheduled programming to announce the news item. The TV screen would show a plain dark screen with the word in large white print: NEWSFLASH, It was usually accompanied by a deep voice saying, "We interrupt the scheduled programme to go over to the news studio for an urgent newsflash." Excitement followed for the viewer, who, with bated breath, waited for the impending news. Lately, however, I have noticed that the studios no longer use the word 'newsflash', and now go for the rather disappointing 'news report', which, to me, sounds rather limp and not exciting at all. Also, it has to be said that the news report has of late been followed with a mediocre story, which makes me angry thinking why the hell they broke into my favourite TV show to tell me this boring, mundane story!

At some time in our lives, we will all experience the shock of a newsflash, like the death of Princess Diana or the attack on the Twin Towers in New York. My first time was in 1963, but I can still vividly remember. I was a young lad happily playing with my train set while my father watched our state-of-the-art black and white 10-inch screen valve television set (only two channels, by the way). Suddenly, normal scheduling was interrupted with a 'newsflash'. I can remember my father shouting at me to be quiet and his face turning pale with serious anticipation of the impending news. The date was 22 November 1963 and, although it was after 7pm here in Britain, afternoon was just beginning in the American city of Dallas. The telephone network was going into meltdown as reporters tried to find a telephone and call in their stories. (No mobile phones then.) There had been a shooting in Dallas, Texas, and early reports said President John F. Kennedy had been seriously wounded travelling in his motorcade through Dealey Plaza...

By pure chance, at the same time here in Britain, the annual dinner and ball of the Guild of Television Producers and Directors was taking place at the Dorchester Hotel in London, celebrating workers in the news industry. The cream of staff included station producers, directors and reporters, most of which had left their stations hours before to get themselves ready for the big event. The news studios were, therefore, covered by a skeleton staff, working on a few mundane stories, when suddenly the tickertape machines burst into life. As the shooting of the president was being flashed over the wire, one can only imagine the panic setting in the television newsrooms. Someone was chosen to break the news to the British public. The man chosen (because he happened to be wearing a tie) was John Roberts, a man on the junior reporting staff, more used to working off camera. A nervous John Roberts was thrust in front of the camera and duly delivered the most important news report of his career. President Kennedy had been shot. He later broke into normal

programming again looking solemn to announce that President Kennedy had died of his wounds. After that, incidentally, we never heard from John Roberts again.

The Secret Service Detail

Today in the United States, the Secret Service protecting the president is run with a huge budget and have at least six times as many men as were available to President Kennedy back in 1963. Nowadays, the Secret Service uses multiple communication devices, such as a two-way radio combined with earpiece /microphone. The Internet gives them access to worldwide police forces to exchange information and photographs of known terrorists and anybody else who may be a threat to the president. When a president travels to a city, a few agents will visit the city days before the official visit. These agents will liaise with the local police, and plan the best and safest route. A prearranged plan of the nearest hospital will be made aware to drivers. Back in the motorcade somewhere will be an ambulance or a van equipped like an ambulance complete with a few litres of the president's blood group... just in case.

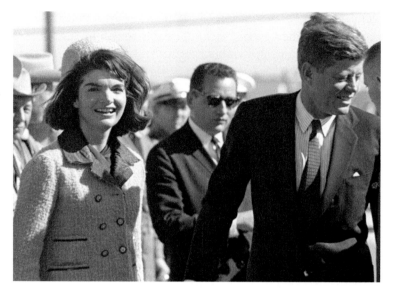

Agent Clint Hill, (Centre) watches over the Kennedys

However, in 1963, no such contingency plans were in place, although the main motorcade vehicles did have two-way radios (which worked occasionally). Individual walkie-talkie radios were not available to agents; they usually communicated with each other with hand signals. They did have the obligatory dark sunglasses to scan the crowds, looking for someone who looked out of place and did not fit in. They would have also had a few 5x3 photographs in their pockets of suspected known threats in the area.

President Kennedy was soon to be running for re-election, and was visiting Texas to attend a fundraising dinner at the Dallas Trade Mart, where the distinguished guests were waiting to greet the president and the First Lady. Although it had been raining heavily the previous evening, the following morning, it was just light drizzle and, by around 10.45am on 22 November, it was a fine sunny day. At President Kennedy's insistence, the Limousine bubble top was removed. Although the presidential vehicle had small retractable platform steps fitted alongside and fixed rear steps with grab handles for

agents to ride on the side and back, President Kennedy wanted the voting public to see him clearly, and ordered the agents to stay off his vehicle.

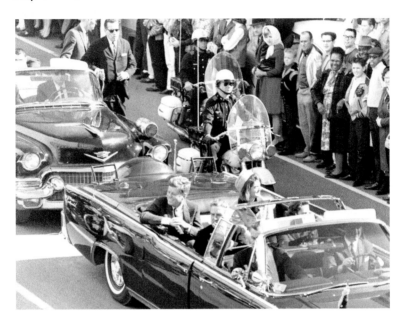

Secret Service Agent Clint Hill was not actually assigned to protect the president, but he, and one other, were the two agents detailed to protect the First Lady, Mrs Kennedy. The presidential Limousine was being driven through the Dallas by Agent Bill Greer and, as he drove down Houston Street, he was not driving down the centre of the street, but more to the left, as he thought it would keep the president further away and at a safer distance from the large crowd lining both sides of Houston Street. This, however, put Mrs Kennedy closer to the crowds on her side of the street, and also caused a problem for the police motorcycle outriders attempting to travel alongside the president's vehicle. Clint Hill did not like the fact that his assignment, the First Lady, was closer to the crowds. Clint was so concerned that he rushed forward from the agents' follow-up vehicle and jumped on the rear footplate to

signal Bill Greer to keep the vehicle down the centre of the street. Clint Hill gently stepped off and returned to the follow-up car and his post of front left footplate. Large crowds lined both sides of the street and were cheering and waving at the president and the First Lady. To JFK, it must have seemed like re-election was in his grasp. However, as the motorcade drove down Houston Street and turned left in front of the Texas Book Depository building, the dream of re-election was to end. The nightmare on Elm Street was about to begin.

A Nightmare on Elm Street

The Secret Service agents' eyes were everywhere, scanning the crowds and various open windows for potential threats. As the presidential motorcade drove down Elm Street, something strange happened. Off to the right by the street crowd, in the blazing sunshine, a man opened a black umbrella! Suddenly, there was a loud bang – was it a firecracker? Clint Hill's eyes shot ahead to his detail, the First Lady, and he noticed that President Kennedy had his hands up to his neck and had slightly slumped towards his wife. Agent Hill knew something was wrong, and immediately jumped off the follow-up car and raced towards the Kennedys vehicle. As he approached the Limousine, another shot rang out and struck the president in the head. Jackie Kennedy had started to climb over the trunk (boot) of the car to retrieve a section of her husband's scalp, which had been blown off by the bullet strike. As Clint Hill reached the president's car, he just got his foot on the rear footplate when driver Bill Greer stepped on the accelerator to get the vehicle away from the scene, almost causing agent Hill to slip and fall off the back step.

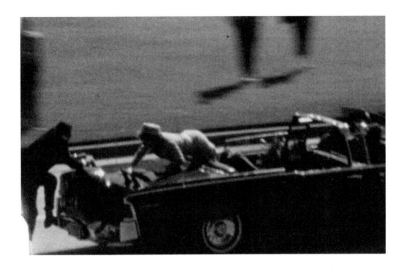

Clint launched himself over the boot, quickly pushing Mrs Kennedy back into the vehicle. At that point, the president had fallen over onto her lap. The First Lady and Clint, by this time, were covered in the president's blood and brain matter. As the police directed the driver towards Parkland Memorial Hospital, Clint quickly accessed President Kennedy's condition, then, looking back at his fellow agents in the follow-up car racing behind, Clint shook his head, giving a thumbs down hand signal. This was probably to indicate that the president was already dead or, at the very least, had a non-survivable wound.

The news of John F. Kennedy's assassination shocked the world, and it wasn't long before various conspiracy theories started to circulate. A spectator and amateur cameraman, Abraham Zapruder, had his cine camera filming the motorcade from a good vantage point near the soon-to-be-famous grassy knoll. Mr Zapruder managed to film the assassination in full graphic detail. As the president's Limousine approached, President Kennedy and his wife, Jackie, can be seen smiling and waving to the crowd. For a second, the president's Limousine is hidden by a large road sign (which has since been

removed). When the vehicle emerges from behind the sign, John F. Kennedy can be seen clutching his neck with both hands. His wife, Jackie, is by his side. They look at each other. She seems unsure as to what's happening. At this point, I do not think the wound was fatal, and perhaps the president and Mrs Kennedy should have bent over low down and taken cover. I now know, however, that the president was suffering from back pain due to a wound he received during World War Two. Consequently, he was wearing a back support, which he often wore to keep him more upright and presidential – I mean, who wants to vote for a president who stoops over and looks frail? This back support stopped him from bending over to take cover. Within seconds, another shot rang out and the president's head was pierced by an assassin's bullet.

At that point, Bill Greer, the Secret Service agent driving the Limousine, stepped on the gas and the motorcade accelerated away to Parkland Memorial Hospital, with Agent Clint Hill hanging off the back of the Limousine. News spread quickly that an amateur cameraman had caught the entire assassination on cine film with his Bell & Howell 8mm cine camera. Reporters from various media publications were soon on the telephone offering money to purchase the film. Zapruder asked them all to come to his home at 9am the following day. One reporter from *Time Life Magazine* turned up at 8am and promised to not exploit the footage and only use still pictures from the footage, excluding the fatal head shot. Zapruder agreed that his film should not be exploited and a deal was signed for $50,000 for the copyright of his film by *Time Life Magazine*. Two days after the initial print agreement, *Time Life Magazine* obtained the full motion picture rights for an additional $100,000. Although today the footage is now widely available to see over the Internet, the American public did not get to see it until 6 March 1975, when it was first shown on *Good Night America*, a TV chat show hosted by Geraldo Rivera. When the American public saw the assassination for the first time and viewed the president's head forced

backwards with the impact of the fatal bullet strike, it only helped fuel the speculation that at least one additional gunman was involved. Plus, the fatal shot had been fired from the front right, therefore proving a conspiracy. Perhaps the Mafia had ordered the hit. President Kennedy and his brother, Bobby (the attorney general) had certainly been putting pressure on the Mafia and their ill-gotten financial gains from drugs and gambling.

Most of us have seen the movie JFK starring Kevin Costner and directed by Oliver Stone. It's a great movie and Mr Stone certainly directs the viewer to believe more than one gunman was involved. It was Lee Harvey Oswald who worked in the Texas Book Depository building overlooking Dealey Plaza who would eventually be arrested for the president's assassination. He, however, would claim to be innocent and set up as a patsy.

Many conspiracy theories have been raised over the years, of multiple shooters, including one behind the picket fence on the grassy knoll. I recently visited Dealey Plaza and the grassy knoll area – although it is possible a shooter could have been concealed behind this picket fence, I find it highly unlikely that an additional sniper was located at this position. A shooter firing shots from this location would have almost certainly struck Mrs Kennedy, and I doubt if Mr Zapruder would have been able to hold his camera steady if bullets were whistling past his head.

While the president was rushed to Parkland Memorial Hospital, back at Dealey Plaza, police quickly closed off the area of the shooting. Dallas Police and detectives took sworn statements from witnesses, conducted official enquiries and later requested citizens who were in Dealey Plaza on that fateful day to come forward and hand in their cameras. Most did just that, although one elderly lady seen taking photographs or cine footage near the president's assassination was never traced despite repeated requests for her to come forward.

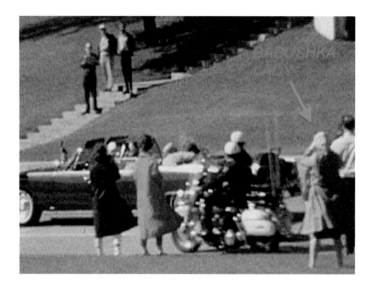

She was later dubbed 'the Babushka Lady'. The aforementioned 'umbrella man' did hand himself in to the police. His name was Louie Steven Witt, and he claimed to have opened his umbrella as some protest against the British Government. Another thing that bothered me when I viewed the Zapruder cine footage on YouTube is that the first bullet to strike the president from the rear and exit his neck seemed to be of a different calibre of bullet, if you compare it with the catastrophic trauma caused by the second and fatal bullet strike to the president's head.

One interesting theory came from experienced Australian Police Detective Colin McLaren, who conducted a thorough investigation in Dallas, which I will summarise here. Detective McLaren discovered that, the previous day (21 November 1963), most of the Secret Service agents had gone over the motorcade route and then retired to a bar for a few beers, continuing to drink when back at the hotel. On the fateful day, the agents were allocated their positions; some were drivers, others would run alongside while the rest were in the Limousine immediately following the president's Lincoln

Continental open-top Limousine. When the first shot was fired, Agent George Hickey (who was in the follow-up Limousine) reached down to the vehicle's floor well and grabbed a standard Secret Service AR15 automatic assault rifle. This weapon was loaded with hollow-tipped (often called dum-dum) bullets. He swung to the right in the direction from which he believed the shots were coming (the Texas Book Depository building). It is at this point that Detective McLaren believes that, as the safety was switched off, and in the excitement of the situation, as Agent Hickey swung his AR15 assault rifle in the direction of the Texas Book Depository building, Hickey accidentally discharged his weapon, striking the president in the head. However, Agent Hickey (who died in 2005) denied ever firing his weapon.

At Parkland Memorial Hospital, Dr James Humes performed emergency life saving procedures in front of the Secret Service agents and discovered that the fatal bullet had fragmented in the president's brain. JFK was officially pronounced dead at 1pm. Afterwards, despite it being illegal to remove the body from Texas until after the body has been released by the coroner, President Kennedy's body was forcibly removed from the hospital by the Secret Service, despite protests from the attending doctors. These doctors were later to claim they were ordered to falsify documents regarding the autopsy and angle of the trajectory of the entrance wounds. Were the agents protecting one of their own?

In the aftermath of the assassination, the aircrew of Airforce One had to remove a few seats from the aircraft to make room for the president's coffin. Vice President Lyndon B. Johnson, who was about to be sworn in as the 36th President of the United States of America, refused to allow Air force One to take off until he was sworn in. There is only an audio recording and a still photograph of LBJ being sworn in, and by his side is a dazed and shocked-looking Jackie Kennedy, who stood witness to the 36th president (LBJ) being sworn in.

Air Force One eventually took off, and landed at Andrews Air Force Base in Washington. New, clean clothes were laid out for Mrs Kennedy on the plane, but she had refused to change, saying, "Let them see what they have done to my husband." Jackie Kennedy emerged from the aircraft steps still wearing the same clothes she had worn all day, her pink wool suit and stockings stained with her husband's blood.

As I mentioned earlier, I travelled to Dallas and visited the site of the assassination myself. Many tourists visit Dealey Plaza, where street vendors are happy to sell photographs, newspapers and DVDs made from old cine footage from that fateful day. Dallas City authorities have painted an 'X' on the road at the exact spot where the fatal shot struck the president. When the traffic lights momentarily stop the vehicles a hundred metres up the road, tourists take turns to jump out and get their photograph standing on the spot. How tacky, I thought, then, waiting my turn, I also ran out and got my photograph taken at the spot.

X marks the spot, I am standing in the kill zone

The Texas Book Depository building is now a museum dedicated to President Kennedy and his family. Like many museums, photography is not permitted in the building. Tours are conducted throughout the building and, on the sixth floor, you can see the sniper's nest concealed by cardboard boxes. It is partitioned off by glass panels and left as they found it in 1963. A replica of the rifle they found at the sniper's nest is also on display. I have no doubt the sniper's nest on the sixth floor is where at least one assassin was concealed; whether any of them was Lee Harvey Oswald or not will remain (to me, at least) inconclusive.

The sniper's view

The Magic Bullet

In Oliver Stone's movie *JFK*, much was said about "'the magic bullet' and how it was impossible for a single bullet to strike the president in the back, exit his throat, change direction and hit Governor Connolly directly seated in front of him. However, the thing is, the Texas Governor *was not* seated directly in front of Kennedy. The open-top Limousine had two jump seats, which, although they were in front of the president and First Lady, were housed slightly inward and not directly in front of the rear seats. Governor Connolly and his wife were seated in these jump seats. Also, when the first shot rang out (and missed), Governor Connolly turned to the right in the direction in which he heard the first shot come; it was the second bullet, which struck and passed through the president, continuing on to strike the slightly turned Governor Connolly. Using backtracking analysis, experts later proved that this bullet that struck the governor in the back directly lined up with the president's throat, and right up to the Texas Book

Depository window, proving at least one sniper was located at that position.

There is an amateur photograph that was taken from beneath the underpass bridge directly in front of the president's Limousine.

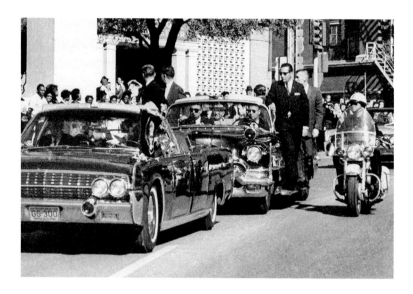

Through the windscreen, you can see the president clutching his neck after the bullet struck him from the rear and exited from his neck. In the background, you can see a group of book depository office workers gathered outside the main front entrance, including what appears to be Lee Harvey Oswald peering around the doorway at the entrance. Yet, at that exact moment, authorities would have us believe that Oswald was six storeys up re-bolting his rifle and taking aim for another shot from the open window.

BY DAWN'S EARLY LIGHT

Admittedly, the figure in the distance is a little grainy, but it looks remarkably like Oswald, and is certainly wearing similar clothes as Oswald was wearing in his arrest photograph taken by Dallas Police. The Warren Commission claimed to have located this man and said it was not Lee Harvey Oswald. The chance to further interrogate Lee Harvey Oswald ended abruptly three days later, when local nightclub owner Jack Ruby (who was known to the police and said to have connections with the Mafia) silenced Oswald by shooting him dead, right in front of the Dallas Police and the world's media.

In hindsight, two agents should have been travelling with the president on the rear footplates; they may have blocked the sniper's view, or at least, after the first non-fatal bullet strike, pushed JFK out of view, low in the car. It must have been embarrassing for the Secret Service to lose the president under their expert protection, and, if Agent George Hickey did indeed accidentally kill the president, it would have made the Secret Service look very amateurish.

The Warren Commission Report

When President Johnson moved into the Whitehouse, he soon got rid of staff loyal to Kennedy and introduced his own staff. We shouldn't read too much into this, as it is normal practice for an incoming president to want his own people surrounding him during his time in office, especially those who helped him on his campaign trail to the Whitehouse. Perhaps to pacify the American public, President Johnston issued Executive Order 11130, ordering an investigation into President Kennedy's assassination, and asked Chief Justice Earl Warren and a team of prominent people to lead the investigation and deliver him a full report.

The report concluded that there was no conspiracy, it was one gunman, namely Lee Harvey Oswald, and he had acted alone, firing all shots from the Texas Book Depository

building window, concluding in the assassination of President Kennedy.

I have some doubts regarding the Warren Commission's final report. I will list them here.

1: A few of those chosen to be part of the Warren Commission were no friend of the Kennedy administration, including Mr Allen Dulles, who was the Director of Central Intelligence and head of the CIA during the early years of the Cold War. President Kennedy had fired Dulles in 1962 after the fiasco of the Cuban Bay of Pigs invasion.

2: The CIA refused to co-operate with the Warren Commission.

3: Had the assassin or assassins turned out to be Cuban or indeed Russian, it would have increased tension in the already sensitive relationship between the two leading powers, especially after the Cuban Missile Crisis the previous year. Indeed, had the assassin proved to be Cuban or Russian, it may well have led to World War Three – a war that would have been very expensive, in both financial and human cost; something that neither country could afford or wanted.

4: I found it very convenient that they had a dead man lying on a slab, a man who worked in the Texas Book Depository building, and a man who had just killed Police Officer Tippet. Oswald couldn't talk, as Jack Ruby had shot him dead days after the assassination. It seemed very suspicious to me that circumstances were conveniently stacking up against an already dead man. I feel sure that President Johnson wanted to close this investigation as soon as possible, pacify the American public and move on with his own presidency.

5: J. Edgar Hoover, who was the director of the FBI, was heard to say, "We must convince the American public that Lee Harvey Oswald was the sole gunman in the Kennedy assassination." Now it may have been that J. Edgar Hoover was convinced that Oswald was the assassin and just wanted to confirm that belief to the American public, or was it some other, sinister alternative? I don't know.

A recent survey in the States concluded that 75% of the American public did not believe the official conclusion of the Warren Commission and their report on President Kennedy's assassination.

Larry King

Larry King was a respected TV entertainer and chat show host, known for his no nonsense approach to his interviews. He said that he spoke with Jim Garrison, who was the District Attorney for New Orleans. Larry added that, in around 1965, he saw some of the evidence that Garrison had on the Kennedy assassination, which never made the press or the Warren Commission. It included the story of a private pilot who was given $5,000 to fly to Dallas airport and wait until 5pm and fly out this man to Mexico, where the pilot was to be given a further $5,000. The man whom he had to pick up had a similar description to Oswald. However, the pilot waited until nearly 6pm, then departed alone, as that man never appeared. Also, Larry King spoke to the Dallas police detective who took the arrested Oswald to police headquarters. Larry enquired, "Did he [Oswald] say anything?"

"Yes," said the detective. "He just kept repeating 'I'm a patsy; I'm a patsy'."

Larry King had several meetings with Garrison, and, after his final meeting, he drove Jim Garrison to a hotel. Just as Garrison got out the car, he leant back into the open window and said to Larry, "And they are gonna kill Robert Kennedy." That scared the bejesus out of Larry King, especially when, in 1968, Robert Kennedy was also assassinated.

The Grassy Knoll

Many photographs of the crime scene have been studied, and one photograph shows the picket fence on the grassy knoll,

where some people claim to see a figure standing in the shadows holding a rifle. They go on to say that a white smudge in the photo is the officer badge of an assassin disguised as a policeman. I have studied this photo in detail, and I cannot see anything suspicious. An additional photo shows a building just beyond the picket fence; in an upper window, it seems to show two men peering around the windows. Although I do not see any rifles, I do have to ask myself why these two would be trying to be discreet and in the shadows when the most famous and powerful man on the planet would be on a scheduled drive-by. We can go on and on analysing the president's assassination, but, at the end of the day, people will see what they want to see in a photo. It is possible there was a second gunman concealed somewhere and, if so, it would be deemed a conspiracy. Then again, if indeed Secret Service Agent George Hickey did shoot the president with his AR15 automatic rifle, it was an unfortunate mistake. Also, we should consider perhaps the Warren Commission conclusions were correct: that all shots came from the book depository building. One thing I do believe is that we are not being told the truth or all the facts.

A congressional investigation from 1976–1979 found a 'probable conspiracy' in the assassination of John F. Kennedy and recommended that the Justice Department investigate further. However, to date, they have refused to comply. President Donald Trump has said he will release top secret files on President Kennedy's assassination soon. We all wait with bated breath.

Agent Clint Hill

For his actions on that fateful day in Dallas, 22 November 1963, Special Agent Clint Hill was later awarded a commendation, the Treasury Department's highest award for bravery. One other agent also received a bravery commendation for that day of the assassination: Agent Rufus Youngblood

had (when the shots were fired) jumped on the vice president's car and pushed Lynden B. Johnson low in the vehicle.

Agent Clint Hill, sleeping on Air Force One

Clint Hill remained in the Secret Service for many years, eventually covering protection detail to five presidents: Eisenhower, Kennedy, Johnson, Nixon and Ford. Mr Hill eventually retired in 1975. Over the years, Clint Hill has thought back to that November day in Dallas, and wondered if he could have done something different to save the president, no doubt suffering many nightmares in the process. Personally, I feel Clint Hill did all he could and more, considering the various circumstances out of his control. At the time of this book going to press, Clint was approaching 90 years of age and happily retired. I did contact Clint Hill and asked him to contribute to my story on the President Kennedy assassination, but he declined. I guess he feels he has spoken enough about that dreadful November day in Dallas. I did, however, get a signed copy of his book, *Five Presidents*, and I found his story of his time with the Secret Service fascinating. It is a fantastic read and I highly recommend the book.

Agent Clint Hill with his book.

Trivia

The presidential Limousine was a model 74a Lincoln Continental (four-door) convertible.

The Secret Service official code name for the president's Limousine was SS-100-X.

The agents gave the follow-up car the nickname Half Back.

SS-100-X was delivered to the Secret Service in 1961. The midnight blue coloured Limousine had a normal price tag of $7,347. However, the Limousine was not owned by the president or the Whitehouse, but, at the time, was leased to the Secret Service for the nominal sum of $500 per year.

Modifications to the Limousine included stretching it to 6.5m long, and adding rear and side (retractable) foot plates and grab handles for Secret Service agents. The rear seats could be elevated 10.5 inches using hydraulics, for better views of the VIP occupants. A two-way radio was installed. It had a removable bubble top, with an additional vinyl cover, neither of which were bulletproof.

After President Kennedy's assassination, the Limousine was flown back to the Whitehouse garage, where it was examined by the Secret Service and the Warren Commission who were assigned to investigate the president's assassination. Thereafter, it was thoroughly cleaned and modified with bulletproof panels and reinforced floors. At President Lyndon B. Johnson's request, the midnight blue vehicle was repainted black.

The Limousine SS-100-X was put back into service and served a further five presidents, and was finally put into retirement in 1978.

The Limousine had the licence plate GG 300. In 2015, this iconic registration licence plate sold at auction for $100,000.

SS-100-X is now on permanent display at the Henry Ford Museum in Dearborn, Michigan, and, each anniversary of President Kennedy's assassination, a single red rose appears by the Limousine. Who places the rose by the Limousine apparently remains unknown, although I find that a little hard to believe – considering the historical importance of this rare vehicle, I'm fairly sure it will have a few security cameras aimed in its direction.

To this day, Robert McClelland MD, who was one of the first doctors to attend to President Kennedy in the trauma room at Parkland Memorial Hospital, and has experience with several gunshot wounds, is convinced the exit wound was at the back of the president's head ,and Dr McClelland is convinced that the fatal shot came from the grassy knoll.

In 1999, the original 8mm cine footage of the assassination, for which, in 1963, Mr Zapruder was paid $150,000, was appraised at $16 million dollars.

In Oliver Stone's movie *JFK*, the real Jim Garrison was given a small part, playing none other than Earl Warren and Mr X was played by Donald Sutherland. Mr X actually existed and his name was Colonel Leroy Fletcher Prouty. Col. Prouty was interviewed on television by Jeff Steinberg in 1992, and the following is a section taken from this interview.

In 1963, Col. Prouty was The Chief of Special Operations, supporting clandestine operations for the C.I.A. and joint

chiefs of staff. One of his other duties was to travel with The President on City visits, and (together with troops) support the Secret Service in going over the travel route and making sure all windows were closed and sealed shut. However, in October '63 Col. Prouty received orders that he was flying out on 10th November to the South Pole, to oversee an installation of a small nuclear plant at McMurdo Sound. This was a routine and mundane job that any junior officer could have done, yet it appears somebody wanted Col. Prouty nowhere near the Presidential trip to Dallas that November.

After the nuclear plant was installed, Col. Prouty began his return trip, and was actually in Christchurch, New Zealand having breakfast when it was announced on BBC Radio that President Kennedy had been assassinated. Later that morning he bought The Christchurch Star newspaper. On the front cover was a photo of The Texas Book Depository building with open windows, and Prouty immediately knew something didn't look right as, had he been there in Dallas, there is no way he would have allowed open windows along the motorcade route. Furthermore, down the right hand side of the newspaper column was a photo and biographical history of the alleged assassin, Lee Harvey Oswald. What you have to think about here, is although that edition of The Christchurch Star was dated 23rd November '63, it wasn`t the following day; as the time zone in New Zealand crosses the International date line, so it was not the following day, but rather only a few hours after the assassination. How on earth did this newspaper and other media publications get all of this information on Lee Harvey Oswald so quickly? Was it because most of the copy was already pre-written? Perhaps Oswald was indeed what he always claimed to be, set up as a Patsy. Col. Prouty goes on to say that perhaps we should not be trying to ascertain who shot the President, but rather why he was assassinated.

War is an expensive business, and the transportation of thousands of troops to South Vietnam was being carried out by commercial airlines, who were making millions of dollars.

Military aircraft, weapons and other hardware was manufactured by companies supported by subsidiary companies, all again making millions of dollars in Government contracts. Yet President Kennedy was running for re-election in 1964 and was cancelling government contracts, and was in the process of getting all American personnel out of Vietnam by 1965. That was all to change on November 22nd in Dallas.

Once Lynden B Johnson became president, he re-opened previously cancelled Government contracts and escalated troops and resources to the Vietnam war. Up until his death in 2001 Col. Prouty maintained the belief that President Kennedy's death was the result of a coup d'état, to stop the president from taking control of the C.I.A.

President Lyndon B Johnson died of heart failure in 1973 and just a few months prior to his death, in one of his last interviews he gave to Reporter Leo Janos, published in the Atlantic Monthly magazine, (Edition July 1973) former President, Lyndon B Johnson said in the interview that he believed that their WAS a conspiracy in the Kennedy assassination, and although Oswald pulled the trigger, he was not the only one.

Quirky Facts

It has emerged that there are some bizarre coincidences between the assassinations of President Kennedy and President Lincoln.

Abraham Lincoln was elected to Congress in 1846.
John F. Kennedy was elected to Congress in 1946.
Abraham Lincoln was elected president in 1860.
John F. Kennedy was elected president in 1960.
Both were particularly concerned with civil rights.
Both presidents were shot on a Friday.
Both presidents were shot in the head.
Now it gets really weird.

Lincoln's secretary was named Kennedy. Kennedy's secretary was named Lincoln.

Both were assassinated by southerners.

Both were succeeded by southerners named Johnson.

Andrew Johnson, who succeeded Lincoln, was born in 1808.

Lyndon Johnson, who succeeded Kennedy, was born in 1908.

John Wilkes Booth, who assassinated Lincoln, was born in 1839.

Lee Harvey Oswald, who assassinated Kennedy, was born in 1939.

Both assassins were known by their three names.

Both names are composed of 15 letters.

Lincoln was shot at the theatre named Ford.

Kennedy was shot in a car called Lincoln made by Ford.

Lincoln was shot in a theatre and his assassin ran and hid in a warehouse.

Kennedy was shot from a warehouse and his assassin ran and hid in a theatre.

Booth and Oswald were assassinated before their trials.

And here's the kicker...

A week before Lincoln was shot, he was in Monroe, Maryland.

A week before Kennedy was shot, he was with actress Marilyn Monroe.

THE LADY VANISHES

Amelia Mary Earhart was born on 24 July 1897 in the small hamlet of Atchison, Kansas, USA. Amelia was an American heroine who gave talks on her adventures, and was a best-selling author. However, she will be forever known as a famous aviator. In the 1930s, it was rare to be a female pilot, as, at the time, flying aircraft was an activity usually dominated by men.

Amelia championed equal rights for women and was a supporter of the Equal Rights Amendment, and was also an active member of the National Women's Party. Amelia even formed a club specifically for female pilots called The Ninety Nines.... Sometimes people, both men and women, attempt to rise to some challenge, and for whatever reason fail. Amelia said specifically to women: "Women must try to do things as men have tried; when they fail, their failure must be but a challenge to others." Poignant words from an extraordinary woman who rose to many a challenge herself. Amelia was the first female pilot to fly solo across the Atlantic; for this achievement, she was honoured with the US Distinguished Flying Cross. Her next and most famous challenge would be a great topic for her proposed new book, and would see her recorded forever in the history books. However, it would be for all the wrong reasons.

World Circumnavigation

Amelia planned her next adventure, intending to be the first female pilot to fly an aircraft the furthest distance around the

world. To fly an aircraft such a vast distance, especially the planned route over the Pacific, requires a lot of planning and preparation. The Pacific can be a very lonely place to find yourself. There are many islands, of course, but they can appear very sparse in a vast, empty ocean, and, with the navigation technology available in 1937, finding those islands would be very difficult indeed. To undertake such a journey, a pilot has to have a good reliable aircraft, with large fuel tanks. The aircraft would have to be robust, but light enough in weight to conserve aviation fuel, so no unnecessary excess cargo. The aircraft Amelia decided on was a Lockheed Model 10-E Electra; it was modified, of course, with extra-large fuel tanks and all unnecessary equipment removed to reduce weight. This world record flight would require an experienced navigator, and the first choice of navigator was Harry Manning; second choice was Fred Noonan, who Amelia first met in early 1937. Both were former sea captains and believed to be highly competent navigators. It is assumed that Fred Noonan, who was about to start his own navigation company, was thinking of the publicity this flight would bring him, and he jumped at the chance to join Amelia on this epic flight.

For the first part of the world circumnavigation attempt, both Harry and Fred would join Amelia on the flight, with an additional pilot, Paul Mantz, who was a former stunt pilot, training Amelia on long-distance flying. However, while attempting take off from US Navy's Luke Field on Ford Island Pearl Harbour, the front undercarriage collapsed, causing the aircraft's nose to drop and the rotating propellers to hit the ground. The severely damaged aircraft was shipped back to the Lockheed Factory in Burbank for essential repairs.

Second Attempt

The second attempt departed Miami on 1 June 1937 and, after several scheduled stopovers, they reached Lae, New Guinea on 29 June, having completed approximately 22,000 miles of

their journey. By this time, however, the aircraft's occupants had narrowed down to two: Amelia Earhart as pilot and only Fred Noonan as navigator. It is not known if Harry Manning withdrew from the project voluntarily or was fired. However, it was obvious that, when space and weight was at a premium, only Amelia and one navigator were ever going on to undertake the final and most dangerous part of the journey, flying over the mighty Pacific. Some people have stated that Amelia even left behind the inflatable life raft to conserve weight. I find the very thought of such a dangerous flight, with a possibility of ditching in the ocean, with no emergency life raft on board absurd; there is no way they would be so stupid as to leave such an important piece of emergency safety equipment behind.

The radio equipment for both communication and navigation was a Western Electric 13c Transmitter and a 20b receiver. The Lockheed Electra Aircraft had a rotating radio direction finder (RDF) loop antenna, which was housed upward behind the aircraft's cockpit, while the ventral receiving antenna was housed downward below the Lockheed Electra fuselage. To help Amelia and Fred find their target landing strip on Howland Island, the United States Coast Guard cutter USCGC Itasca was stationed offshore. I would like to mention at this point that Amelia Earhart and Fred Noonan could only verbally communicate with the ship, while Captain Harry Manning (who was no longer involved in the project) was highly proficient in Morse code.

Amelia Earhart and Fred Noonan took off in their Lockheed Aircraft from Lae airstrip on 2 July 1937. The aircraft had additional fuel tanks fitted and, loaded with 1,100 gallons of aviation fuel, spectators at Lae watched as the Lockheed Electra headed over the Pacific for their next scheduled stop, Howland Island. The media, of course, were on hand to take photographs and record the start of the epic flight.

There is recorded cine footage of the take-off at Lae, and later, while viewing the footage, some people noticed as the Lockheed Electra aircraft (which was heavily laden with fuel, and lying lower to the ground) increased speed while bouncing down the runway, there is a puff of dust below the aircraft. This is believed to be the ventral receiving antenna being scraped off, or at the very least bent back, dramatically reducing its ability as a functioning antenna.

The route would have them flying over the International Date Line and, had Fred Noonan failed to take this into account, it would have them approximately 60 miles from where they thought they were. However, it seems highly unlikely that an experienced navigator like Fred Noonan would have failed to take this into consideration when doing his calculations.

Approaching Howland Island

The last presumed position of the aircraft had them within the 100-mile vicinity of their Howland Island destination, but

there were severe communication problems. The Coast Guard cutter Itasca could hear Amelia voice transmitting, but, for whatever reason, Amelia was not responding or could not hear any voice communications from the ship stationed offshore at Howland. The navy radio operator on board USCGC Itasca, Leo Bellarts, later commented how frustrating it was to hear Amelia Earhart clearly, but he was unable to do a damn thing about it. Itasca's captain ordered the ship's oil fired boilers to make smoke, but, perhaps due to low cloud cover, this went unnoticed. It should also be pointed out that Howland Island is very flat, and for that reason made it ideal for a landing strip, but, unfortunately, being void of a decent mountain range also caused the island to be low in profile, and difficult to see on any horizon.

By this time, verbal communication from Amelia Earhart was becoming garbled, but she managed to transmit that they were flying at 1,000 feet, still searching for Howland, but down to the last half hour of fuel; clearly, things were getting desperate. The ship latterly sent signals in Morse code, which Earhart confirmed on hearing, but neither Earhart nor Noonan could decipher. The last known signal from the aircraft was unintelligible, perhaps due to the fact that the aircraft was now down and ditched at sea.

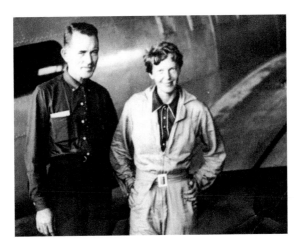

Official Air and Sea Search

Amelia Earhart was a national heroine and a personal friend of President Franklin D. Roosevelt. At the president's orders, several ships were sent to the area, including the Aircraft Carrier USS Lexington and the battleship USS Colorado, which was sent to take overall charge of the official search, which, rather surprisingly, included two ships from the Imperial Japanese Navy – surprisingly, as, at the time, relations between the US and Japan were tense, to say the least.

(Japan was an overpopulated island low on natural resources, so had ambitions to expand its empire. It had been expanding its military arsenal, determined to establish its dominance throughout Southeast Asia. In 1931, Japan had invaded Manchuria and, by 1937, the area had erupted into a war zone. America had memories of World War One and wanted to avoid another costly military intervention, so instead responded by economic sanctions against Japan, and America also gave military aid to China. This infuriated Japan, who was dependent on oil from America. When the United States cut off the oil supply altogether, Japan started to look at other military options, which culminated in the attack on the US station at Pearl Harbour in December '41, but that is another story for another day.)

Ham Radio

Although there were obvious communication problems between Amelia and the navy ships stationed along her fight route, there is, in the final moments of the flight, several amateur radio hams who claim to have heard distress calls from Amelia Earhart. You may ask how it is possible for amateur radios in America to pick up signals from Amelia Earhart somewhere over the Pacific when navy ships in her immediate vicinity found it difficult to communicate. Well, apparently, it is all down to 'harmonics' bouncing off the atmosphere.

Some of these amateur radio operators may well have been crank calls or, at the very least, ham operators receiving crank calls and believing them to be genuine. However, one of the most interesting ham radio operators was from St Petersburg, Florida, where 15-year-old Betty Clank switched on her father's radio and was scanning frequencies to pass the time. Betty had the habit of writing down in her notebook transmission messages she heard, to pass on to her father when he returned. Although the receiving signal was intermittent and occasionally sounded garbled, Betty did write down a few very interesting messages. Firstly, she heard a woman say 'this is Amelia Earhart', and clearly heard the woman say 'George, get the suitcase from my closet'. (Amelia had, on previous occasions, instructed her husband, George, and close family members to get the suitcase from her closet and destroy the papers within should anything happen to her.) This is a fact of which Betty Clank would have no knowledge. Betty also wrote down that the woman said, "I have landed near New York City." Well, there is no way that Amelia landed anywhere near New York. However, there is an interesting possibility. During a storm on 29 November 1929, a cargo ship ran aground on Gardener Island. There is very little left of the wreck now, but, back in 1937, it was very much intact, with the ship's name clearly visible on the hull: SS Norwich City. Is it possible that Amelia landed her Lockheed aircraft on the flat surf near this shipwreck? Perhaps young Betty Clank mistook the garbled message as New York City instead of Norwich City.

There is an organisation called TIGHAR (The International Group of Aircraft Recovery), which has made several expeditions to Gardner Island (now renamed Nikumaroro Island) to search for remains of Amelia's aircraft, especially near the Norwich City shipwreck. They found a few artefacts dating from the 1930s, including an aluminium panel that seems to match up, including the rivet holes, with a section of the wing of Amelia's Lockheed aircraft. Although, this aluminium panel also matches a wing panel of a C-47B

aircraft that is known to have crashed on the island during World War Two, so this evidence of a matching alloy panel remains inconclusive.

Meanwhile, some US aircraft engineers were later to claim that Amelia's Lockheed airplane was fitted with several cameras. According to these engineers, Amelia was to photograph any Japanese shipping and military installations over which she flew. The thought of Amelia Earhart as a spy is nothing more than speculation. However, it may well be the case that the US Government 'discreetly' helped finance her world circumnavigation flight and, in return, asked her to take a few photographs. Certainly, when her flight went missing, the US President authorised an extensive and unprecedented costly search for the missing aircraft and its occupants. The total cost of the official search was in excess of $4 million dollars, which, in 1937, was an obscene amount of money. The official search covered more than 150,000 square miles, including nearby islands. Gardener Island was flown over several times. However, the search proved fruitless and was finally called off on 19 July 1937.

Unofficial Search

Normally, it takes the passing of seven years before someone can be declared dead by the official court system. However, Amelia Earhart's husband, George Putnam, applied for this to be fast-tracked. The court agreed, and granted 'absentia', with Amelia Earhart legally declared dead on 5 January 1939. This made George Putnam the sole beneficiary to Amelia Earhart's property and financial accounts. Amelia had amassed a considerable amount of money from her book sales, sponsorship and giving talks, etc. To his credit, George Putnam, who already had considerable wealth, used the majority of Amelia's money to fund private searches of nearby islands along the flight route. Unfortunately, these searches were also unsuccessful.

So What Happened?

First and foremost, one has to question why an experienced navigator like Fred Noonan did not ensure that communication between the aircraft and the Coast Guard cutter Itasca was perfect. The aircraft's RDF (radio direction finder) loop antenna did not seem to operate as it should have, and were the radio transmitters between aircraft and ship on the same frequency? The flight was almost doomed from the start, with both Amelia and Fred being very complacent with their lives, venturing out over the vast Pacific in a small aircraft, in the hope of locating an equally small island, equivalent to looking for the proverbial 'needle in a haystack'.

Many possible theories have been raised as to what happened to the flight in those final moments.

1: First and most obvious is: they ran out of fuel and ditched in the ocean and, assuming Amelia and Fred survived the forced landing, they then drowned in the ocean.

2: They ditched on the surf of Gardener Island (now called Nikumaroro Island) near the wreck of Norwich City, where they lived for a few days, or even weeks, but, as the island has very little fresh drinking water, they then succumbed due to lack of water.

In 1940, Gerald Gallagher found a few bones on Gardener Island, which were taken to the Central Medical School on Fiji. At the medical school, Dr Hoodless examined these bones and identified them as belonging to a male. However, in the 1940s, technology was not as good as how medical experts can analyse human remains today. The bones were unfortunately discarded, or at least mislaid, but later examination of the paper studies, especially the length of bones, identified the remains as female, matching Amelia Earhart's height. Hopefully, one day, these bones will be found again, and a modern and more extensive examination, like DNA, can be done.

3: A very interesting photograph was discovered in 2015, which I have to immediately point out was found in a US Military photo archive from 1935. So, if it was correctly filed as a photo taken two years before Amelia Earhart and Fred Noonan departed on their epic flight, obviously it cannot be them. However, as a photographer myself, I understand how easy it is for a photo to be filed incorrectly, perhaps in the wrong drawer. The photograph is a little grainy and shows a group of native islanders with two people, both Caucasian, a male and female, on the quayside. The male is looking almost directly at the camera and appears to have the same hairstyle as Fred Noonan. A female off to the right is sitting with her legs dangling over the quay; she is facing away from the camera, but her hairstyle looks remarkably like Amelia Earhart. In the background is the Japanese Imperial Navy ship positively identified as the Koshu Maru; a navy support vessel, which often towed an aircraft sitting on a barge. Analysis of the photograph shows the aircraft on the barge is approximately 38 feet long, which, as it happens, is the exact length of Amelia's Lockheed Electra.

The photo is marked as having been taken on Jaluit Atoll, part of the Marshall Islands, which, at the time, was under Japanese control. Japanese authorities had deep distrust of foreigners and had banned Westerners. If there were cameras on board Amelia's aircraft, this would not go down well with the Japanese, and almost certainly sealed their fate. Natives have confirmed that a white man and woman were taken prisoner by the Japanese and taken to Saipan Island, where additional natives claim they were interrogated for a few weeks, then executed. There is a US Military document confirming the execution theory, but, like so many military documents of the time, it was quietly filed away to be forgotten. At the end of the war, Japan denied all knowledge of Amelia and Fred being captured and executed. Perhaps American and Japanese authorities know more than they care to admit.

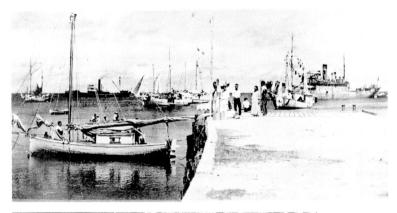

'L-MARSHALL ISLANDS, JALUIT ATOLL, JALUIT ISLAND. ONI #14381
JALUIT HARBOR.

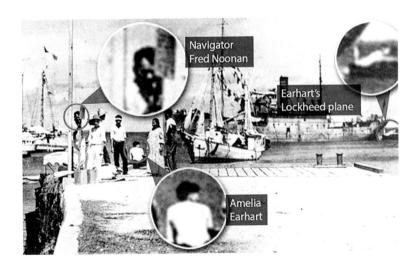

I have tried to look at this from all angles and with an open
mind. I see a few problems with the various theories on offer.
If Amelia's later messages are to be believed, and she was low
on fuel, but in the vicinity of her intended destination of
Howland Island, how on earth did she manage to fly on to
Gardner Island more than 250 miles away? If she did indeed
land on a reef near the wreck of SS Norwich City lying on the

north-west tip of Gardner Island, I can only assume that her navigator, Fred Noonan, was way off in his navigational calculations. This might explain why neither Amelia nor Fred were able to see the smoke belching from the Coast Guard Navy cutter Itasca anchored off Howland Island.

The shallow reef that surrounds Gardner Island suddenly drops off to very deep water, so it would take the likes of an expensive submersible to locate the remains of any aircraft that may have been washed off the reef. Perhaps the mislaid skeleton that was located on Gardener/Nikumaroro Island will be found again, and positive DNA from a living relative can finally put this theory to rest.

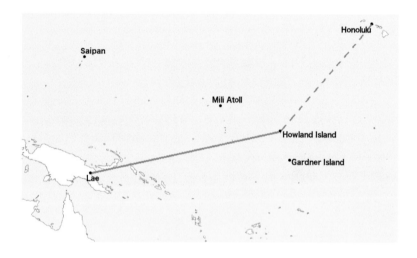

Since 1937, at least three female aviators have succeeded in completing the same world circumnavigation flight, following the very same route as Amelia Earhart, and I'll bet you cannot name any of them. It is indeed ironic how some people become more famous for trying and failing, rather than had they completed their challenge in the first place. The three female aviators who have since flown over the same route in similar aircraft were Linda Finch in 1997, Dr Carlene Mendieta in 2001 and Amelia Rose Earhart (no relation) in 2013.

The speculation of what happened to the famous aviator continues to mystify us to this day. There is a memorial stone in honour of Amelia Earhart called Earhart Light; it stands in a prominent position on Howland Island overlooking the very airfield that eluded her...

Trivia

The United States Coast Guard cutter Itasca, which played a big part in the search for Amelia Earhart, was later loaned to the British Government during the early part of World War Two, in what was to be known as the Lend Lease Agreement. The Itasca was renamed HMS Gorleston and served in the Royal Navy in various convoy escort duties. At the end of World War Two, she was handed back to the American Navy, renamed the USCGC Itasca, and served for a few years more before being sold for scrap in 1950.

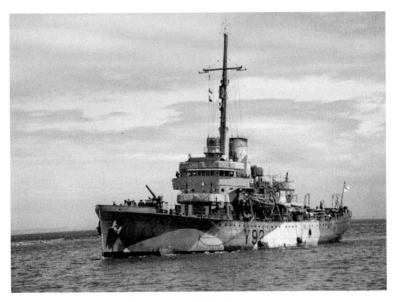

USCGC Itasca/ HMS Gorleston

FIAT JUSTITIA RUAT CAELUM (LET JUSTICE BE DONE THOUGH THE HEAVENS FALL)

THE PEOPLE'S PRINCESS

In 1991 and the following year' 92, I had the honour of photographing members of the British royal family at Balmoral Castle and the Braemar games here in Scotland for the publication *The Braemar Book*. There were many photographers at the highland games, but I was one of 20 who were allocated a 'Royal Press Pass'. Many things stick in my mind, like I recall we were all body scanned, and some policeman spoke to me. I thought he said 'can I see your keys', so I handed over my car keys, to which he looked at me, bemused, and said, "No, can I see your case?" It was his broad Aberdeen accent that caused the confusion. Anyway, he searched my camera case and was happy to see only camera equipment. All the photographers were standing side by side in a group, and rooted to the spot; making any sudden movements would have breached protocol and certainly freaked out the royal protection squad. We were not permitted to speak to the royal party, although, had they spoken to us, I'm sure we would have had to reply. However, they never did. I did, however, receive four letters of thanks when the publication came out; two from Her Majesty the Queen, one from the Queen Mother and one from Princess Diana. It was then with some sadness that I learnt about the Paris tunnel crash and Diana's death.

We were all shocked when Diana, Princess of Wales died in a car crash in the Pont de l'Alma tunnel in France on 31 August 1997. Also with the princess in the hired black 1994 Mercedes Benz W140 were Diana's companion, Dodi Fayed, driver Henri Paul and the Fayed company bodyguard, Trevor Rees-Jones.

In the previous days, Diana and Dodi had been holidaying at the French and Italian Riviera, staying on board the multimillion-pound, 60-metre luxurious yacht, Jonikal, where the official and freelance photojournalists (commonly known as the paparazzi) had been photographing the couple relaxing on deck. Were the couple lovers or just friends? Whatever this relationship was, it sure was making headlines worldwide, with magazines and newspapers willing to pay thousands of pounds for photographs of the couple. People wondered if they were indeed a couple. What about their religious beliefs? Could this relationship work?

The thing is: both Diana and her former husband, Charles, the Prince of Wales, had endured a marriage breakdown due to various circumstances, including affairs on both sides. Diana and Charles both took part in their own separate televised interviews trying to blame each other for the breakdown of their marriage, as Diana herself said in the 1995 televised interview for BBC's *Panorama*. Talking with Martin Bashir, Diana said, "Well, there were three of us in this marriage..." I have to say it is my opinion that Diana knew how to play the

press card. When her head was lowered and she walked smartly, Diana was obviously not interested in chatting or posing for photographs. On the other hand, when her head was up and she had something to say about the establishment, the Princess of Wales was very open and approachable. Sitting for the world's press in front of the Taj Mahal was a deliberate message of loneliness and she knew it.

We all knew that, from this moment on, Diana was no longer going to adhere to the falsehood of a loving marriage. Less

than two months later, as Diana had to present Charles with a winning polo trophy, as Charles lent forward to kiss his wife on the lips, Diana turned her head to one side and the heir to the throne was forced to kiss Diana's cheek. This was a clear sign to the royal household and, of course, the public, that the marriage was over. The royal couple separated in 1992, officially divorcing on 28 August 1996. So, while holidaying with Dodi, I'm sure Diana was fully aware that they were clearly visible to the press as she snuggled up to Dodi on that yacht. Perhaps it was her way of giving the middle finger to the establishment. However, unbeknown to Diana, she was also under surveillance by the National Security Agency (NSA) and very likely the British and French authorities.

The Tunnel Crash

After their holiday on the yacht, Dodi and Diana boarded a private jet in Sardinia and flew to France to spend some time at the Fayed-owned Hôtel Ritz Paris, where the couple were besieged by the press encamped outside.

After enjoying a meal in the hotel restaurant, a decoy Limousine drove off at speed from the hotel entrance, with some of the press in hot pursuit, while Dodi and Diana escaped from a rear exit with Henri Paul (deputy head of hotel security) driving, and Trevor Rees-Jones, who formerly served in the 1st Battalion of the Parachute Regiment (the Paras) and was now employed by the Fayed company as a bodyguard.

The Mercedes was heading for Dodi's apartment at Rue Arsene Houssage (a few miles from the hotel), but was spotted leaving the area, and a chase ensued with the paparazzi following on their scooters. Henri Paul drove at speed and had reached approximately 65mph as he entered the Pont de I' Alma tunnel, where the speed limit was 30mph. The driver lost control with a glancing blow with the right wall of the tunnel, then, swerving sharp left, the vehicle came to an abrupt halt after colliding with the 13th support pillar within the

tunnel. Although it was widely reported that the paparazzi were immediately behind the Mercedes, in fact, it was several minutes later that the photographers on their scooter/mopeds caught up with the now-smashed Mercedes at the crash scene. Some of the photographers immediately attempted to give assistance, while others took photographs. It should be noted that none of the Mercedes occupants had been wearing seat belts. Henri Paul and Dodi Fayed were killed outright, while Diana was to succumb to her injuries later in hospital. Bodyguard Trevor had serious injuries, but (probably due to his fitness) survived. On news of how serious the car crash was, Prince Charles flew to Paris with Diana's two older sisters, Lady Sarah McCorquodale and Lady Jane Fellows, returning to Britain later with Diana's body.

Diana's death caused an outpouring of grief not only here in Britain, but throughout the world; she was, after all, dubbed the People's Princess. More than 2.5 billion people watched her funeral live on television.

So What Happened in that Tunnel?

There were reports of a blinding white flash (possibly a camera flash, or something more powerful and sinister) – did this temporarily blind the driver, Henri Paul? We will never know. There was, however, additional evidence that something did happen within that tunnel, which was never fully explained. In the aftermath of the crash, white paint scratch marks were discovered on the black Mercedes, and a white piece of a car (later identified as belonging to a white Fiat Uno) was found in the tunnel. The French investigation team said they were unable to positively locate and match the Fiat Uno debris from the tunnel to any actual car.

James Andanson

There was however a white Fiat Uno, owned by 54-year-old amateur photographer James Andanson, who, along with driver Henri Paul, happened to be known informers for the British MI6 and various foreign agencies. That is to say that they were not directly engaged by the agency as full-time agents, but were regularly paid cash to pass on information on a freelance basis. It was interesting that, within six hours of the fatal crash, Andanson flew out of Paris and headed for Corsica. When Andanson did return, he had the white Fiat Uno car repaired and resprayed red, then sold it a few months later in October 1997. The vehicle is now owned by part-time cab driver and body builder Le Van Thenh.

This information doesn't seem to have been looked into or taken seriously by subsequent investigations. WHY?

Conspiracy

When somebody famous dies, there may well be various conspiracy theories. However, I put it to you that the following are conspiracy *facts*, not theories, and the following facts may well raise more questions than answers; so ask yourself this…

Since 1988, it has been British law that any UK national who dies abroad must have an inquest into his or her death as soon as possible upon the body returning to the UK. Yet, despite repeated requests, a British inquest was delayed or avoided. Much later, and only due to public pressure, the British inquest on Diana's death was finally held on 2 October 2007, more than 10 years after her death.

The French traffic police was the first emergency service to arrive at the crash scene, yet their accident reports were ignored by the French authorities who took over the official inquiry. Also ignored was a key witness to the crash, Mr Erik Patel, who was driving a car immediately behind Diana's Mercedes…. Just after the Mercedes wreck was removed, French authorities sent in their green council 'Property de Paris' road vehicles to sweep and scrub the road and clean the walls, thereby ending all hope of retaining vital forensic evidence that may have been there. At 7am that morning, Chris Dickey (from the news desk) arrived at the scene to do a follow-up report, expecting to find the tunnel barricaded off with police 'no entry' signs, but was surprised to see the crash scene cleaned and the tunnel reopened to the public.

The French inquest into Diana's death was held behind closed doors, with only the findings made aware to the public…. The French authorities released the fact that the driver, Henri Paul's, alcohol level was three times over the limit *before* the results of his blood level were officially obtained… The Mercedes had previously been stolen, crashed

and repaired – had it been repaired correctly and safe to drive? The French authorities claimed the Mercedes speedometer was frozen stuck at the crash speed, reading 192kph. However, the Mercedes automobile company quickly pointed out that, in the case of one of their vehicles crashing, all speedometers automatically revert to zero. The French authorities quickly retracted their original speedometer statement... Mercedes-Benz automobile company then offered to send their expert engineers to inspect the vehicle; this offer was rejected by French authorities. Then, when Mercedes requested to at least be allowed to view the authorities' report sheets on the Mercedes wreck, this was also refused....

At the entrance to the Pont de l'Alma tunnel, there was an automatic security speed camera, which must have taken pictures of Diana's Mercedes entering the tunnel and will have recorded the speed of the Mercedes, and any vehicle immediately in front or behind of the Limousine. These photos were not produced at the subsequent investigation, and the tunnel camera has since been removed. There was one photo that was circulating around the Internet, taken from directly in front of the Limousine looking back at all the anxious occupants of the Mercedes moments prior to the crash – who took this picture, and from what vehicle?

While Dodi and Diana were at the Ritz Hôtel De Paris, Dodi had called his father, Mohamed El Fayed (who, at the time, was the owner of Harrods, a store in London), saying it was crazy outside the hotel, with crowds of spectators and lots of paparazzi photographers. His father, Mohamed, said, "Look, you are safe in the hotel; just stay there." Dodi agreed with his father to stay at the hotel, yet, within the hour, he had been persuaded to relocate to the flat by the second head of hotel security and driver, Henri Paul, who, as it happens, was also a known freelance informer for MI6. What we will never know is why driver Henri Paul chose to advise Dodi to leave the safety of the hotel and risk the crowds to go to the apartment. Furthermore, why did Henri Paul not drive directly to Dodi's flat, instead of the detour that took him through the tunnel and in the opposite direction of Dodi's apartment?

After the crash, Diana was removed from the vehicle and taken by ambulance to the Pitié-Salpêtrière Hospital, a mere three miles away. Yet the ambulance stopped twice. The medics on board the ambulance said they stopped to attend to Diana's blood pressure, which was getting dangerously low. This is certainly possible and makes sense, yet, no matter how defensive this looks, it still took one hour and 10 minutes for the ambulance(fitted with emergency blue lights and sirens) to travel the mere three miles to the hospital.

Finally, it has emerged that, back jn 1996, a year before that fateful car crash, Diana had written to her butler, Paul Burrell, stating that she believed that she would be killed, probably by a staged car crash or brake tampering, etc., and even naming the person who was trying to kill her. When Paul Burrell released the letter to the press, he had the name of this person from the royal household blacked out.

I do not mean to imply that Princess Diana's death was the result of foul play. However, surely the authorities must realise that they are not doing themselves any favours by keeping the public in the dark? The whole episode reeks of a cover-up and fuels conspiracy theories.

Official Investigation

The official French investigation into the crash blamed the driver, concluding that Henri Paul was driving too fast and under the influence, with a combination of antidepressants, prescription drugs and alcohol. The subsequent British report returned a similar verdict of unlawful killing due to negligent driving. To date, the National Security Agency has refused to release details of their file on Diana, Princess of Wales, stating it was not in the public interest and it was an issue of national security.

Oh, and by the way, if you're wondering what happened to James Andanson, the MI6 informer and original owner of the white Fiat Uno... well, he dropped off the radar by lying low for a while. When he thought the heat was off, he resurfaced, but only to be found later, dead in a burnt-out car. The first man of the emergency services to arrive at the scene, Fire Officer Pelat, said he had been shot twice in the head.

MY FAVOURITE QUOTES

A product of the untalented, sold by the unprincipled to the totally bewildered.

Artist Al Capp

(Al Capp was referring to some abstract art, although I thought the words also seem quite relevant to the recent Brexit problems of the British Government.)

Surrounded by his solemn-looking friends while on his death bed, playwright and wit **Oscar Wilde** is reputed to have said with his final breath before passing, **"Either these curtains go, or I do."**

A cheeky reporter asked model and actress **Marilyn Monroe** what she wore in bed. She replied with a wicked smile, **"Chanel No. 5."**

A reporter asked **President George W. Bush** where the most dangerous place in the world was. The president replied, **"Between a mother and her children."**

On his death bed, the family of comedy legend **Bob Hope** asked if, when he passed, he wanted to be buried or cremated. Bob replied, "Surprise me."

"A lot of the recent actresses look and act like my niece. Now, she's a good girl, but I wouldn't pay to see her." – **Vincent Price**

"The only thing that ever really frightened me during the war was the U-boat peril." – **Winston Churchill**

"**Houston, we have a problem...**" Probably the biggest understatement of all time was calmly delivered by Apollo 13 Commander **Jim Lovell**. This was not his first quote regarding the incident. Astronaut Jack Swigert actually said, "Houston, we have had a problem here." Houston Space Centre replied, "Say again." Then Commander Jim Lovell said, "**Houston, we have a problem.**"

"**As I was saying before I was so rudely interrupted...**" – A quote by TV announcer **Leslie Mitchell**; his first words on the resumption of TV after the end of World War Two.

"We must convince the American public that Lee Harvey Oswald was the sole gunman in the Kennedy assassination." – **J. Edgar Hoover (FBI Director)**

Philip Mould (the art expert often seen with Fiona Bruce on TV's *Fake or Fortune*) became firm friends with Julian Lennon (John Lennon's son) and, at one time, Julian gave Phillip a signed copy of his father's latest album. However, during one school morning, Phillip was feeling rather peckish and exchanged the album for a Curly Wurly chocolate bar. Considering that Phillip Mould would go on to become a highly successful art dealer with an eye for a bargain, Phillip himself said, "This was not one of my finest deals."

Punk group the *Sex Pistols* were recording in a studio while pop group *Queen* were recording in the adjoining studio. **Sid Vicious** popped in and said to Freddy Mercury, "So are you taking ballet to the masses, Freddie?"
Freddy Mercury replied, "Dear Mr Ferocious, we're trying our best, dear..."

"Give the world the best you have, and you'll be kicked in the teeth, but give the world the best you have anyway." – **Hedy Lamarr (actress and inventor)**

"He has Van Gogh's ear for music." – **Billy Wilder**

"I didn't attend the funeral, but I sent a nice letter saying I approved of it." – **Mark Twain**

Speaking to the host on leaving a rather dull party: "I've had a perfectly wonderful evening, but this wasn't it." – **Groucho Marx**

"If success can be measured by the love and kindness you are surrounded by, I feel like the richest man in the world – thank you from the bottom of my heart." – **Chef Andrew Fairlie**

When asked where he thought the supersonic fixed wing aircraft Concorde would get us (Britain) in 20 years, bouncing bomb inventor **Sir Barnes Wallis** replied, "Nowhere."

"A girl should be two things, classy and fabulous." – **Coco Chanel**

About international actress Ingrid Bergman, **Sir John Gilguid** once said, "Ah, Ingrid Bergman, a woman who can speak five languages, and cannot act in any of them." (MEOW)

When asked by an inquisitive reporter why (when holiday-ing) he and his wife always travelled on Italian cruise liners and not British, the former prime minister took his cigar out of his mouth and replied, "Well, firstly, they are very opulent, secondly, their cuisine is delicious, and thirdly and most important, in the case of an emergency, there is none of this women and children first nonsense." – **Sir Winston Churchill**

"I believe one day, every city in America will have a telephone." – **Alexander Graham Bell**

Question: "Which of all the animals is the most cunning?"
Answer: "That which no man has yet seen." – **Unknown**

"No more ammo – God save the king." – **Last radio message sent by the surrounded British forces at Arnhem (Operation Market Garden, 1944)**

"Never trust a man who, when left alone with a tea-cosy… doesn't try it on his head." – **Billy Connolly**

About the movie *House of Wax* (1953) and its director, Andre de Toth: "It's almost my favorite Hollywood story; I mean where else in the world would you hire a man with one eye to direct a picture in 3D?" – **Vincent Price**

"Always remember you are absolutely unique – just like everybody else." – **Margaret Mead**

"Life is a journey, not a destination." – **Laura Dekker**
(Laura is the youngest sailor ever to sail solo around the world in her yacht, Guppy, which she started when she was only 14 years old.)

"Do not go where the path may lead; go instead where there is no path and leave a trail." – **Ralph Waldo Emerson**

"Twenty years from now you will be more disappointed by the things that you didn't do than by the ones you did do, so throw off the bowlines, sail away from the safe harbour, catch the trade winds in your sails, explore, dream, discover." – **Mark Twain**

"The tragedy of many life's failures are the people who did not realize how close they were to success when they gave up." – **Thomas A. Edison**

"Life's tragedy is that we get old too soon and wise too late." – **Benjamin Franklin**

"Life is never easy. There is work to be done and obligations to be met – obligations to truth, to justice, and to liberty." – **John F. Kennedy**

"Below 50 degrees south there is no law. Below 60 degrees south there is no God." – **Sailor folklore**

"If people are doubting how far you can go, go so far that you can't hear them anymore." – **Michele Ruiz**

"The single biggest threat to man's continued dominance on the planet is the virus." – **Joshua Lederberg PhD (Nobel Laureate)**

"Tomorrow is the most important thing in life – it hopes we learned something from yesterday." – **John Wayne (American actor)**

"…And I looked and I beheld a pale horse, and the name that sat on him was death, and hell followed with him." – **Revelation**

THE ITALIAN JOB

"This is the self-preservation society."

In 1975, when I was in my late teens, like most lads my age, I loved fast cars. My friend, Phil Wyllie from Forfar, had several Mini Coopers, and I remember at one time he had this gorgeous purple Mini Cooper S, in which he removed the small front orange traffic indicators, and had them replaced by moulding in large orange spot lamps; you certainly knew when that Mini Cooper was making a turn. After seeing Phil's Mini Cooper, I wanted a Mini Cooper too, and I eventually bought a red and black one (one year's MOT: £150). It was a great wee fun car to drive and, of course, I thought I was the racing car driver Stirling Moss. However, after driving around for several months, I was informed it would not pass another MOT test, so, with some reluctance and six months' MOT still valid, I decided to take the Mini Cooper down to Errol car auctions. Well, the car sold for £18, of which, after seller's commission, I received the grand sum of £9, which, if I recall correctly, I think I spent treating my girlfriend at the time, Allison Paul, to a Chinese meal. Happy days. I liked the Mini Cooper, but my dream, which I have never managed to achieve (yet), was to own a classic 1960s Mini Cooper S, like the type featured in one of my favourite movies, *The Italian Job*.

The Italian Job, starring actor Michael Caine, was a comedy caper telling the story of a patriotic bunch of British criminals who travel to Italy and steal gold bullion off the Mafia. The British criminals are the good guys, of course, and are led by Charlie Crocker (Michael Caine). The British gang

have to practise the raid, and there are quite a lot of minis wrecked in the process. In yet another practice session prior to the bullion raid, one of the gang wires an armoured van with explosives, similar to the one they intend to rob. Leader Charlie Crocker and the hood do a countdown from 5, 4, 3, 2, 1, at which point the hood presses the button, which blows the armoured van to smithereens. It's another funny moment in the movie, and Caine (as Charlie Crocker) delivers probably his most memorable line in his movie career when he says in his Cockney accent, "You're only supposed to blow the bloody doors off."

"THE ITALIAN JOB"

Technicolor® A Paramount Picture

After arriving in Italy, the British gang have a brief encounter with the Mafia, but go ahead and successfully steal the gold, making their escape in three Mini Cooper S cars throughout the streets of Turin. Just to emphasise the patriotic British connection, the minis are coloured red, white and blue and are always filmed driving in that order. Their escape involves a lot

of stunt driving through tunnels, over flooded weirs and roofs and down stairs, etc. It is quite a dramatic, exciting and an often funny car chase, while all the time being chased by the Italian police driving Alfa Romeo Giulia automobiles.

The movie was shot in late 1968 and the production company approached BMC (British Motoring Corporation) regarding acquiring several Minis. Even though this was to be the biggest advertisement for minis to be shown in cinemas worldwide, BMC only agreed to supply the three Mini Cooper S vehicles at cost price. However, the other 30 Minis (not all Coopers) had to be purchased at full retail cost. After *The Italian Job* movie was released, the sale of Minis increased tenfold, earning British Leyland a fortune. Fiat, on the other hand, could not have been more helpful. They understood the comedy and, even though their Italian vehicles usually come off as inferior, they wholeheartedly got on board with the project, supplying the film company not only with as many Fiats as they wanted, but also other vehicles that feature in the movie.

In one scene, while being chased by a police car, the three Mini Cooper S cars jump from one rooftop to another. This was actually filmed on Fiat's test track on the top of the Fiat Lingotto factory in Turin. The film's producer, Michael Deeley, was warned (on location) that the rooftop jump was a very dangerous stunt, for which, if the scene went wrong, he would be held responsible and jailed immediately. The producer authorised Remy Julienne and his stunt team to go ahead anyway, but had a fast car nearby and an aircraft standing by on the runway to escape Italy fast. As he was later to say, if things went wrong with the fly over jump, "I would rather fight the case from my own country, rather than an Italian jail." Thankfully, the Minis jumping from one roof to another was done to perfection. Vehicle production temporarily stopped at the factory for a few hours, as Fiat allowed their workforce to gather outside at ground level and watch the three Mini Coopers jump overhead, and the factory staff are clearly visible in the movie.

There was a bit of an outcry over certain scenes in the movie, especially by vehicle enthusiasts. For instance, when you see an actor shot and killed in a movie, the viewing public are aware that it's not real and the actor is still alive. However, when you see a classic car get smashed up, you know you are seeing a car get killed. In the opening scenes, you see an orange Lamborghini Miura P400. This was a brand-new 1968 model fresh off the production line. There was actually a waiting list to purchase this vehicle at the time when the scene was shot. The Lamborghini drives into a tunnel and rams into a JCB digger placed there by the Mafia, who then proceed to push the classic car wreck off the mountainside. What an expensive waste of a car, you might think. However, what you actually see is the Lamborghini drive into the tunnel, then, in the darkness, a large staged explosion, then, from a different angle at the tunnel exit, you see the digger pull out the smashed-up Lamborghini. This vehicle was a similar car supplied by Lamborghini, which had been wrecked the week before in an

accident. It was the same model and same colour, but a different car, and just the shell. If you look closely when it is pushed over the mountain, you can clearly see that there is no engine in the vehicle. However, there were a couple of E-Type Jaguars that the production company managed to purchase cheap, and a car made to look like a Aston Martin DB4 and countless Minis all wrecked during filming.

In one of the final dramatic scenes, the Mini Coopers all escape by driving up ramps into the back of a moving bus. There is a guy suited up as one of the British gang, hanging off one of the bus doors and directing the cars up the ramp. This was quite a dangerous thing to do and was actually performed by the film's director, Peter Collinson.

The movie ends (literally) with a cliffhanger, as the bus skids off the road and ends up dangling over the edge of the mountain. There was a sequel planned, but, as the movie wasn't financially successful in America, partly due to bad promotion, and also the American public couldn't understand the actors' cockney accents, the sequel was shelved indefinitely.

Trivia

The three Mini Cooper S cars had the following registration plates: red, HMP 729G; white, GPF 146G; blue, LGW 809G. These registration plates were not street legal, as the movie was shot in 1968 (F plate), but the registration plates were post-dated to coincide with the movie's release date of 1969. These registration plates may well exist today and be allocated on other vehicles.

The aforementioned three Mini Cooper S vehicles were used in the movie stunt scenes. However, when they are pushed out of the bus over the mountainside, they are not the same Coopers; they were replaced with three standard Mini cars dressed up to look like three classic Coopers.

The plot has the British gang stealing £4 million pounds in gold bullion. Even split between three Mini Coopers and with

two passengers in each escaping car, that would mean each Mini Cooper would be carrying more than one and a half times its own weight, making them highly unlikely to jump over roofs.

Quincy Jones wrote the music, with Don Black providing the lyrics. The title song, *On Days Like These*, was to be sung in English, but Don wanted a few of the opening lines sung in Italian. So Don Black's sister, who spoke fluent Italian, obliged by translating these lyrics, which were beautifully sung by Matt Monro.

When Noel Coward as jailed crime boss Mr Bridger hears of the success of his sponsored British heist, he is applauded by fellow inmates all clapping in unison and cheering, "England!" These scenes were filmed in an actual prison at Kilmainham Gaol in Dublin, Ireland, with the actual inmates all used as extras. These prisoners were mostly Irish, including a few actual members of the IRA, and consequently no friend of the British Government. However, each and every one of the inmates was happy to help the film-makers and chant for England for the good of the movie plot.

While filming the encounter with the Italian Mafia, the three sports cars are to be shoved off the mountain road. When the silver Aston Martin DB4 is pushed off the cliff, it was supposed to explode halfway down the mountain. However, the special effects team got their timing wrong and it exploded near the top, almost injuring a few of the crew. That scene had to be re-filmed, but they only had the one (now destroyed) DB4. So the crew searched for miles around, but couldn't find a replacement. What they did find was a similar silver Lancia Flaminia 3C with a black vinyl roof. The special effects crew changed the headlamps, added some features and touched up with silver paint here and there. In the movie edited scene, it is the Lancia Flaminia doubling for the DB4 that is shoved off the mountaintop road.

Fiat offered the movie produces £40,000 to shoot the movie replacing the Minis with Fiat cars. However, as *The*

Italian Job was a pro-British morale-boosting movie, they politely refused, and kept the British Mini Coopers. Nonetheless, Fiat were very co-operative during production, and get a thank you on the end credits. Incidentally, BMC (who charged for the Minis used) are not thanked or mentioned in the credits.

The bus was embossed down both sides and the rear with the words 'Charlie Crocker Tours'.

There was a deleted scene where the three Coopers and three police cars drive around in an indoor hanger, in what was an intended 'dance scene', to the music of *The Blue Danube*. It was a well-choreographed sequence, but this scene was cut from the film, as it was thought to slow down the otherwise exciting car chase.

In the car chase sequence, you can see the three Mini Coopers driving up a ramp of a building under construction, closely followed by the Italian police car. This building under construction was the new Turin Air Museum. I often wondered why the Italian police car just didn't wait and block their escape at the bottom of the ramp. The Minis would have nowhere to escape, but then that would spoil the movie's plot.

The Kirrie Job

At the end of the car chase, the three Mini Cooper S cars drive up ramps into the back of a moving bus to conceal themselves and evade capture (after all, the Italian police are looking for three Minis, not a bus).

The bus used for filming was a 1964 Bedford Val 14 Harrington. This was a unique bus with a double axle and four turning wheels at the front. After filming was finished, the bus had its rear opening doors welded shut, and passenger seats were replaced. The bus then went back into service, mainly in Scotland, and, from September 1973 to 1979, the log book states it was purchased by James Meffan, a bus operator in Kirriemuir, Angus, who often used the bus for

school runs. Some people from Angus, especially the folk of Kirriemuir area, may well have travelled on this famous bus, on a school trip, or perhaps private hire.

Michael Caine, relaxing between takes

The James Meffan Bus Company sold the bus in 1979. From then on, the bus was owned by several people, getting converted to transport cars and, at one time, even a horse box. By the late '80s, the bus was showing its age, and was finally sold for scrap in 1990 to a scrap dealer in Mount Flurie near Fife. If I can use another famous line often credited to Michael Caine... "Not a lotta people know that..."

The Bus History

ALR453B Bedfod VAL14 Harrington C52F
 Chassis No. 1370
 Body No. 2979
 Italian Job **bus logbook (compiled by John Wakefield)**
 6/64 new to Batten (grey green) London N16
 9/66 Arlington (dealer)

3/68 Paramount Films converted to car transporter and used in the film *The Italian Job*

5/69 William Marshall, Blackpool converted back to a coach

7/71 Edmund Birch, Liverpool in Wendy's Coaches livery

2/73 Andrew Drummond, Heart Hill (dealer)

9/73 James Meffan, Kirriemuir

-/79 Archie Cromar Bridge Garage, Anstruther, converted to a racing car transporter with front section as living accommodation. Archie was a successful formula Ford racing driver who was sponsored by The Craws Nest Hotel, Anstruther and, although their name appeared on it, they did not own it.

c1983/4 Raymond Gatherham, Edenside Riding School, Anstruther as a horsebox

Bill Davie, a motorcycle sidecar racer of Strathmiglo, went to IoM TT with it in 1986

By 1990, broken up. Bill Davie sold it to a scrap dealer at Mount Flurie near Fife.

When Kylie Came to Town (I Should Be so Lucky)

During the 1980s, Radio Tay disc jockey Ally Bally bought the discotheque at the seafront on the former site on the outdoor bathing pool, formerly known as Smokey's; he renamed it Bally's. I would often go there and take photographs of the many celebrities he would book to appear. Some were singing artists, while others might be actors from popular TV shows at the time, such as *Brookside* and the Australian show, *Neighbours*. I remember on one occasion Jason Donovan was booked to appear. Jason was not only an actor in the show *Neighbours*, but thanks to the hit making record producers Stock, Aitken and Waterman had also become a pop singer. Jason was a very handsome young man and, due to his popularity on the hit TV show *Neighbours* and his newly discovered singing voice and associated hit records, he had

become a very sought-after teenage idol. No doubt his photo posters adorned many a teenage girl's bedroom wall.

It was around 1987 and at the height of Jason Donovan's popularity when Ally Bally booked him to appear at Bally's right here in Arbroath. A capacity crowd (mostly teenage girls) had turned up to see their idol, and I, together with local photographer Jim Ratcliffe, was hanging around the reception area waiting for him to arrive. Jim was there to take photographs for the *Courier*, while I was there for the *Arbroath Herald*, both local newspapers. I have to say, at this point, neither Jim Ratcliffe nor I had our cameras ready. We both knew that we were going to get shots of him on stage and a few with his fans, so we didn't see the need to have our

cameras ready; why should we, for what we believed would be him just walking in the front door with his entourage? What happened next was (for me, anyway) most unexpected. Firstly, a few security guys, then his tour promoter, then, to my utter surprise, in walked a small, pretty girl. "Oh my God," I said. "Look who it is."

Somebody asked, "Who is that?" I remember looking at him as if to say 'where have you been lately'. It was, of course, none other than the beautiful and petite singing sensation, Kylie Minogue.

Kylie was also an actress from *Neighbours*, and, in fact, she and Jason's characters from the show had married each other. Kylie, too, had branched out to singing and she was also from the stable of Stock, Aitken and Waterman's hit factory. Kylie and Jason even had a hit record together singing as a duet, *Especially for You*, which was a huge hit recording.

Anyway, back to Bally's in 1987 and Jason Donovan. He was about to perform on stage and meet his fans, while Kylie was just there to watch from the background. Probably on advice from their managers, they both denied in public that they were in a relationship. It was the common belief at the time that it was better for the fans to think their idols were single and available for romance, and much better for their career, in the belief that an unattached artist would sell more records. However, it was obvious to me and everybody else that Jason and Kylie were a couple in a relationship. It turned out that my only chance to photograph them close together was as they arrived that evening through the entrance to Bally's nightclub. If only I had my camera ready, I might have made a few pounds selling the scoop photos to newspapers. Kylie made sure she was a good distance away from Jason during their time in Bally's, so there was not an opportunity for me to photograph them together.

I got a few photographs of Jason meeting fans on stage and, during this time, Kylie was seated with four local lads almost unobserved, watching her boyfriend from the back of the

nightclub. It was later that Ally Bally told me that he bought Kylie a drink from the bar and, at the same time, asked her to sign the discotheque's visitors book. To which she replied in her drawn-out Australian accent, "Sorry, I'm having an autograph-free day today." To this, rather amusingly, Ally said he asked for his drink back. Once the couple had retired to the green room, Ally mentioned to the four lads who had been sitting next to Kylie, "Did you know who that was you were seated next to?"

"No," said the lads, who, by this time, had consumed a few drinks. It seemed that the Arbroath lads had no idea they had been sitting next to Kylie Minogue.

I had called a few newspapers to say Kylie was here with Jason and I was asked to get photographs of them together. So, armed with my camera, I went into paparazzi mode and waited in the car park just outside the main entrance, hoping for my chance. However, I was spotted by their security team and they exited out of a side door. So I missed my chance. Not long after that, they were open about their relationship, which lasted a while before they separated. I suppose Kylie fancied a 'new sensation', because the Ozzie songstress started dating Michael Hutchence of the rock group *INXS*, but that's a whole new story.

Jason's popularity waned over the years, but Kylie Minogue continues to be a huge star. Although she has had limited success acting in mainstream movies, her singing career has been stratospheric, selling millions of albums. Kylie has also branched out, increasing her fortune from designing and selling her range of lingerie and perfume. Well done, that girl. I will never forget Kylie and her brief visit to Arbroath, and, if I was to meet her again, I would just tell her straight, I just 'can't get you out of my head'.

ART FOR ART'S SAKE

Artist Jilly Henderson, remembering Alice in Wonderland

Artist Kerry Bews displaying her work

Arbroath Library, Art display

Mary-Ann Orr with her tribute to the NHS at Auchmithie

Fun day at Auchmithie

AOS Art festival

Angus College Art students

The Fishwives at Auchmithie Art Festival

Disney Princesses

Red Rock Music students at Hospital Field House

Pioneering women at the Signal Tower Museum

Angus Music festival

Artist, Rikki Craig with his social distance painting

Artist, Karen Elliot with her Auchmithie beach creation

THE WELL READ LICHTIE

We Loved the Book

"What a wealth of wonderful stories about places and people in and around Arbroath – I think every household in Arbroath should have a copy – I hope too that it manages to reach Arbroathians across the world, as it paints such a wonderful picture of the town they or their ancestors left behind." – **Georgiana Osborne, Lord Lieutenant of Angus (2001–2019)**

"I'd love to read your book." – **TV personality Lorraine Kelly**

"It really is a remarkable piece of work. There is something in it for everyone. One can dip in and out of the book and still find items of interest, time after time." – **Major General Andrew Whitehead CB DSO**

"I am very much enjoying your book." – **John Swinney, MSP for Perthshire North**

"*The Well Read Lichtie* is a treasure chest filled with gems of stories and photographs which portrays Arbroath, the surrounding area and its people. It is an encyclopaedia of knowledge for anyone who wishes to have a knowledge of Arbroath, its hinterland and folk who make it a unique part of Angus." – **Ronnie Proctor MBE FSA, Scot. Provost of Angus**

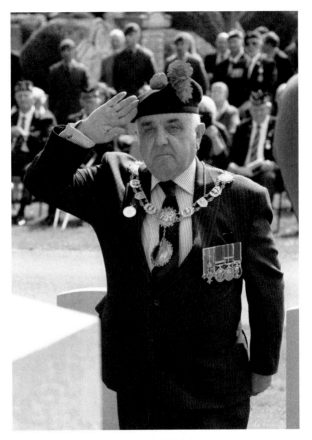

Major Ronnie Proctor MBE FSA, Scot. Provost of Angus

"I have thoroughly enjoyed reading your book of stories and anecdotes of my adopted home town. I found it very interesting; it has helped me more understand the character that has evolved to make Arbroath what it is today." – **Doctor Arnold Hornsby**

"I'm descended from Arbroath folk although born and living in New Zealand, and I found this lovely book fascinating. It's packed full of stories and photos from Arbroath past and present, and filled many a gap in my knowledge of the wee town and surrounding area.

255

"It is clearly well researched, but Wallace imparts the research with a sure and light hand, neither overwhelming nor ever boring. The production values are very high for a publication of this sort, and the photographs outstanding and plentiful.

"The breadth of coverage is astonishing – history, geography, natural and built environment, and of course the people. The locals and personalities. There's coverage of the military associations with the town, sporting greats, entertainment and Industry.

"I found *The Well Read Lichtie* a total delight." – **Gordon Findlay, New Zealand**

"Hi Wallace, your book *The Well Read Lichtie* arrived. Danny and I have been looking through it. It's Fab'. Love all the pictures; nice to have something so familiar from home while we are over here." – **Jenna Swankie, Sydney, Australia**

"The book is very nice; today arrived by my parents. They are pleased for it." – **Lenka Matousova, Děčín, Czech Republic**

"A spectacular read that captures the beauty of our wonderful town brilliantly. Rich in history, interesting facts, quirky stories and well known faces. The book helps us to realise the uniqueness of our people, their talents and gifts all of which should be celebrated and each page of "The Well Read Lichtie" helps us do just that".
Lois Speed - Arbroath Independent Councillor.

"We are reading it now; it is great." – **Vendulka Mulacova, Alicante, Spain**

"A must read, not just for the people of Arbroath, but Red Lichties all over the world." – **Former Arbroath Boxing Club Junior and Senior Midlands Champion, now leader of Angus Council, David Fairweather**

"I have just finished reading *The Well Read Lichtie*. It has totally amazing stories about Arbroath. I love showing my students in Japan the photos from the book. Well done Wallace. I am looking forward to the next book." – **Tracy Holland, Yokohama, Japan**

"Hey Wallace, It was an interesting read! A great book to flick through every now and then." – **Ant Middleton, former serving Royal Marine/Special Boat Service (TVs SAS)**

"*The Well Read Lichtie* is the first book ever I got with the author's signature. I was in Scotland for a year and a half, and travelled a bit, but when I started to read the book with all the stories in it, I could not stop reading. So many interesting things. I found out about places I have been passing by.

Amazing book, I loved reading it. Thank you Wallace." – **Eva Briede, Cēsis, Latvia**

The Old Wooden Cross

Long before the military base of Condor by Arbroath was home to the 45 Commando Group, it was home to a Royal Naval air station. The runways were in tip-top condition, as flights regularly came and went. Indeed, I have some fabulous aerial photographs of Arbroath by those pilots and crew of the Fleet Air Arm. It was with some sadness that, on 27 February 1943, one aircraft, a Fairey Swordfish torpedo bomber, took off from RN Condor on what should have been a routine instrument check training flight.

On board this flight were Sub-Lieutenants Arnold Waterhouse and Brian Honeyman; both these men were only 21 years old. Not long after take-off, the pilot radioed that he was experiencing difficulties with the aircraft and he was attempting to return to base. Unfortunately, soon after, the

Swordfish nosedived into a field at Gask farm near Letham, Angus, approximately four flying miles from Condor. A farmer was working in an adjacent field and ran over to see if he could help. However, both Waterhouse and Honeyman had been killed in the crash. Sub-Lt Waterhouse's family arranged for a wooden cross to be erected at the crash site; however, over the years, the cross rotted away. A metal detectorist found the original brass plaque from the wooden cross while scouring the field. A more permanent stone cross was placed at the site and the brass plaque replaced. This new stone memorial was financed by nephews Andrew and Keith Waterhouse, who had never even met their Uncle Arnold Waterhouse. This stone memorial cross still stands today on a field at Gask farm, now owned by Angus Councillor David Lumgair, who also happens to be a descendant of the farmer who ran over to the air crash in 1943.

My photograph shows a memorial service that took place at the crash site at Gask farm.

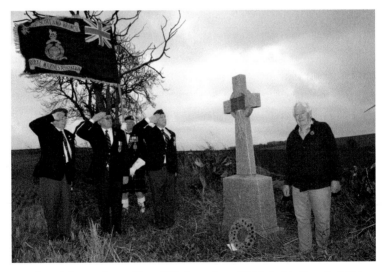

Left to right are: Stuart Thom RM, Steve Russell RM, Roddy Campbell RM, Doug Carstairs RM and councillor/farmer David Lumgair.

RULE BRITANNIA

In the late 1940s, the British Government decided to build a royal yacht and the £2 million pound contract was awarded to John Brown & Company Shipyard in Clydebank, Scotland. Prior to the launch, the name of the royal yacht was a tightly guarded secret, known only to a chosen few. Her Majesty the Queen attended the launching ceremony and was to pull the lever, which swung the bottle of Empire wine to smash on the ship's bow. As Her Majesty did so, she said the words, "I name this ship Britannia [which drew cheers of approval from the crowds]. God bless her and all who sail on her." So started Britannia's long and illustrious career as she was launched on 16 April 1952.

Over the decades, HMY Britannia has circumnavigated the globe several times, taking various members of the royal family around the Commonwealth and other countries. The luxurious Britannia has been host to royal honeymoons and state visits, where the Queen's personal chefs produced banquets, unsurpassed in any fancy five-star hotel. The ship was designed with separate engineer and crew compartments, which allowed the crew to negotiate around the ship, but simultaneously made it unlikely that sailors on their day-to-day duty would ever bump into members of the royal family or any high-profile guests on board; only high-ranking officers had regular contact with VIPs on board. While Britannia had royal family members on board, the yachtsmen (crew) were allowed to break navy protocol by wearing plimsolls (not usually part of the Royal Navy uniform). Shouting and running around deck was not permitted, just in case the noise

interrupted the royal family relaxing on board, and crew usually communicated to each other using hand signals. On the off chance that a yachtsman met a member of the royal family (for instance, in a passageway), the protocol was that the yachtsman kept silent, move to one side and stand perfectly still, while allowing the royal party to pass.

The Falklands War

In 1982, the British sovereign islands of the Falklands group were invaded by the Argentines, and British Prime Minister Margaret Thatcher ordered a task force of Royal Navy ships to set sail to the South Atlantic with direct orders to retake the Falkland Islands. Britain was, for all intents and purposes, at war with Argentina. Ships from the merchant navy and passenger liners were also modified and temporarily taken over by the Royal Navy. This official action is called STUFT (Ships Taken Up From Trade). Much has been said as to why the royal Yacht, Britannia, was not part of the task force. Perhaps the Queen ordered that her beloved yacht not be allowed to go to war. This seems unlikely, considering her son, Prince Andrew, travelled with the task force serving as a helicopter pilot during the Falklands war. Britannia certainly would have been a high-profile target, and quite a coup for the Argentines to sink the royal yacht, and admittedly it would have been a terrible loss to British morale had Britannia gone with the task force and been attacked and sunk. The truth is much simpler.

The real reason that HMY Britannia was not STUFT as part of the naval task force is that Britannia was fitted with two Pametrada steam engines not compatible with the fuel of other naval ships in the task force. Had Britannia travelled south with the rest of the British fleet sailing to the Falklands, she would have required her very own fuel tanker to accompany her. The logistics were just not feasible and, although the idea of Britannia going to the Falklands was

discussed, the idea was very quickly dropped. So there it was then, why the royal yacht had no part in the Falklands War. However, four years later, in 1986, she was caught up in her own conflict, which made international headlines.

Britannia to the Rescue

An uprising was taking place in Aden between government troops and rebellious students. As usual in this type of conflict, many innocent civilians were caught up in the fighting. The refugees gathered at the beach, which was deemed to be the safest area, and waited for rescue. The South Yemen Government refused to allow warships within a 12-mile zone, but a rescue mission began, with Russia taking charge. As the royal yacht, Britannia, was registered as a reserve hospital ship, she was granted permission to enter the 12-mile exclusion zone. Many refugees from various nationalities found themselves stranded on the beach, surrounded by infighting. They all waited patiently for rescue from the flotilla of ships anchored offshore. The Russians initially took charge of the rescue operation, but it soon became apparent that they were only interested in recovering their own people, preventing stranded people from other countries from entering their boats. Britannia took up position, anchored off the Abyan beach. While she defiantly and proudly flew the royal naval white ensign, five of her Liberty boats were lowered and headed for the beach. One can imagine the disbelief of those stranded on the beach on hearing that their rescue vessel, and saviour, was to be Her Majesty's royal yacht, Britannia.

On board each of the five Liberty boats were medics and sailors and, as they landed on the beach, most refugees were anxious to board the boats and get the hell off that beach, as, by this time, government tanks and heavily armed rebels were shooting at each other nearby and getting closer by the minute. A British officer from Britannia stood quite defiant and calmly took command as beach master. He was Lieutenant Easson. In

his white naval uniform of cap, top and shorts, with nothing more than a side arm, he calmly directed refugees onto his small boats as ordinance exploded nearby. After the multinational refugees were transported to Britannia, they were well looked after by the Royal Navy. The refugees, who mostly escaped with nothing more than the clothes on their backs, were given food, drinks and blankets and, while they lay scattered around the ship, occupying most decks and various rooms, at least now they were all relieved to be in safe hands of the Royal Navy. They were taken to the safe port of Djibouti. Once survivors were safely escorted off the ship, Britannia again returned to Abyan beach to pick up more refugees. In total, the royal yacht, Britannia, had successfully rescued 1,082 refugees from 52 nationalities off the dangerous beach.

At the end of this mission, the royal yacht sailed on to New Zealand to pick up Her Majesty the Queen and Prince Phillip, who had been on a state visit. A few weeks later, on returning to the UK, it was announced that, for his bravery as beach master, Lieutenant Easson had been awarded The Queen's Commendation.

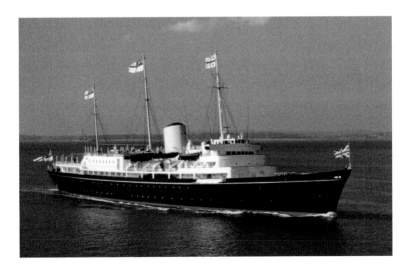

Decommissioning

The royal yacht, Britannia, visited many countries, playing host to foreign dignitaries, with Her Majesty holding lavish state dinners on board, boosting British export trade and earning millions of pounds for the British economy. However, back in the UK, there was some discontent. The populous started to question how much the royal family was costing the British taxpayer. Politicians under pressure have to listen to the voting public and, when they looked into the annual running costs of Britannia, serious discussions took place. The royal yacht was due for a refit and her engines were long overdue for replacement. The government faced quite a dilemma, with a decision of ploughing millions of pounds into a massive refit, which no doubt would have made the voting public discontent, or informing Her Majesty that her yacht was to be decommissioned. Her Majesty was well aware of how her subjects were questioning the cost of the royal family. A few years previously, the Queen had agreed to pay tax on her earnings. So it was then that meetings were held in the government (of which Her Majesty was kept informed), and the ultimate decision was made that Britannia would be decommissioned. Her Majesty was there at the launch, and Her Majesty was there on 11 December 1997 when the royal yacht, Britannia, sailed into Portsmouth Dockyard to be decommissioned. As Her Majesty watched Britannia, surely happy memories came flooding back and, in a rare show of emotion, the Queen was seen to wipe away a tear as she said her final farewell to her beloved floating home.

Back in 1973, when I was a young and naive naval cadet, I got a chance to stay several days on board the navy training vessel HMFT (Her Majesty's Fleet Tender) Bembridge. I got my travel papers and, proudly dressed in my naval uniform, travelled by train down to London. I had to change trains and go to Portsmouth. While in London, I spotted two other guys

around my age also dressed in their navy uniform. We spoke, and it turned out the three of us were joining the Bembridge crew. It was a long time ago and I cannot remember the exact dock number, but that is where we had to go to join ship. We all had our kit bags slung over our shoulders as we headed down the dock searching for the Bembridge. Bearing in mind how naive and inexperienced we were, I suddenly piped up, "Over there; look, it's flying the white ensign (Royal Navy flag) and it even has bunting to welcome us. How cool is that?"

We all started walking up the gangplank, getting about halfway across when an officer shouted, "And where the hell do you think you ratings are going?"

I rather sheepishly replied, "Is this HMFT Bembridge, sir? We have papers to join ship."

"No, it's ruddy well not; this is the royal yacht, Britannia," he replied rather sternly.

"Any idea, sir, where the Bembridge is docked"?"

The officer pointed as he replied, "I believe that's the Bembridge over there."

We all swung around in unison and my heart sank as our eyes fell on the navy's smallest pile of rust bucket crap, which surprised me it was still afloat. We boarded and handed our papers to the commanding officer, and we were shown to our bunks below deck at the bow of the ship. I got the distinct impression that, to the captain, having us on board was more bother than what we were worth, especially when we were given our first duties, and ordered to stand at the bow as lookouts and inform him of any ships approaching. As he gave us these orders, I was looking over his shoulder and high up there on the main mast was at least two working radar sets spinning around. However, we did as we were ordered and stood at the bow. We had heard on the grapevine we might get a trip to Paris, but that was not to be; we sailed on some exercise to Hastings further up the coast. That night, while we lay in our bunks, to much hilarity, one of the other guys broke

wind with enormous ferocity. So much for life on the ocean wave. *Kill me now,* I thought. *Kill me now.*

Floating Museum

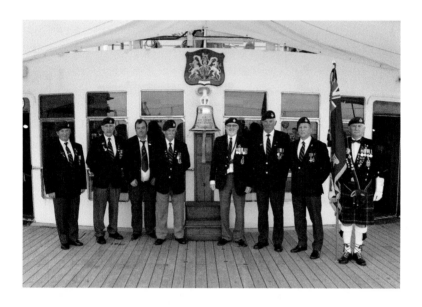

The royal yacht, Britannia, is now a floating museum on permanent berth at Ocean Terminal Edinburgh. As the photographer with the East of Scotland branch of the Royal Marines Association, I went with them on the annual trip down to Edinburgh to photograph members of the branch taking part in the Thomas Peck Hunter memorial service near the terminal. After taking part in the memorial parade, branch member and former Britannia yachtsman, Sergeant Chris Frith RM, arranged for us to tour the royal yacht. Normally, tourists can get a conducted tour or use the handheld interactive speaker system to get a detailed informative vocal introduction as they proceed around the vessel. Not for us, though. Chris was able to take us around various parts of the royal yacht, and regaled us with fabulous tales of his time on board.

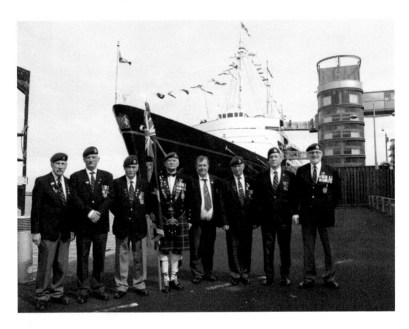

The adjoining photographs show members of the East of Scotland branch of the Royal Marines Association getting a conducted tour by Sergeant Chris Frith RM, who served on Britannia from the mid-1970s to 1980.

Britannia may no longer rules the waves, but this grand old lady continues to be a huge tourist attraction and is well worth a visit.

HEY GOOD LOOKIN' - WHAT'S COOKIN'?

I was very proud of my former girlfriend, Dita, when she entered and won a cooking contest run by a well-known Scottish newspaper.

The rule for the competition was to follow one of celebrity Chef Nick Nairn's recipes, cook the dish, then photograph the meal and send in a photo of your cooked dish. Dita did just that and won the top prize of a cooking course at one of Nick Nairn's cooking schools, which she attended in Aberdeen.

Pictured are Dita and Ruth Ferrier at our home in Arbroath, with her winning entry of a Nick Nairn cheesecake, which, by the way, was delicious.

Top Chefs in Arbroath

I received a tip-off that a few top chefs were in Arbroath at the Boathouse Restaurant near the harbour. I went down to check it out and, sure enough, Andrew Fairley and Michel Roux Jr were inside with a film crew, all having fish and chips. They had been in Angus recording a television advert for potatoes, and decided to end the day with a meal at the Arbroath restaurant. They were made aware of my presence outside and got word to me that they would pose for a photo once they had enjoyed their meal. As I hovered around the main entrance, the restaurant owner, Marco, made sure I was well

supplied with cups of tea, which I highly appreciated. I had contacted the *Courier* newspaper and the picture editor said he would keep space for the photo, although I was well aware that the publishing deadline was fast approaching. Finally, the top chefs came over and posed for me, and I dashed off to e-mail the photo to the *Courier*, which they published in the following day's edition.

Sadly, since this photo was taken, Andrew Fairley is no longer with us. Andrew, who ran his Michelin two-star eatery at Gleneagles, died of a brain tumour on 22 January 2019.

Andrew Fairley – Marco – Michel Roux Jr.

The 2014 MasterChef winner, Jamie Scott, gave a cooking demonstration at the Arbroath Seafest.

Nick Nairn has also visited Arbroath and introduced the Arbroath Seafest on a show that was recorded for the BBC.

REV DR MARTIN FAIR

Martin Fair was born in Glasgow and educated at Woodfarm High School. He did his initial training at the faculty of divinity of Glasgow University, then studied for his Doctorate of Ministry, at Princeton Theological Seminary in New Jersey. Martin was appointed to a church in sunny Bermuda, where he stayed for two years. Rev Fair first came to Arbroath back in 1992 after he was officially ordained to take over the ministry at St Andrews Church. In that time, he has become a highly valued member of the Red Lichtie community. Rev Fair has been a great comfort to families of the bereaved, and

married many a young couple within St Andrews Church. As for the church itself, Martin went about modernising his sermons with a live musical band, and installing a projector to spread images clearly visible on a large screen, and also facilities such as loudspeakers and microphones to enhance listening. These have been of great assistance to those who endure poor vision or are hard of hearing.

In 2006, Rev Fair took over an old shop in Fisheracre and started the Havilah Project, which has a drop-in centre called Community Spirit. This small seed started by Rev Fair has grown into a fabulous place to reach out and encourage anybody who feels excluded or isolated, or who has low self-esteem combined with mental health issues and drug addiction. On a similar theme, Rev Fair organised the Wellbeing Gardening group, which continues to blossom today. Another charity close to Martin's heart was the Malawi Project, in which he rallied around church members to send medicines to children and adolescents in Africa. More recently, in the Covid-19 crisis that still has some of us housebound, Martin held a regular quiz online, which kept us all amused with our thinking caps on. Rev Fair married his lovely wife, Elaine, in July 1987 and they are blessed with three children, Callum, Andrew and Fraser.

In May 2020, Rev Martin Fair had the honour of being appointed as the Moderator of the General Assembly of the Church of Scotland. We congratulate you, Rev Fair.

DANCE YOURSELF DIZZY

Dancers at RM Condor

St Andrew's Church Concert

Irish singing sensation Margaret Keys with the Arbroath Male Voice Choir

Highland Dancing at the Webster Theatre

275

JJ Christine with her dancers

Dance JC Exhibition

Arbroath Seafest Highland Dancing

All that Jazz

The fabulous Chloe Leuchars,
Hula Girl

Highland Dancers at the Harbour

Angus Minstrels

Notorious Dance - winning team

Angus Minstrels

A BEAUTIFUL MIND

The golden age of Hollywood saw many beautiful women walk through the studio doors; some would make a career for themselves, while most would fade away. Those starlets lucky enough to succeed were in high demand to appear in movies. At the time, being attractive was compulsory; being blonde with an ample bosom also helped a starlet to get a contract. However, for me, one actress stood out above the others, not because of her looks, although she was very attractive, but because of her genius mind. She was born Hedwig Eva Maria Kiesier on 9 November 1914 in Vienna, Austria. She went on to become an actress, firstly in Czechoslovakia, where, in 1933, she made a controversial movie called *Ecstasy* in which she gave an outstanding performance, acting the first orgasm ever shown on screen.

She married very young at 18 years old, to a much older man. This man was 33-year-old Fritz Mandl, an ammunitions manufacturer of considerable wealth. Among his shady customers were none other than Adolf Hitler and Mussolini. As Hedwig was of Jewish origin, and the fact that Fritz Mandl was very possessive of his young wife, Hedwig felt she had to escape this marriage and fled to London. While in the English capitol, she met with Louise B. Mayer, who was the head of Metro Goldwyn Mayer, and who was in London scouting for new talent. Louise B. Mayer was so impressed with Hedwig that he immediately offered her a contract. (Talk about being in the right place at the right time.) So she packed her things and moved to Hollywood, where she changed her name to Hedy Lamarr. After appearing in several movies, Hedy Lamarr

was becoming quite the star. She went on to act with many leading male stars of the time, including James Stewart, Spencer Tracy, Clarke Gable, Walter Pigeon and, in one of her most famous roles, *Samson and Delilah*, starring alongside Victor Mature.

Hedy Lamarr was very intelligent and spoke several languages. To relieve boredom between movies, Hedy became somewhat of an inventor. She had no formal training in either science or engineering, yet she was always doodling and writing down ideas for projects. Hedy invented a small cola-tasting tablet that, when dropped into a glass of water fizzed away to produce an instant cola. She also designed a better-working

traffic light system to ease congestion on the roads. Hedy was a close friend of the multimillionaire Howard Hughes and helped him design an aircraft with less drag over the wings. Hedy explained that she thought aircraft of the day were very box-like in shape, so: "I began by looking at the shape of the birds' wings and certain fish and I was fascinated by how quickly fish could move through water without causing a ripple. So I redesigned the profile shape of an aircraft, which would produce less drag, and gave it to Howard Hughes. He was so impressed he provided me with finance and a team of engineers, who were at my disposal."

Hedy Lamarr realised that American submarines during World War Two fired torpedoes that homed in on a target ship using a radio frequency. These frequencies, however, could easily be interrupted and jammed by the enemy, causing the torpedo to miss its intended target. Hedy Lamarr invented a sequence of frequency hopping signals that skipped around every few seconds, rendering it almost impossible for the signal to be jammed. This would eventually be named 'spread spectrum'. Hedy Lamarr patented her idea and, together with drawings, presented the idea to the US Military. However, the US Military did not take her seriously and, as she was of Jewish Austrian origin, deemed her an 'enemy alien'. Hollywood equally never took her inventing seriously and, during the war years, did not support Hedy in her innovative inventions; they instead had her touring the country at conventions, exploiting her glamorous looks and fame as an actress to boost the sale of war bonds.

Similarly to what still happens today, as actors (especially women) grow older and their glamorous looks fade, their acting roles dry up. In the 1970s, in an attempt to regain her youth, Hedy Lamarr underwent a series of plastic surgery and facelifts, with disastrous results. Hedy lost her confidence and became somewhat of a recluse, withdrawing from society and rarely venturing out of her home. She no longer gave interviews, other than those over the telephone. Hedy was

invited to accept an award she had won – she didn't go, of course, but sent her son instead. He was actually on stage at the microphone just starting his speech on behalf of his mother when he was handed a phone. He stopped speaking and, while taking the phone call, apologised to the audience, saying it was his mom calling. Everybody laughed as they heard him say, "I'm accepting it now, Mom; I'm on stage." He passed on his mother's thanks and regards, and it must have warmed her heart to hear the audience clapping and cheering for her.

It was 1963 before the US Military finally used her spread spectrum invention during the Cuban Missile Crisis, but Hedy Lamarr was never compensated financially.

Today, her spread spectrum invention has been modified, developed and incorporated in so many of our everyday modern technology, which we all take for granted, such as GPS, Wi-Fi and Bluetooth, to name but a few. It has been estimated that, had Hedy Lamarr's patent been approved and accepted, her net worth would be in excess of 20 billion pounds.

Hedy Lamarr passed away aged 85 years on 19 January 2000 from pulmonary heart disease. As per her final wishes, her son, Anthony Loder, scattered her ashes in Austria's Vienna Woods. Today, an honorary gravestone to Hedy Lamarr stands proudly in Vienna's Central Cemetery. Hedy was a wonderfully talented actress, an icon from the golden age of Hollywood. She was indeed a beautiful woman, with an equally beautiful mind.

HOLLYWOOD NIGHTS

"America and Britain are two nations separated by a common language." – A famous quote jointly credited to George Bernard Shaw and Oscar Wilde. This quote is certainly true when it comes to America and their understanding of Shakespeare.

When *Henry V* (Henry 5th) was shown to the American audience, it was often called 'Henry Vee'. Also, when a certain Hollywood studio considered filming 'Richard III' (Richard 3rd), studio executives thought about it, but then pulled the plug and cancelled the project, as they said no one would be interested in paying to see 'Richard III' before first seeing 'Richard I and II'.

I'm sure there are countless amusing stories from Hollywood over the years. Following are some that I enjoyed.

Cleopatra

In the late 1950s, the studio 20th Century Fox was in financial trouble after a succession of box office flops. Sifting through some old scripts, they found the movie *Cleopatra*, which had been a big hit for them in the 1920s, although that had been a silent movie. A script was written and now a filming location was sought. They firstly decided to shoot the movie at Pinewood Studios in London. Filming in Britain offered the production many benefits, including financial subsidies, provided they used mainly British technicians, cast and crew. It initially made financial sense. Many leading ladies at the time were considered for the lead role, including Susan Hayward and Joan Collins, who

were both under contract with 20th Century Fox. Joan Collins even filmed a screen test, but director Rouben Manoulian wanted Liz Taylor. Manoulian managed to trace Liz Taylor and called her on the phone, offering the part of Cleopatra. Liz, however, scoffed at the idea and said that was ridiculous and she didn't feel right for that part. Manoulian pressed her to reconsider. listening in the background was Liz Taylor's then husband, Eddie Fisher, who said, "Tell him you will do it for a million dollars." Partly joking, Liz said she would play Cleopatra for a million dollars. This was an unprecedented sum of money for an actor to demand in those days, but, to her complete surprise, Manoulian agreed.

Partly due to bad weather and Liz Taylor constantly falling ill during production, the film soon ran over budget and Manoulian was fired and replaced by Director Joseph Mankiewicz. The new director, Mankiewicz, took advantage of the fact his leading lady was recuperating from her illness in the States, and used the delay to rewrite the script. He also decided to move location to the warmer climate of Italy. The set at Pinewood was mostly dismantled, although a few large set pieces were left behind.

Once Liz Taylor was fully recovered from her illness, filming began in earnest. Still more delays occurred and some actors were hanging around for days doing nothing. Two actors, Richard Burton and Roddy McDowall, nipped over to France and got a small part in the war movie, *The Longest Day*, before flying back to Italy to act in *Cleopatra*. As Liz Taylor's filming schedule began to go over her contractual shooting dates, it cost the studio an extra $50,000 per day to keep her. Then there were the other actors and extras who all required food and bottled water every day. The studio was haemorrhaging money and it was clear to all that this movie had to be a success or it would bankrupt 20th Century Fox. What the movie needed urgently was some good promotion and publicity, and it was handed to them from an unexpected source.

BY DAWN'S EARLY LIGHT

It soon became apparent that Richard Burton and Liz Taylor were having a secret affair with each other. At the time, they were both married to other people and it seems highly likely that their affair was deliberately leaked to the press, and the paparazzi descended on the location to snap the couple at every opportunity. The publicity turned out to be fantastic for the studio and the movie, which, on its 1963 release date, became a box office hit. *Cleopatra* went on to win several awards, including four Oscars.

Carry on Cleo

As for the abandoned period set pieces back at Pinewood, at the time, there was a series of bawdy comedy movies with the prefix of 'Carry On'. Director Gerald Thomas, not one to miss out on a bargain, immediately seized the opportunity to quickly write a script for his next *Carry On* movie, which he called *Carry on Cleo*. They used as much of the abandoned *Cleopatra* set as possible, including a few costumes and weapons.

Pirates of the Caribbean

Under normal circumstances, computer games or funfair rides are conceived after a well-known movie. However, *Pirates of the Caribbean* was a funfair ride at Disneyworld Florida for many years before the eponymous movie was released. The movie even mirrored a few of the themes from the attraction.

Australian actor Geoffrey Rush, who played Captain Hector Barbossa, insisted that any scenes with him involving the monkey should show the monkey sitting on his left shoulder. Geoffrey believed that people watched a movie the same way as they read a book – from left to right. Geoffrey wanted the viewing public to focus on his face first and not be upstaged by a monkey.

Star Trek

William Shatner and Patrick Stewart both performed as captains of the Enterprise. William Shatner played Captain James T. Kirk in the original TV series and, decades later, Patrick Stewart played Captain Jean Luc Picard of the Enterprise in *Star Trek, The Next Generation*. Both actors appeared together as their characters in the 1994 *Star Trek* movie *Generations*. One day while on set, William Shatner said to Patrick Stewart, "Patrick, tomorrow we have a long shoot together where we will spend most of the day riding on horses. It can get very sore spending most of the day in the saddle; let me give you some advice. Underneath your costume, wear women's silk pantyhose [tights]; trust me, by the end of the day you will thank me for it." Well, Patrick, knowing that Bill Shatner owned several horses and had stables at his home, thought he had better take heed of the advice given, and wore silk tights beneath his *Star Trek* uniform. During the following day's long shoot in the saddle, Patrick said to William, "I must say my butt is getting sore; I don't think the tights are much help."

William replied with a smile, "Oh that, I'm afraid I was joking and made that all up..."

True Grit (1969)

The 1969 movie *True Grit* was based on the novel of the same name by Charles Portis. It was filmed in Colorado, in and around the towns of Ouray and Ridgway. Many of the set pieces were left behind and it's possible to see them while visiting various filming locations around the area. Elvis Presley was to be cast as the Texas Ranger La Boeff. However, Presley's manager, Col Tom Parker, insisted that Elvis Presley got top billing, with his name on the titles above John Wayne. Nobody got their name above 'The Duke', so the producers instead offered the part of La Boeff to Glen Campbell, who also sang the movie's theme song.

John Wayne wanted his daughter, Aissa Wayne, to play the part of Matie Ross, but the director refused. Sally Field and singer Karen Carpenter were considered, but the part eventually went to actor Kim Darby.

Bodyguard

We all loved the movie *Bodyguard* starring Kevin Costner and Whitney Houston, but the script had been bouncing about Hollywood for years. The script for *Bodyguard* was originally conceived in the 1960s, and was to star Steve McQueen and Diana Ross as the African American singer. However, the 1960s was a period of racial tensions and producers were nervous about a screen kiss between a black woman and a Caucasian man, so much so that the movie project was shelved indefinitely. The first interracial screen kiss was actually on the TV series *Star Trek*, when William Shatner (as Captain Kirk) kissed Lieutenant Uhura (played by Michelle Nichols) in the 22 November 1968 *Star Trek* episode 'Plato's Stepchildren', which, at the time, caused quite a stir.

007 Stage

In 1967, Pinewood studios filmed two movies back to back with *Chitty Chitty Bang Bang* and James Bond, *You Only Live Twice*. Both movies were based on books by Ian Fleming, both had internal scenes filmed at the Bond Studios at Pinewood, both were produced by Cubby Broccoli and the film crew worked on both movies, as did some of the Bond regulars hired as actors. Desmond Llewellyn, who plays Q (Quartermaster) in the Bond series, was hired to play the scrap dealer in Chitty. Goldfinger himself Gert Frobe played the crazy Baron Bomburst (although his voice was dubbed). Future Bond producer and Cubby's daughter, Barbara Broccoli, was seven years old and played a child extra in Chitty's fairground scene.

In Chitty, when the duchess and king are being chased by children, they escape down a hidden access chute. This chute

was reused in the Bond movie; when James is chasing a Japanese female agent Aki, 007 falls down a chute and lands in a chair in front of Tiger (head of Japanese Intelligence). In *Chitty Chitty Bang Bang*, the vintage car used by Truly Scrumptious has the registration plate CUB 1, which is a little nod to producer Cubby Broccoli.

On Her Majesty's Secret Service

Many countries around the world will have their own secret service agents, spies, informants, call them what you will; even during World War Two, we had agents parachuted behind enemy lines to operate with the resistance on various daring operations. Spies do not get offered the luxury of the Geneva Convention, and many captured agents were tortured and executed. A perfect spy is someone whom you wouldn't give a second glance, someone who is not too good looking, but not too ugly either; that spy should not be tall or too small – just Mr or Mrs Average. Someone who drives the most common car that everybody else drives; someone who just blends in.

I have to admit to being a fan of the James Bond movies; they are great fun, but let's be honest, James Bond would make the worst spy ever. He draws attention to himself by driving top-of-the-range sports cars, he surrounds himself with beautiful women and he stays in top hotels worldwide, where the hotel manager seems to know him by name. That said, I always visit the cinema to watch a Bond movie and, as a kid, I loved all the gadgets issued by Q (Quartermaster branch). Who could forget the Aston Martin DB5 with the machine guns and ejector seat that has appeared in several Bond movies, or how about 'Little Nellie', the WA-116 miniature gyrocopter from the movie *You Only Live Twice*. The gyrocopter was actually flown in the Bond movie by its creator, Wing Commander Ken Wallis RAF DSO MBE Ceng FRAeS. Ken was a World War Two veteran who flew bombers. Ken said that, during filming, he had to wear a short-sleeved

open-necked shirt like Sean Connery had worn for the close-ups. However, flying over those volcanos in Japan at 6,000 feet above sea level was bloody cold.

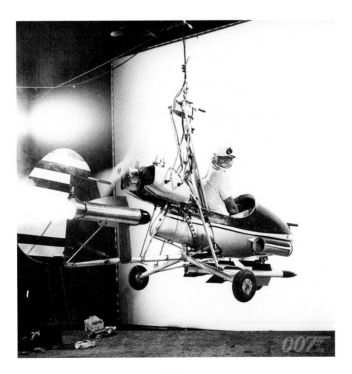

The first photo above shows Ken Wallis sitting in the gyrocopter at an exhibition many years later, and the second photo shows Sean Connery filming his flying scenes in front of a special effects blue screen. Frank Sinatra was asked to sing the film's title song, *You Only Live Twice*, but he turned it down. His daughter, Nancy Sinatra, sang the song instead.

Bond Trivia

The first Bond car used in *Dr No* was a Sunbeam Alpine, which the production company rented for 7/6 shillings per week. As the James Bond franchise had yet to take off and as the budget was tight, Cubby Broccoli actually wrote to the car hire company at the time, complaining about the excessive cost of renting this vehicle. Fast forward 20 years or so and the Bond franchise has really taken off. Desmond Llewelyn (who played Q) said that, once word got out that they were looking for a sports car for the latest Bond movie, one couldn't get into Elstree car park for car manufacturers offering their vehicle for free to be the next 007 car.

Sean Connery's first outing as Bond was in the 1962 movie *Dr No*. His fee was £6,000.

During the filming of *Diamonds are Forever*, Sean Connery got little sleep. During the day, he played golf, while most of the filming was done during the night. Sean also played the slots, and delayed filming on one occasion while he collected his winnings.

While filming *Diamonds are Forever*, Sean Connery dated his co-star, Lana Wood. In my opinion, the best line in all the Bond movies was delivered by gangster Mark Lawrence. When he throws the busty Plenty O'Toole, played by Lana Wood, out of the hotel window, Bond rushes to the window in time to see the screaming girl fall several storeys into the hotel swimming pool. "Nice shot," Bond says. The surprised-looking gangster replies, "I didn't know there was a pool down there."

No doubt over the years there has been several filming mistakes during the Bond franchise. Hopefully, most will go unnoticed. Two stick out in my mind and both involve Sean Connery, although they were not his fault. If you remember *Diamonds are Forever*, actors Sean Connery and Jill St John are being chased by police through the streets of Las Vegas. Bond is driving a Ford Mustang Mach 1. While he drives into a dead-end alleyway, he says to Tiffany Case (Jill St John), "Lean over." Then he drives up a ramp over onto the vehicle's two *right wheels* and continues through the narrow gap. However, as the car exits the alleyway, we see the Mustang magically emerge, showing it's underside, as the car is on its two *left wheels*. That mistake happened as the entrance to the alleyway was filmed at Universal Studios by one director, who then shouted 'cut'. The cast and crew take a two-week break. Filming restarts (with a different director) at an alleyway at Fremont Street Las Vegas, where Bond's car is filmed exiting the alleyway. It was only in the cutting room later that the mistake was noticed. The producers decided not to reshoot the scene and just left it in. A similar continuity mistake happened during the filming of the *Thunderball* remake, *Never Say Never Again*. James Bond (Sean Connery) is standing at a beach bar watching a girl waterskiing on a *single* water ski board. Soon after, she skis up the ramp into Bond's arms, but she is wearing *two* skis. The director just left this mistake in, as he thought nobody would notice.

Q branch have provided James Bond with may innovative gadgets over the years, but, for me, the worst gadget in a Bond movie is from *Moonraker*, when Roger Moore, as Bond, exits the canal in the gondola that turns into a road vehicle (dubbed by the crew as the 'Bondola'). I thought that was ridiculous and too far-fetched.

In the movie *You Only Live Twice*, the script had Sean Connery as 007 get into a white two-seat sports 1967 Toyota 2000 GT with a beautiful Japanese female agent, Aki, performed by the wonderful actor Akiko Wakabayashi. When

filming started, however, it was obvious that Sean (who is over 6ft tall) was having trouble getting into the car because of his height. So the producers asked Toyota for a roofless convertible version of the car. This was Toyota's latest vehicle off the production line, and a convertible version didn't exist, but, realising how much a Bond vehicle could boost sales, they said, "Give us two weeks." True to their word, two weeks later, the white Toyota 2000 GT convertible arrive on set (only two were made), and filming resumed.

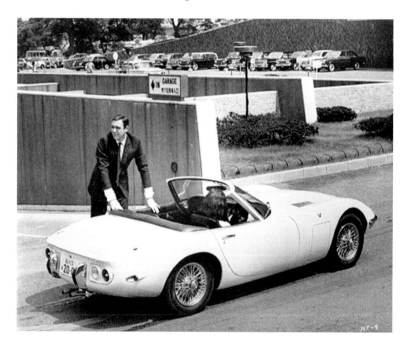

There are less than 150 of these cars left in the world, and each are worth well over a million dollars. One of the convertible 2000 GT cars used in the movie is now in the Toyota museum in Aichi Japan. Current James Bond actor Daniel Craig said his favourite bond vehicle of all the movies was the Toyota 2000 GT.

The two female lead actors in *You Only Live Twice* were Akiko Wakabayashi as Agent Aki and Mia Hama, who played

Kissy Susuki, although Mia was supposed to play Agent Aki, while Akiko was offered the part as Kissy Susuki. Both Japanese actors came to England to learn to speak English, but it was obvious that Akiko had a better command of the English language, so the actors swapped parts. Akiko spoke her own English during the movie, while Mia Hama was over dubbed.

The main actors from the TV series *The Avengers* have all been in Bond Movies. Honor Blackman was Pussy Galore in *Goldfinger*, while both Diana Rigg and Joanna Lumley performed in *On Her Majesty's Secret Service*, with Rigg playing Tracy Bond and Lumley playing the English girl. Patrick Macnee played Bond's helper, Sir Geoffrey Tibbet, in *View to a Kill*.

Until his death, John Barry composed most of the James Bond themes and incidental music, and Shirley Bassey is the only singer who has sung three of the Bond themes, which were *Goldfinger*, *Diamonds are Forever* and *Moonraker*.

The author of the James Bond books, Ian Fleming, was actually a cousin of Christopher Lee, who played the villain Francisco Scaramanga in *The Man with the Golden Gun*. Ian Fleming himself has a cameo in *From Russia with Love* – just after Bond and Tatiana jump off the Orient Express, Ian Fleming can be seen standing next to a car. Ian Fleming's private home was at Oracabessa on Jamaica; the 52-acre estate was called Goldeneye.

In the first Bond movie, *Dr No*, filming was on a tight budget. While some scenes were supposed to be located as Eastern Europe, the scene where 007 is being chased by a helicopter and Bond hides beneath a large stone was filmed in Glen Michael, Scotland. Also filmed in Scotland was the boat chase at the end of the movie, which was filmed on Loch Craignish near Crinon.

In a clever last-minute addition to the set in Dr No's lair, a painting was hung on the wall. When James Bond enters the room to have dinner with Dr No, he is surprised to see the

portrait of the Duke of Wellington by Goya. The real painting had been stolen by somebody just a few days prior to filming, to much publicity. Set designer Ken Adam thought it would rather amusing if Dr No had the painting, so he arranged for a copy to be hung on the wall.

A few actors have repeated their roles in different Bond movies. A few examples are:

Eunice Gayson played Sylvia Trench in both *Dr No* and *From Russia with Love*. Jeffrey Wright played Felix Leiter in three Bonds: *Casino Royale*, *Quantum of Solace* and *No Time to Die*. Then who can forget the Southern Sheriff J.W. Pepper in *Live and Let Die*, played by real-life World War Two hero Clifton James. He proved so popular with Bond fans that he was asked to play Sheriff Pepper again, in *The Man with the Golden Gun*.

Then there are the actors who have returned to play different characters:

Maude Adams played the girlfriend of Scaramanga in *The Man with the Golden Gun*, then returned for a leading role playing *Octopussy*. Charles Gray played Henderson (Bond's contact in Japan) in *You Only Live Twice*, then returned a few years later as Ernst Stavro Blofeld in *Diamonds are Forever*. Mark Lawrence played a gangster in two Bond movies: *The Man with the Golden Gun* and another gangster who throws the busty girl out of the hotel window in *Diamonds are Forever* – it is not thought to be the same character....

Pygmalion

In 1956, a stage musical, based on the 1913 book *Pygmalion* by George Bernard Shaw was proving very successful. It came then as no surprise that Hollywood soon caught-on and decided to turn the successful play into a movie. The movie was to be called, *My Fair Lady* and all members of the lead cast from the play were hired to reprise their roles in the movie, all except one that is. In the play, the character of Eliza

Doolittle was played by Julie Andrews, however she was not hired for the movie; snubbed in favour of Audrey Hepburn. Now although Audrey Hepburn was a good actor, she sadly could not sing a note and her singing parts in the movie were in fact dubbed by Marni Nixon, a contract singer whose singing skills were over-dubbed for many leading actors performing in musicals at that time. In most cases Marni Nixon had to sign a contract stating that she would never reveal that she was the singer behind the leading actors. It must have been a terrible snub for Marni not to be given any credit for her singing, and an equal disappointment for Julie Andrews to be publicly snubbed and passed over for Audrey Hepburn in the 1964 movie. However, Julie was to get the last laugh, as the following two years saw her perform in the highly successful movies *Mary Poppins* and *The Sound of Music*. Julie Andrews was subsequently nominated for an Academy Award for both movies; winning an Oscar for Mary Poppins.

Marni Nixon's voice was used as a "Ghost Singer" for many a leading actor during the singing scenes; including that of Natalie Wood in *West Side* Story and Deborah Kerr in *The King and I*, which included singing on the associated albums released at the time; again receiving no credit. We did, however, see Marni's face when she played Sister Sophia, singing with other nuns in the scene of *How do you solve a problem like Maria*. Marni Nixon passed away in 2016 and her son became the successful 1970's pop singer Andrew Gold, who had a big hit with "Lonely Boy".

Jennifer Lawrence

Jennifer Lawrence was born in Kentucky. During school breaks, she helped her mother, who ran a children's nursery. When she was 14 years of age, she was on holiday in New York walking around Union Square. Jennifer was spotted by a talent scout, who signed her up to a modelling agency, including Abercrombie & Fitch. One of her first acting jobs

was for a peanut buttercup commercial. A part on the TV series *The Bill Engvall Show* followed, which catapulted her to a career in movies. Jennifer has won several awards, including an Oscar for her leading actress role in *Silver Linings Playbook*. Actor Donald Sutherland said of Jennifer Lawrence: "She is a highly talented actor, on par with the great Lawrence Olivier." In the years 2015 and 2016, Jennifer Lawrence was the highest-paid actress in the world. During the filming of *The Hunger Games*, lead actor Jennifer Lawrence assured director Gary Ross and her co-star, Josh Hutcherson, that, during their fight scene, she could do a side kick and clear Josh's head in perfect safety. When the fight scene started, Jennifer miss-timed her side kick, smacking Josh square in the face and momentarily knocking him out. OOPS – I'm sure they laugh about it now.

Jennifer Aniston

Before she found fame, Jennifer Aniston worked as a waitress in a Hollywood restaurant, just to make ends meet. She auditioned for several sitcoms, which either failed or she didn't get the part. While getting petrol in her old beat-up car, she bumped into TV executive Warren Littlefield, who was also fuelling up his vehicle. "Will it ever happen for me?" she complained.

He encouraged her and said 'here, read for this', and handed her a script for a proposed sitcom called *Across the Hall* (later renamed *Friends*). Well, as they say, the rest is history.

The B Movies

The B movies were low budget movies that used to be shown at cinemas prior to the main feature. The actors were often straight out of drama school or older actors who were no longer in such demand. The film crew were also of similar stock, such as the film studio giving an unknown director his

first job directing a B movie. Many of these B movies are now made for television, and shown mid-week afternoons. Prior to becoming a famous actor, John Wayne was cast in a series of Western B movies as Singing Sandy, where Wayne would sing a song as he approached another cowboy for a quick-draw shootout.

Much later, after becoming famous, John Wayne was so embarrassed by these movies that he sought to buy them all and have them destroyed. Very few exist. Wayne, who had the nickname of The Duke, was actually born Marion Robert Morrison on 26 May 1907 in the state of Iowa. It was the studio who gave him the name John Wayne, and John wasn't even present at the discussion to his movie-allocated name. During the 1930s, Wayne did a lot of what he himself dubbed 'horse operas' – mainly low budget bit parts that were mostly movie flops, some of which he is not even mentioned in the credits. In 1939, director John Ford gave him his first big leading role in his movie *Stagecoach*. All of a sudden, John Wayne believed that he had finally made it

in Hollywood. Then World War Two started, which led to America joining the war after the attack on Pearl Harbour. It has been said that John Wayne did try to enlist in the military during the war; that may be true, but I feel that Wayne knew all too well how hard it had been to get into leading movies. After struggling for nearly 12 years in minor roles, he must have been concerned that going away to war would have perhaps ended his career in movies. Wayne did try to enlist on several occasions, but, perhaps due to his age and family status, he was deemed exempt. He did, however, tour with the USO (United Service Organizations) in the Pacific, visiting US Military bases and hospitals during 1942–1943. In 1973, Mel Brookes offered him the role as the Waco Kid in his comedy Western *Blazing Saddles*, but Wayne turned it down, saying that it was rather rude for his wholesome family image. He added that he would be first in line to see the movie when it was released. (Gene Wilder got the part as the Waco Kid.) John Wayne wore the same gun and holster in all his Westerns. In his final movie role, *The Shootist*, Wayne played an ageing gunman who is dying of cancer. Three years later, John Wayne died of cancer on 11 June 1979.

The Notebook

During the filming of *The Notebook*, the main actors, Ryan Gosling and Rachel McAdams, did not get along on set and often argued, and Ryan even attempted to get Rachel McAdams replaced. It was causing so much delays on set that Director Nick Cassavetes got the two of them in a private room to air their differences. The two not only became friends, but they started dating in real life.

Charlie and the Chocolate Factory

In the movie *Charlie and The Chocolate Factory* starring Johnny Depp, Nestle supplied 1850 real bars of chocolate.

12 Years a Slave

While playing an alcoholic, actor Michael Fassbender rinsed his mouth out with strong alcohol and had it brushed onto his moustache so the actors he was playing off would have a natural reaction to his breath.

Into the Woods

During rehearsal for a scene, Meryl Streep had to jump on a table, but she slipped on her costume and fell backwards towards a concrete floor. Lucky for Meryl, fellow actor Emily Blunt jumped forward and caught her before she hit the floor.

Star Trek (Movie)

The sound effect of the automatic doors opening on the USS Enterprise was recorded from a Russian train's toilet flushing.

Forest Gump

Lead actor Tom Hanks did not charge a fee for filming the movie; he instead negotiated a percentage of the box office earnings, which, in the end, netted him $40 million.

Elizabeth: The Golden Age

While filming the second part of Elizabeth: The Golden Age, filming was to take place on location at St Paul's Cathedral in London. However, the building was getting some exterior maintenance and the set was a building site. Rather than arrange a reshoot at a later date, the director, Shekhar Kapur, had the real builders dress up in period costume and supplied them with old tools of the era; basically, the real builders were used as stonemason extras.

Armageddon

I enjoyed the space movie *Armageddon* starring Bruce Willis. However, as far as NASA is concerned, the movie is so full of mistakes of things that are impossible and just cannot happen that NASA show the movie in their space management training programme. NASA says there are at least 168 things that could never happen. Can you spot them?

Carry On Camping

Filming *Carry on Camping* was actually filmed in a field behind Pinewood Studios in Buckinghamshire and, although the plot is set on a summer holiday campsite and the actors are wearing bikinis and light summer clothes, the movie was shot in the winter months of 1968. It's a bawdy comedy, of course, and, in the scene where the girls are exercising, Babs (Barbara Windsor) loses her bikini top. The bikini top was removed via a thin nylon fishing line, and Barbara Windsor just manages to keep her modesty, covering her ample bosom with her hands. However, did you notice the hat on Hattie Jacques? The bikini top removal scene took several takes to get right, and was filmed from a few cameras at different angles, and spliced together later in the editing room. As filming of this scene took some time, Hattie was getting chilly and put on her hat. However, as you watch the final scene that was spliced together, you see Hattie wearing the hat, then not wearing the hat, then wearing it again. Most people's eyes, of course, are drawn to the bikini top flying off.

Brian Cox

Dundee-born actor Brian Cox landed two roles back to back, firstly playing Killearn in *Rob Roy*, then, days later, playing Argyll Wallace in *Braveheart*. All of his scenes were filmed in Scotland and he stayed in the Spean Bridge Hotel during filming of both movies.

Brian Cox performed as Hannibal Lecter first in the 1986 movie *Manhunter*, while at the same time Anthony Hopkins was playing King Lear at the National Theatre. Fast forward five years and, in 1991, Brian Cox was performing as King Lear at the National Theatre, while at the very same time Anthony Hopkins was playing Hannibal Lecter in the movie *Silence of the Lambs*.

Musicals

In what was known as the golden age of Hollywood, the '20s, '30s, '40s and even the '50s, the making of musicals was popular and commonplace throughout the various Hollywood studios. The 1948 movie *The Pirate* featured the fabulous song *Be a Clown*, written by Cole Porter, which was sung twice in the movie – firstly by Gene Kelly and the *Nicholas Brothers*, and later by Gene Kelly and Judy Garland. Then, in 1952, the musical *Singing in the Rain* featured the song *Make Em Laugh*, which used different lyrics, but was a complete rip-off of Porter's original song, *Be a Clown*. Cole Porter even appeared on set when the song *Make Em Laugh* was being sung and recorded. Either Cole Porter didn't notice or didn't care, but, just to be on the safe side of the copyright laws, he was ushered away. Later, in *Singing in the Rain*, Gene Kelly gave his famous dance routine, *Singing in the Rain*, which he arranged and choreographed himself. On the filming day, he was ill with a 39°C temperature and, although the dance seemed to flow in one take, this was due to several cameras at different angles and clever editing – it actually took three days to complete the dance scene. The movie cameras had difficulty picking out the droplets of the rain shower, so the special effects crew got around this by adding a few gallons of milk to the rain machine's water tank.

By the 1960s, the era of the musicals had begun to decline. In fact, the whole movie industry was in trouble. Fewer people were going to the cinema due to more people owning a

television set. Whatever the reason, 20th Century Fox was, as they say, up that creek without a paddle. They had bought the rights to *The Sound of Music* in June 1960. It had already been successful as a stage musical. This was a big gamble for 20th Century Fox; if *The Sound of Music* failed, the film company would go bankrupt. They needed a lead actress to play Maria. Julie Andrews had a successful career on the stage and had filmed *Mary Poppins*, but that movie had yet to be released. The rumour was that Julie Andrews was not very attractive, so Ernest Lehman and director Robert Wise called Disney to see if they could view a few reels of *Mary Poppins*. Disney sent over a few reels and, once viewed by Lehman and Wise, they both agreed to sign up Julie immediately before she was snapped up by another production. *The Sound of Music* was a resounding success, winning five Academy Awards (Oscars) and was the highest grossing film of 1965. It saved the studio from bankruptcy. *The Sound of Music* did very well in most countries worldwide, with the exception of Germany and, surprisingly, Austria, where most of the external scenes were shot, in and around the City of Salzburg. Fans of the movie can take *Sound of Music* bus tours visiting filming locations in Salzburg, Austria, even though most of the city's residents have never seen the movie and do not understand what all the fuss is about.

Lights, Camera, Action – That Final Scene

Making a great movie is like baking a cake. If you get all the ingredients correct, it will end up as a delicious blockbuster. Required ingredients should be perfect and include the following: the script, the cast, locations, musical score, healthy budget and, of course, an innovative director. Remove any of the aforementioned and you may still have limited success, but it won't be a delicious movie. Of course, tastes differ from person to person, and we all have our own favourite movies; movies we can enjoy watching again and again. Over the years,

many movies have been successful, winning multiple and various accolades, including the well-sought-after Hollywood Oscar. Having a huge financial budget doesn't necessarily guarantee success. I'm sure many directors have never worked in Hollywood again after taking charge of a big budget movie that ended up as a flop at the cinemas, losing millions of pounds for financial backers. On the other hand, low budget movies such as the 1981 British-made *Chariots of Fire* (budget £3 million) was a huge box office hit, grossing around £49 million. I have always enjoyed movies by talented directors such as Steven Spielberg, David Lean, Alfred Hitchcock and Robert Zemeckis, to name but a few. Then there are the actors who went on to become fabulous directors, like Clint Eastwood, Richard Attenborough and Sydney Pollack.

As for Alfred Hitchcock, I loved how he always gave himself a non-speaking cameo in his movies; like in his movie *The Birds*, he can be seen walking out of the pet shop with two dogs on a lead. In *To Catch a Thief*, he is seated on a bus next to Cary Grant and, in *North by Northwest*, he fails to catch a bus. It's fun trying to spot him in his ever-so-brief cameos, but I can assure you he will be in his movies somewhere. It has often been said that Alfred Hitchcock was the master of suspense, often ending his movie plot abruptly, leaving the viewer wanting more or letting the audience think for themselves on how they believed the next scene would play out.

The Time Machine

I have always loved a good ending to a movie. Sometimes a movie ending reminds me of a complicated jigsaw puzzle; it's not until you insert the last piece that it all falls together and makes wonderful sense. I recall seeing the 1960 movie *The Time Machine* starring Rod Taylor as H.G. Wells and Alan Young as Mr Filby. When H.G. Wells departs to go back (or is it forward) in years with his time machine, his friend, Mr Filby, runs through with a maid from the next room, but his

friend has vanished in his time machine. "Is there anything missing?" Filby asks the maid.

She has a quick look around. "Only two books," she replies.

"Which two books?" asks Filby.

"Oh I don't know; does it matter?" the maid replies.

Filby responds with the closing line of the movie. "No, I don't suppose it matters." He pauses, then adds, "Only, which two books would you take?"

Lawrence of Arabia

David Lean was a very innovative director often going against what was considered the norm. In his movie, *Lawrence of Arabia*, I believe he was one of the first directors to start his movie with the ending. *Lawrence of Arabia* was released in 1962 starring the then-unknown actor Peter O'Toole. It tells the story of T.E. Lawrence and his time around World War One. The start of the movie has the credit titles roll over the scene of T.E. Lawrence getting his motorcycle ready for a ride. Then, as he thunders down the road at high speed, Lawrence loses control and crashes into a field. As the camera focuses on his motorcycle goggles hanging from a bush, the scene switches to Lawrence's funeral. A reporter is interviewing prominent people as they exit the funeral. One general says, "No, I never knew him; he had some minor function on my staff in Cairo." Then Director Lean starts the movie properly, going back in time to tell the story of Lawrence, beginning with him working in Cairo.

There is a fabulous edit when Lawrence blows out a match flame and the scene switches to a desert sunrise. David Lean also did an unusual thing by putting the sound ahead of the next scene. For example, after Lawrence travels with the boy across the Sinai desert, the shot holds on Lawrence's face, as you already hear the bells from the travelling train, prior to seeing the train in Cairo itself. Also, in what was considered

by David Lean an important scene in the movie, he was desperate to film directly into the sun, but, even using several filters, it always burnt out the film. In the scene where you see the direct image of the burning-hot sun, it is actually a painting; all else is real in the movie. I always thought it was very brave to hold focus on the delayed shot (for several seconds) of the mirage, which turns out to be Omar Sharif riding his camel out of the desert, but it did help to prolong the anticipation and tension of that scene. The movie really is a master class in directorial work, and was nominated for 10 Oscars, winning seven. The final scene gives a hint of how the movie began; while Lawrence is being driven out of Arabia in a staff car, their vehicle is overtaken by a fast motorcycle, which catches Lawrence's attention.

Castaway

One of my favourite movies was *Castaway*, released in 2000 and starring Tom Hanks. He plays Chuck Noland a systems engineer for the FedEx parcel delivery company. Chuck travels around the world visiting various FedEx outlets to see if he could improve company productivity. Just prior to the festive period, Chuck is at the airport and says a rather hurried goodbye to his long-time love, Kelly, and boards a plane to fly to his next assignment. The aircraft gets into difficulties over the Pacific and crash-lands in the ocean. Chuck survives, finding himself alone on an uninhabited island, with a few FedEx parcels washed up alongside him. In an attempt to find something useful, Chuck opens the parcels, but one has angel wings on the cover and he decides to leave that package unopened, to hopefully one day deliver himself. The movie had several locations, including Moscow and America. The desert island scenes were shot on the island of Monuriki in the Pacific, which is actually part of the Mamanuca island group.

During the filming, the other surrounding islands are never in camera shot or are painted out of the scene. The production company built a small village using ship containers. Filming of *Castaway* was done in two parts, with production actually stopping for a year to allow lead actor Tom Hanks to lose weight. The village containers were locked up during this break in production. (During the year break, director Robert Zemeckis and his film crew shot the movie *What Lies Beneath* before return to *Castaway*.)

Chuck survives for four years alone, with only his memory and a faded image of Kelly for company, no doubt cursing the fact that he boarded that plane without saying the things he wanted to say to Kelly. Realising that he is likely to die on that island, he builds a raft and sets off on a dangerous journey. He is rescued by a passing ship and returned home. However, things have changed dramatically, none more so than the fact that his true love, Kelly (believing he was dead), married and had a child with another man. Chuck and Kelly do get together for an emotional meeting, and there is obviously so much love still between them, but it is Chuck who tells Kelly she has to stay with her family and, after a tearful goodbye, Chuck drives off. Later, we see Chuck arriving at a secluded house to deliver

the package with the angel wings. Nobody is home, but he leaves the package at the door, with a note saying: "This package saved my life." He then drives down to a crossroads and stops his vehicle and gets out to look at a map.

As he does so, a truck pulls up with a lady saying, "You look lost." She gives the directions to where each road would lead. Then, after saying 'good luck, cowboy', she drives off up the road. It is only then that Chuck notices the angel wings attached to the rear of the truck. (The lady in the truck was played by country singer Lara White, who sadly died of cancer on 28 January 2018, aged only 52 years.) Earlier, I mentioned how some movies leave you with an ending that prompts you to think for yourself what would happen next; well, this is another classic example. After pausing for a moment, we see Chuck standing in the middle of the crossroads. His life has been turned upside down, he has lost his true love and he cannot look back, but he can move forward and go in any direction he pleases. He has the rest of his life in front of him. Looking in each direction, the camera slowly zooms close on Chuck's face, and he begins to smile... (movie ends).

If we're honest, perhaps at some time in our lives we may all find ourselves at a crossroads, anxious about tomorrow and unsure which path to take, (especially after a year like we've had in 2020). You might feel depressed, lonely and, metaphorically speaking, trapped on your own desert island. If you find yourself in that situation, never give up; no matter how many obstacles are placed in your path, keep trying, keep going, because you never know what the morning tide will bring you. After all, tomorrow is another day, and it begins by dawn's early light....

This book can be purchased globally online or locally at the following Arbroath outlets:

The Meadowbank Inn on Montrose Road, *Abbey Music* in Kirk Square.

Bosun's Cabin opposite The Lifeboat Shed, *Keptie Newsagents* on Keptie Street.